Picture Yourself Making Creative Movies with Corel® VideoStudio Pro™ X4

Marc Bech

Course Technology PTR

A part of Cengage Learning

COURSE TECHNOLOGY
CENGAGE Learning™

Australia • Brazil • Japan • Korea • Mexico • Singapore • Spain • United Kingdom • United States

COURSE TECHNOLOGY
CENGAGE Learning™

Picture Yourself Making Creative Movies with Corel® VideoStudio Pro™ X4

Marc Bech

Publisher and General Manager, Course Technology PTR:
Stacy L. Hiquet

Associate Director of Marketing:
Sarah Panella

Manager of Editorial Services:
Heather Talbot

Marketing Manager:
Jordan Castellani

Development Editor: Kim Benbow

Project Editor and Copy Editor:
Kim Benbow

Technical Reviewer:
Roger Wambolt

Interior Layout Tech:
Judy Littlefield

Cover Designer: Mike Tanamachi

Indexer: Larry Sweazy

Proofreader: Sandy Doell

For product information and technology assistance, contact us at **Cengage Learning Customer & Sales Support, 1-800-354-9706**.

For permission to use material from this text or product, submit all requests online at **cengage.com/permissions**.

Further permissions questions can be e-mailed to **permissionrequest@cengage.com**.

Corel KPT Texture Explorer, Painter, PaintShop Photo Pro, VideoStudio Pro, and WinZip are trademarks or registered trademarks of Corel Corporation and/or its subsidiaries in Canada, the United States, and/or other countries.

All other trademarks are the property of their respective owners.

All images © Cengage Learning unless otherwise noted.

Library of Congress Control Number: 2010926279

ISBN-13: 978-1-4354-5726-3

ISBN-10: 1-4354-5726-9

Course Technology, a part of Cengage Learning
20 Channel Center Street
Boston, MA 02210
USA

Cengage Learning is a leading provider of customized learning solutions with office locations around the globe, including Singapore, the United Kingdom, Australia, Mexico, Brazil, and Japan. Locate your local office at: **international.cengage.com/region**.

Cengage Learning products are represented in Canada by Nelson Education, Ltd.

For your lifelong learning solutions, visit **courseptr.com**.

Visit our corporate Web site at **cengage.com**.

Printed in the United States of America
1 2 3 4 5 6 7 13 12 11

To Jacqueline

I'm prouder every day to be your father.

Acknowledgments

My name may be on the cover, but there is a small army of people behind the scenes who got this book into your hands or on your computer. My Project Editor Kim Benbow has the patience of Gandhi and is more detailed than a dual core computer processor. I would also like to thank Stacy Hiquet, Publisher, and Megan Belanger, Acquisitions Editor, for helping to keep this project on track.

Roger Wambolt, Technical Editor, made me look good by checking and rechecking that all the lessons and files worked as written and that terms were correctly and logically explained. Thank you to Corel for co-marketing this book with me and for giving me access to Jan Piros, Senior Strategic Product Manager, and Greg Wood, Digital Media Product Marketing Manager. Other Corel folks to thank include Evelyn Watts and Tanya Lux. They were always there when I needed them.

There are also many layout and quality assurance folks too numerous to mention. I have a new-found respect for the publishing industry.

About the Author

Marc Bech started his digital career at Macromedia (before the company coined the term *multimedia*) and now has over 20 years of experience in multimedia, graphics, and e-learning software sales, sales engineering, business development, and training.

At first, Marc joined a startup called Paracomp, which merged with MacroMind and Authorware, to create Macromedia. Over 12 years and at least a dozen acquisitions and mergers later, Marc was a consistent top salesperson, Macromedia's first sales engineer, sales engineer manager, and technical evangelist, entertaining global audiences with the exciting possibilities of desktop and Internet multimedia software.

Marc was then recruited by Adobe Systems as a web business development manager. Further opportunities took him to Corel as a field market specialist, then back to Adobe as an Acrobat specialist. From there, it was on to custom e-learning developer, Enspire Learning, in a business development role. From there he went back to Corel, which is how this book turned from an idea and a need into reality. (How many times can you say that you've returned to two employers twice?)

Born in France, then raised in Hawaii, Marc is now based in Austin, Texas.

Table of Contents

Introduction

M Y, HOW THE WORLD OF VIDEO and video editing has changed over the years. Video has evolved as fast and as far as the automobile in about the same number of years. The first automobile was introduced in the same decade and just a few years after a team of inventors at Thomas Edison's lab created a motion picture camera called the *kinetograph*. In just over a century since then, cars have gotten faster, easier to use, and more complex, not unlike the digital camcorders of today. Now you can hold a high-definition video camera in the palm of your hand and purchase very capable video editing software for under $100 that just about anyone can use and many can master. Prices continue to drop and features continue to evolve.

Whether you're in this for fun, a serious hobby, or for your business, I will show you how to create digital videos that you'll be proud to share with family, friends, customers, and colleagues by following the easy-to-use steps included in this book. I'll show you how to share them on the Web, upload them to portable devices, and burn CDs and DVDs with custom menus and labels.

You'll learn how to add your own animated titles and audio clips, as well as create premade and custom video, title, and audio effects. Using the downloadable working files means you'll learn by doing and then experiment on your own to build digital videos that are uniquely yours.

What You'll Need

Since you have purchased this book, I'm going to assume you have also purchased the Corel VideoStudio Pro software. And although it is not a requirement, it is highly recommended for obvious reasons that you have the version of VideoStudio Pro that's covered in this book, version X4 (14). You also should know the basics of using a computer, for example, how to open, save, and close files, as well as use a mouse to access menus, select commands, and move objects around the screen. You should also make sure that your computer meets at least the minimum system requirements of running VideoStudio Pro X4. (The requirements are written on the software package and mentioned on Corel's website.) Please remember that using HD (high-definition) clips requires more computer "horsepower" than using SD (standard definition) clips.

How This Book Is Organized

This book is divided into 16 chapters and a couple of appendices—one is a table of keyboard shortcuts and the other lists some useful websites you can visit for more information. You'll start out with some video basics, then learn how to get the software up and running, followed by capturing, editing, and sharing video using VideoStudio Pro X4 through step-by-step instructions with actual video clips that you can download. Tips and tricks are also interspersed throughout.

Companion Website Downloads

You may download the companion Web site files from www.courseptr.com/downloads. Please note that you will be redirected to our Cengage Learning site.

Videography
Basics

CAN I REALLY SHOOT decent videos and edit them myself? Odds are, you've asked yourself this very question at some point during your video-taking adventures. Most likely, you've already taken hundreds, or even thousands, of photos; maybe you've taken hundreds of videos over the years and are deciding to advance to the next step of editing and sharing them with family, friends, colleagues, and customers.

Perhaps, you're already sharing some of your videos. You might share a lot more though if they weren't either turned on their side, jittery, or too long or too large to e-mail or post on a website.

On average, over 50 percent of you manage and edit your photos, but only about 5 percent do so with videos. Fifty percent of folks do most of their photo *and* video shooting with pocket-sized point-and-shoot cameras, while only 30 percent use a digital camcorder to shoot video (see Figure 1.1). As you can see, digital video shooting (and more so with digital video editing) is still in its infancy. Video sharing lags behind photo sharing by half. Backing up media is another issue altogether!

If you're in these lower percentage categories, again you may wonder, can I really edit and customize my own videos? Yes, you can! Follow the lessons in this book, and you will not only impress your family and friends, but you will have fun doing it. With VideoStudio Pro X4 (VSX4), it's much easier than you think. Let's start learning with some basics on the basics.

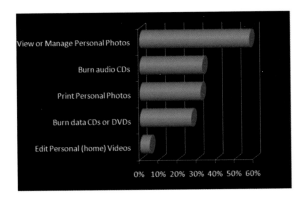

Figure 1.1
How people work with their photos and videos.

What Kind of Video Camera Is Good Enough?

YOU WILL GET A DIFFERENT answer to this question from everyone you ask. But the questions you may be asked in return are these: What do you want to accomplish? And what is your budget? I guess my first recommendation is to not purchase a camera beyond your means to take advantage of its features; you'd be wasting your hard-earned money, and you might become so intimidated by what you have that you set the camera aside altogether.

Instead, purchase a camera that meets your immediate and short-term goals. But, you might say, "I may want to make the next Avatar sequel." Don't worry, cameras are getting better and less expensive all the time. Buy one that meets your needs now, and maybe with just a few new bells and whistles you may want to try out. Important features to consider are the following:

▶ **Standard Definition (SD) vs. High Definition (HD):** High-definition cameras are already rapidly dropping in price and size. They're almost becoming the standard in consumer digital video equipment. If you want to shoot in HD, now is as good a time as any to make that move, especially if you already have or plan to purchase an HD TV soon. A simple buying guide resource can be found here: www.videomaker.com/article/14882/?rfh=10.

▶ **Standard Width vs. Wide Screen:** HD and some newer SD cameras allow you to shoot in both standard width (a ratio of 4:3, width to height) and wide screen (a ratio of 16:9). If you're shooting in HD, you'll also want to shoot in wide screen. Be sure to choose which option you desire in the VideoStudio Launch screen *before* you edit your video.

▶ **Image Stabilization:** Unless you'll be carrying around a tripod everywhere you go, I think image stabilization is an important feature to consider that will help reduce the effects of camera movement while you're shooting.

▶ **Zoom (Optical vs. Digital):** With a point-and-shoot camera, you're lucky to get more than a 3X zoom. Point-and-shoot cameras in between pocket-sized and DSLRs (digital single-lens reflex), can reach up to 10X and higher. Digital camcorders, on the other hand, can reach up to 10-70X and more. Digital camcorder zoom can reach over 3000X. A note of caution though: Optical zoom is real, while digital zoom is interpreted; therefore, digital zoom may adversely affect the quality of your video. Digital zoom can vary between cameras and brands, so make sure you understand which zoom figure they're advertising, optical or digital

▶ **Point-and-Shoot Camera with Video Capabilities vs. a Digital Camcorder with Photo Capabilities:** While the former usually has weak video capabilities, the latter are getting much better at photo capabilities with anywhere from 8 to 10 MP (megapixel) resolutions. Photo capabilities in camcorders may lack many features beyond the basics, but at least the higher resolution is there. You can always edit the photo later in an image editing application, such as Corel's PaintShop Photo Pro.

▶ **Night Vision:** Night vision is a great feature to consider for events like birthday parties (blowing out the candles!), sneaking up on people in their sleep, and the newly popular activity, ghost hunting! It usually adds a good chunk to the selling price though.

▶ **External Light:** Probably more useful than night vision is having a spotlight attached to the front of your video camera. This, again, adds to the price somewhat and drains your battery much more quickly. Also good for night situations, but without the surprise attack!

▶ **LCD Screen:** The LCD screen refers to the hinged panel that swings out from the camera's base containing a viewing screen that allows you to see your shot without having to look through a tiny viewfinder. The benefit is that you can glance around your viewing area at the same time, making adjustments as necessary. I recommend getting a camcorder that has both, as the LCD screen can be very difficult to view in bright outdoor lighting. Be aware that some camcorders may only have a black-and-white viewfinder, even if they have a full color LCD screen.

▶ **Battery Life:** What good is having all this storage space to record if the battery is constantly dead? Good camcorders will have a long battery life. Most cameras, however, don't come with a large-capacity battery. Make sure you include the cost of an extra battery in your budget and take that extra battery with you when you travel.

But wait! There is something else to consider that's equally as important, and maybe even more so. Shooting video takes up *huge* amounts of hard drive space on both your camera and computer. HD video takes up even more.

Memory is commonly referred to as RAM (random access memory), or the system memory that designates how many applications and files you can have open and use at the same time. These are a series of long, narrow chips that are installed side by side inside your computer. The contents of RAM changes constantly, depending on what applications are open and running on your computer. RAM is accessed several hundred times faster than hard drive memory and is very important to the function and speed of your computer during video editing. The more RAM (again, it's cheap and getting cheaper) your computer has, the faster and smoother your computer will perform. Don't scrimp on it. Video editing loves at least 3+ gigabytes (GB). One gigabyte of RAM can be had for about $50.

Hard drive space refers to the "library" of space that permanently holds *all* of your applications, files, photos, videos, and more. It's what you hear spinning off and on inside your computer. It can also be connected as a separate external device, either for extra space or as a backup device. It, like RAM, is cheap and getting cheaper; 500 GB is a great start for basic video editing and can be had for under $100. You might even consider doubling that to a 1-terabyte (1T) hard drive instead.

While photos can take up space in the range of a few hundred kilobytes (KB) to 25–50 megabytes (MB), videos can take up space in the order of hundreds of megabytes to multiple gigabytes. High-definition video can take up to four times the size of standard-definition video. So, you can see how space (both RAM and hard drive space) is *really* important when considering not only the camera you'll be shooting with, but also the medium you'll be using to capture and store your videos to.

Camcorder Storage Options

Let's take a look at the capture and/or storage options inside your digital camcorder. I say "and/or" because, while most folks will download their video and erase what's on the camera's memory in order to reuse it, some folks use these devices to store their content and then purchase additional camcorder storage media for new content. The following list discusses the most popular choices (at the time of this writing) down to your lesser choices.

▶ **Internal Hard Drives:** Hard drives have rapidly become the most popular storage medium on digital camcorders for their, reliability, convenience and rapidly increasing capacity. Hard drive space can range from 30 GB to 120 GB and more. Obviously, the more space you get, the less often you'll have to transfer your video from your camera to your computer, CD, or DVD. Just don't neglect to do that, or you'll probably find yourself out of space *and* away from your computer at just the wrong time!

▶ **Internal Flash Memory Cards:** Memory cards (see Figure 1.2), a type of removable memory that has no moving parts (as opposed to hard drives), are especially handy. When you run out of room, you can just insert a new memory card. The most common types of memory cards found in camcorders are SD cards or Memory Sticks. Memory cards also make it easy to transfer video to your computer; just pop it into a memory card reader or card slot on your computer. However, the downside to memory cards is their limited capacity compared to internal hard drives.

Figure 1.2
Various multimedia cards.

Flash memory is a non-volatile computer storage type that can be electrically erased and reprogrammed. Since flash memory is non-volatile, no power is needed to maintain the information stored on the chip.

▶ **Digital Video (DV) Tapes:** DV tapes (similar to mini-cassette tapes) come in many sizes. Most are pocket-sized and inexpensive. Tape is known for its long-lasting durability and reusability. The current sizes, in order of popularity include S-size or MiniDV, M-size or medium, L-size or large cassettes, and XL-size or (as you guessed it) extra large size. Any cassette size may be used for either SD or HD video and may be recorded on multiple times. Although you can purchase tapes that record for varying lengths of time, the different physical sizes are manufactured more for the requirements to fit the different DV cameras (see Figure 1.3).

Figure 1.3
Digital video tape.

▶ **Optical Discs:** Optical discs, like CDs and DVDs, were popular DV recording media, but are rapidly waning due to their short recording time and relative inconvenience. There are two physical sizes of optical discs: 12-cm discs are your typical audio and DVD size, whereas the 8-cm discs are referred to as *mini-CD* and *mini-DVD*. Capacities can range from 1.5 GB up to 100 GB for dual-layered Blu-ray discs. Data are added to optical discs using

lasers (see Figure 1.4). Although the media is long-lasting, it is not as durable as tape due to its propensity to scratches. Discs also include many recording types. Regarding recording time, if you want to record the highest HD quality, an average optical disc may only record 10–15 minutes of video before you must finalize it, eject it, insert a new one, and prep it for recording. In that time, your child could've recited the Gettysburg Address at the school play and you would've missed it.

Figure 1.4
The laser mechanism of a CD/DVD player.

Video file size can vary depending on the features and quality settings you choose (e.g., resolution and frame rate). As a result of these settings, SD video can take up anywhere from 11 GB to 22 GB per hour of video on your hard drive. HD video can take up anywhere from 145 GB to over 400 GB per hour of video. Keep these figures in mind when choosing storage space on both your camcorder and your computer.

Check your manual *before* you purchase any internal camera storage to see what media your camcorder supports. As explained, there are several differing sizes and shapes, and your camcorder will only support one type.

Use the settings in your camcorder to designate how much video each storage device (mini-CDs, Multimedia Cards, and hard drives) will save or store in terms of length and quality. Lower settings will allow your camcorder to store more video, but at a lower quality. Since storage is inexpensive, try to find the setting that will provide the quality you desire and just make sure you have enough extra storage devices.

What Kind of Media and Features Can I Include in My Movies?

THIS MAY SEEM LIKE A question with a very obvious answer, and you're partially right! You can obviously include videos in your movie projects. But did you know that you can also include photographs? There's a reason that most camcorders these days also have the ability to shoot and store high-quality photographs. Beyond the obvious convenience of not having to carry two devices with you on vacation, camcorder manufacturers know that most video editing applications have the ability to intersperse images in between video clips, along with separate audio clips (and VideoStudio Pro X4 is no exception).

VideoStudio Pro X4 also allows you to add, create, and customize titles that can stand alone or be overlaid on top of your images and video clips.

Music and voice-overs, video and audio filters, as well as special effects between scenes, can also be incorporated into your production.

One of the coolest and most unique features of VideoStudio Pro X4 is the Painting Creator (see Figure 1.5). The Painting Creator allows you to record animated painting, drawing, or writing strokes to use as an overlay effect.

Other visual and audio features you can add to make your video projects unique include special video effects, fancy transitions between scenes, picture-in-picture, animated picture frames, and more So what kind of media can you include in your movies? The answer is, A LOT!!

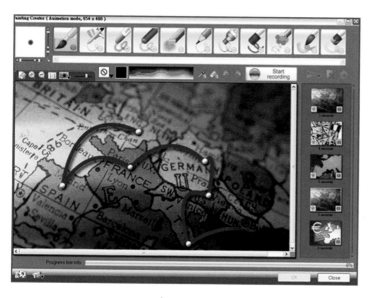

Figure 1.5
Painting Creator.

How to Get the Best Results *Before* You Edit

I'M SURE YOU'RE AWARE of the adage "garbage in, garbage out." This applies to many things, including shooting video. Your editing results in VideoStudio will only be as good as the movies you've imported into it. True, many of the best shots happen when quickly grabbing your camera and shooting when the opportunity presents itself. Sometimes you plan to shoot one thing, but end up getting something completely unexpected. This is the YouTube generation after all.

But there are many ways to get the most from your videos. Knowledge and a little planning can go a long way. You can pretty much narrow down best video shooting practices to just a few items:

▶ **Learn Your Camcorder:** The last thing you want to do, as you pick up your camcorder to record a shot, is to reach for the manual to learn how to do something. It's often too late at that point. Whether it's to set auto or manual focus options or to set the quality of the video, knowing how to quickly set these choices will let you focus more on the shot itself. Take time to read through the manual, and at least play-test the top half dozen or so features you think you'll be using. Remember, we're now in the age of digital video. You can erase and re-shoot at will. Take a few minutes before each event to familiarize yourself again with your favorite features, and maybe add a new feature or two to your arsenal each time.

▶ **Hold Your Camera Steady:** Even if your camcorder has image stabilization, do your best to hold your camera steady. Okay, it may have worked for *The Blair Witch Project* and *Cloverfield* (actually, I almost got ill watching the latter), but the last thing you really want is to give your viewers motion sickness. Videos of UFOs really lose credibility when camera shake makes the object look like a Frisbee or a flare. Use a tripod or lean your camera on the roof of your car, a fence rail, a chair, a window sill, a friend's shoulder, or a stranger's if you ask them nicely.

▶ **Lighting:** Shooting outside in the daytime usually doesn't present a problem. If you're indoors, make sure to turn on enough lights or turn on your camcorder's light. Use the night vision option (if you have it) if you're in candlelit or dark rooms.

▶ **Know What's in the Background:** Although what's going on in the background could be crucial or otherwise add to what's happening in the foreground, make sure it doesn't do the opposite and distract from your main subject. Zoom in to concentrate on the important stuff or zoom out to include what might get your point across even better. Sometimes you might want to do both!

▶ **Sound:** Another distraction can be background sounds. Unless it's desired (like a NASCAR race, a concert, pounding surf, or a babbling brook), do your best to minimize background noise. Camcorders are sensitive to sounds, as they try to make sure all sounds are represented equally in your movie. For this same reason, try to make sure your subject is speaking clearly and loud enough, especially if having to drown out background noise. Consider a microphone to isolate the sound you want recorded.

▶ **Avoid Really Short Shots:** Again, this is not a hard, fast rule. But it takes a good 5 to 10 seconds for the viewer to comprehend what's going on and recognize all the elements in your shot. Shooting for longer periods of time will also give you more room for trimming and editing afterward. Plus, recording is inexpensive and can easily be written over the next time. Don't be shy about it, but make sure to turn off the camcorder when you're done so you don't shoot the ground like my Dad does....

All these rules are just guidelines. These days, pretty much anything goes when it comes to the quest for the ultimate video. Consider these basic rules, but don't let them sway you if you want to create something unique. Videos, after all, are an expression of you. Have fun!

Getting Your Video Clips onto Your Computer

OKAY, NOW THAT YOU'VE shot your Hollywood-worthy photos and videos, what's next? There are typically two ways to get your camera content onto your computer for editing. One way is to use the transfer cables that should've been included with your camera. Connect your camera directly to your computer and then download the material either into an application provided with your camcorder purchase or by capturing directly into VideoStudio Pro X4. If your camcorder uses a hard drive or mini-DV tapes to capture and store video, then physically connecting your camera is the only method to get your content onto your computer.

The differences between capturing and downloading are explained in further detail in Chapter 4, but basically, capturing involves downloading plus converting to a compatible file format for your computer.

If cables were not included, refer to your camera's user guide. Most cameras will require modified USB cables, usually one with a mini-USB connection on one end and a regular USB connection on the other (see Figure 1.6). But there are different mini-USB ends. Again, refer to your manual (or a blue shirt at Best Buy) for the correct cable. The mini end will connect to your camera's USB slot, and the regular end will connect to your computer's USB

slot. For capturing video from a tape-based camcorder, you will need to have a high-speed transfer FireWire (IEEE 1394) cable. (This is discussed further in Chapter 16.)

Figure 1.6
Regular to mini-USB cable.

The other method for transferring your video to your computer is to take the storage media out of your camcorder and either plug it directly into your computer's card slot, use an external MMC (MultiMedia Card) reader, or use the CD/DVD tray for camcorders that save to mini-discs. You can purchase small MMC readers that will fit your specific memory card or a reader that can fit several sizes for several different devices. MMC readers are usually small enough (even with the USB cable connector) to fit in your pocket and are inexpensive, in the range of $15 to $30.

Tip

Placing your mini-CDs/DVDs into a computer tray will not work on a Mac computer. Apple uses a slot that you slide CDs and DVDs into, instead of the pull out tray that PCs use. Do NOT slide a mini-disc into an Apple computer slot because it will get stuck and not eject.

Backing Up Your Video Clips

YOU'VE HEARD THE PHRASE OFTEN: "Save your work!" Well, here's another one: "BACK UP YOUR PICTURES AND VIDEOS!" Does it seem like I'm yelling? That's because I AM! Hard drive space and blank CDs and DVDs are *so* cheap these days. Would you believe you can purchase a 1-terabyte external drive (that's 1,000 GB!) for $100 to $150? You can also get a 100-pack of blank DVDs for $20 or $30. This will also alleviate the possibility of running out of room on, or accidentally deleting content from, your camera.

You would be surprised at how many people are actually afraid to take the video clips and photos off their cameras! Are you one of these? Take a look at Figure 1.7. Only 35 percent of users back up their photos to CDs and DVDs. Thankfully, roughly 70 percent back up their video clips. What happens to the other 30 percent? These folks must keep buying more MMCs, DV tapes, and mini-CDs to shoot and save their videos and photos with. That has to get expensive! Inadvertently deleting content is probably the biggest fear involved in transferring

content from your camera. Do NOT be afraid. Your content will not be deleted when copying it to your computer. Video is only deleted if you erase your media card/disc in a completely separate operation.

One of the topics in this book will be to show you how to use VideoStudio X4 Pro to back up your content. The Backup feature is located in several places within VideoStudio, as if it's acting as a constant reminder to do so.

Figure 1.7
Backup is critical.

Comparing Video File Formats

ALTHOUGH VSX4 ALLOWS you to output to many formats without having to know the particulars about them, I thought I would provide a brief (very brief) explanation of what these formats are and what main purpose(s) they were created for.

Most of the following file formats were designed specifically with the end result in mind (for example, SD vs. HD, DVD vs. web, Mac vs. PC, social networking sites, or mobile/portable devices). VSX4 offers the following choices:

▶ Video files (e.g., QuickTime, AVI, WMV, MPEG, and so on)

▶ Sound files (e.g., WAV, WMA, MP4, and OOG)

▶ DVD (e.g., Blu-ray)

▶ Recording back out to your camera, such as putting your finished movie back onto recordable tape or disc

▶ Mobile devices (e.g., iPod, iPhone, Android, Blackberry, HTC)

Making things even more confusing is the major crossover between all these formats, which is why I'm only explaining the basics. This is merely an overview of what you'll encounter in VSX4.

Out of over 225 different video file formats that exist, here is a brief explanation of the major video output formats pertaining to VSX4:

- **MPEG:** Short for Moving Picture Experts Group, this group sets the standards for the digital encoding of movies and sound. The format includes, but is not limited to, the following:

 - *MPEG-1 (.mpg):* Early format used for audio and video compression, output to the web, and video CDs.

 - *MPEG-2 (.mpg):* Subset of MPEG-1 used in media, such as DVDs.

 - *MPEG-4 (.mp4):* A highly compressed format used for videos on portable devices (like the iPod) and the Internet (YouTube). This format creates small files.

- **AVI (.avi):** Short for Audio Video Interleave and used specifically for playback on Microsoft Windows. AVI files are larger because there is less compression, and thus, may not be suitable for the Internet or e-mail.

- **WMV (.wmv):** A format similar to AVI, but used mainly for downloading to PCs.

- **QuickTime (.mov):** A format originally developed to display video on the Macintosh, it is also viewable on PCs and other operating systems with the QuickTime player.

- **3GP:** A multimedia format used on 3G mobile phones and on some 2G and 4G phones.

- **AVCHD:** Short for Advanced Video Codec High Definition and based on the MPEG-4 format, it was specifically designed for HD camcorder use. It uses a disc structure designed for Blu-ray disc/high-definition compatibility, but it can also be used on standard DVDs. If you have an HD camcorder that does *not* record in Blu-ray, it records in AVCHD instead; in fact, there's a good chance you'll see the letters AVCHD imprinted on your camcorder.

- **H.264:** The latest HD format that provides powerful compression technology while delivering a superior video experience at a low bit rate. H.264 is what YouTube now uses to convert uploaded HD clips for playback on its website, which is a new feature.

- **Blu-ray:** Sometimes known as BD or BDMV, this format uses a new blue-violet (hence the name), smaller wavelength laser for HD video allowing for more capacity on DVDs. It provides the best video and audio quality of any home-based media. . . so far.

- **Flash Video:** Developed by San Diego–based FutureWave Software. Originally called FutureSplash Animator, it was first acquired by Macromedia, which turned into the Flash we know today. Macromedia was recently acquired by Adobe Systems. Flash powers a great portion of video we now see on the Internet. There are two different video file formats defined by Adobe Systems and supported in the Adobe Flash Player: FLV and F4V. Flash video content may also be embedded within SWF files.

RAW video formats usually have the DV or DIF extensions. *RAW* files are those that have not been touched by any file conversion or compression while still in your camera. Many advanced users prefer this format for photo editing. Most camcorders automatically "wrap" RAW files in the AVI or MOV format, so video editing software will be able to recognize and work with them. After editing the clip, you can either save it back in the AVI or MOV format (which will replace the RAW DV or DIF formats), or you can save in one of many other formats.

Now, let me see if can summarize these formats for desired playback devices. Again these are just generalities and not meant to be steadfast rules:

▶ **Windows Computers:** WMV, AVI, MOV, MPG, MP4, Flash

▶ **Macintosh Computers:** MOV, MPG, MP4, Flash (Although the QuickTime player and those of third parties can play most Windows video formats.)

▶ **Websites:** MPG, MP4, MOV, Flash

▶ **Portable Devices:** MP4

▶ **Social Sharing Sites:** MP4, H.264, Flash

▶ **Standard-definition DVDs:** MPEG2

▶ **High-definition DVDs:** H.264, AVCHD, Blu-ray

Quick Review

THIS FIRST CHAPTER HAS HOPEFULLY given you the knowledge and confidence to move on to Chapter 2. Even if you don't yet feel comfortable, future chapters and VideoStudio X4 itself will help guide you. Don't be afraid. Let's see if you know these answers. If not, feel free to thumb back through the pages of Chapter 1 to review. Don't worry, you won't be graded!

▶ What are at least three items to consider when choosing a video camera? (See "What Kind of Video Camera is Good Enough?")

▶ Name three types of media that can be used to capture video on a camcorder. (See "Camcorder Storage Options.")

▶ What are the two most common HD formats? (See "Comparing Video File Formats.")

▶ Name at least two video file formats that are cross-platform for both the Mac and PC. (See "Comparing Video File Formats.")

▶ Name at least three destinations where you can display your final video. (See "Comparing Video File Formats.")

▶ Bonus: What's the easiest way to prevent losing your work? (See "Backing Up Your Video Clips.")

Getting
Started

S O NOW YOU KNOW a little about the technical aspects of video formats, ideas to consider when getting the right video cam-corder, getting the most out of shooting your videos, and the common methods for saving your shots and turning them into memories you'll have for generations.

This chapter will introduce you to the VSX4 package, as well as this book and how you can get the most out of it. I'll cover a little product history on VideoStudio Pro, how to acquire the files to use with this book, and, if you haven't already, how to install VSX4. I'll give you a quick tour of the application, as well as where to get assistance if you run into problems—not that you'll need it with *my* expert guidance! I'll also show you how to download additional free content that Corel provides right in VSX4.

Ready? Set? Go!

The History of VideoStudio

YOU MAY OR MAY NOT KNOW that Corel has been around for over 20 years, celebrating its 20th anniversary in 2009. The CorelDraw Graphics Suite was the first "blend" of graphics software applications on the market, even before any of the Adobe Suites.

VideoStudio, originally from a company called Ulead in Taipei, Taiwan, started a groundbreaking history of its own. Back in the early 1980s, Taiwan decided that the IT and PC industries were a good bet for future fortune and created the Science Park in Hsinchu, about an hour outside of Taipei.

At about that time, three really smart guys were working on image editing software at the Institute for Information Industry (III), Taiwan's hothouse for developing software technology. When the interest in the Taiwan computer industry turned to building scanners to help get existing content onto computers, bells went off. The three smart guys joined forces with Microtek to create Ulead (named in Chinese for the idea of "strength through friendship"). Their first product was a little number for scanners called iPhoto Plus—yes, that's where the Apple product name came from. The next thing they made was a retail product called PhotoStyler.

After scanners, video looked like the next big thing for Taiwan's computer industry, and display card makers started ramping up products to take advantage of Microsoft's new Video for Windows technology. Ulead was there with a simple video editor they called VideoStudio, just right for the new crop of video capture cards. As a result, VideoStudio versions 1 and 2 were designed as OEM (see note) products that would only work with these new video display cards

> OEM stands for *original equipment manufacturer*. It's a term used by companies, such as Ulead, who include their products in a larger solution, making it a more attractive and useful "all-in-one" offering. This is also where the term "value-added" comes from. An example is when you purchase a computer that has a host of other solutions, such as Internet browser software or Corel's Painter Essentials.

In the late 1990s, consumers started asking for products they could purchase separately from the video cards and computers. As a result, Ulead launched its first stand-alone VideoStudio as version 3 in 1998 in the U.S., Germany, and Japan. It was built around the core technology of Ulead MediaStudio Pro, a multi-award winning video editing program designed for the professional market. Would you believe it was priced roughly the same as VideoStudio is today at $99? And it allowed users even then to share video via the Web, through e-mail, and on CD-ROM.

The next big thing was Motion JPEG (M-JPEG) technology that allowed a user to plug in an analog (non-digital) VHS (Hi-8) tape and convert (encode) it to digital in real time. Modern non-linear (being able to jump to any frame at anytime) video editing for home users was born. This ability was added to the next version of VideoStudio.

VideoStudio 4 (1999) added support for DV (digital video) camcorders and the ability to utilize high-speed IEEE 1394 (FireWire/i.LINK) to transfer data at high speeds in real time along with the ability to control the video camcorder. The quality of 1394 support propelled VideoStudio to the number-one spot in the important Japan market, a position the product enjoys to this day! Version 4 also added MPEG-2 and MP3 format compatibilities.

VideoStudio version 5 (2001) added the ability to author and burn VCDs (Video CDs) (MPEG-1) and DVDs (MPEG-2). Unique Ulead technology called "Smart Rendering" eliminated *generational loss* (quality loss resulting from repeated renderings) when editing. If a clip in the timeline is not edited, it will not be re-rendered. Rendering, in videography terms, refers to the process of finalizing all your edits and effects into a single file for playback.

Also added in version 5 was the consumer request to improve the interface and make it more user-friendly, which at that time (and much like other applications of that period), had a similar interface to Microsoft Office. Talking to consumers and professionals, Ulead created a GUI (graphical user interface) for VideoStudio, and one for Photo Express, (the company's consumer photo editing application) in order to create a smoother and more direct workflow.

Version 6 (2002) continued to improve the GUI and video editing features. Version 6 introduced separate DVD authoring workflows, the DVD MovieFactory application, video filters, transitions, text effects, voice-over, real-time preview, and multiple export options. Version 7 (2003) added more timeline tracks for video overlay, as well as titles and audio, while still maintaining its $99.99 price. Version 7 also became a CNET Editor's Choice Award winner, with increased speed, dual-processor compatibility, support for DVD-VR and DVD+RW video recording formats as well as "on-disc" editing capabilities.

Version 8 (2004) introduced the idea of shorter paths to get the basics accomplished more quickly with the Movie Wizard and DV-to-DVD Wizard, support for MPEG-4 and 3GPP (a mobile broadband standard), and Dolby Digital audio mixing, all while receiving seven additional Editor's Choice Awards.

Version 9 (2005) added still more powerful video editing tools, including Chroma Keying (blue/green screen effects), Flash Animation overlays, Pan and Zoom on video, and more video and audio filters. Also new was the DV Quick Scan feature in the DV-to-DVD Wizard. The Movie Wizard offered over 20 movie templates to choose from. Version 9 also included Smart Pan and Zoom (which automatically detected faces in photos), the unique ability to reshape overlaid video clips so they could appear at an angle, and a new Movie Screensaver feature.

VideoStudio 10 (2006) brought the first HDV capabilities. HDV was the first high-definition video (HDV) capability that's captured via digital tape, introduced by Sony through FireWire and the MPEG-2 file format. Also added were multiple video overlay tracks and Smart Proxy, the ability to play back and render large video files (especially HD) in smaller files as proxies, then render the larger ones at the end. Version 10 also upgraded the Dolby Digital support to version 5.1.

Version 11 (2007) brought Advanced Video Codec-High Definition (AVCHD) compatibility, the MPEG Optimizer, more advanced DVD templates and improvements, as well as enhancements to many other areas.

VideoStudio 12 (2008) added the Painting Creator, the ability to upload video to YouTube, Blu-ray support and output, NewBlue Film Effects, iPhone/iTouch, H.264, FLV (Flash video), Intel Quad Core Technology support, a resizable interface, Auto Pan and Zoom, Auto video transition and audio cross-fades, and faster encoding and rendering times.

Finally, VideoStudio X3 (version 13) added a big jump in editing and rendering speed along with direct compatibility with Intel's Core I7 technology. Also added were advanced third-party FX filters from NewBlue and Corel's KPT Collection royalty-free editable/mixable music from SmartSound, and more templates for movies and DVD menus. You could also create advanced Blu-ray menus, then actually burn Blu-ray discs (requires a Blu-ray burner) and save HD files on YouTube and other Internet sites using the H.264 standard.

Getting the Book's Lesson Files

THIS BOOK IS DESIGNED TO get you involved in the video editing process and help you to try out most everything I discuss. The book's lesson files include video and audio clips, as well as photographs. Although you'll have access to all the files needed for use in the book, there will be some cases where you can use your own. I will point out these options as you get to them. On the other hand, many of the book's companion files are designed to show specific features, so be sure to keep them handy.

Although high-definition (HD) files would be lovely to work with and produce beautiful quality projects, their RAW file size would be prohibitive to down-load. (RAW HD AVI files are much larger than their compressed finished DVD cousins.) You'll be using mostly standard-definition (SD) clips instead,

although there is one HD project you'll use. I will point out where HD-specific features exist and how you can use them if you have HD video you want to try out.

To download the lesson files, go to www.courseptr. com/downloads, which will take you to the Cengage Learning Online Companion website. Simply enter this book's title, ISBN, or the author's name in the Companion Search field at the top and click on the Search button. You'll be taken to the book's companion page, where you can download the related files. Be sure to put them someplace that you'll remember, such as in My Documents or the Desktop, then make a copy of the entire folder. You will be using some files more than once, and sometimes you'll want to go back to the original versions.

Rules to Live By

THIS BOOK SHOULD BE EASY to follow without any upfront instructions; but just in case, and since every learning book operates a little differently, here are a couple of rules that will make your experience smoother.

▶ In addition to the step-by-step instructions, you can use the many screenshots to help you locate a button, a menu item, or a tool to use. They will be labeled for easy identification.

▶ Although VSX4 has very few menu commands that you'll need to access at the top of the application window, you'll occasionally see the following instructional format: File > Export > DV Recording. This describes the menu path to a command. In this case, you would go to the File menu, click on Export, and choose DV Recording from the submenu. Another example might be this: Edit step > *icon*. In this case, select the Edit tab (called a *step* in VSX4) at the top of the application window, then click on the described icon in the newly appearing interface.

▶ To access files that you'll need to use with the lessons, I'll assume you remember where you put the folder that you downloaded from the Cengage Learning website. I will start each path to a file with that folder's name. The rest of the path will be similar to getting to a menu item, for example, VSX4_book_files > Videos > Balloon Trip > File name.

▶ When I ask you to select or highlight something, such as a clip in the Timeline, a library item, or an icon or tool, I mean to click it only once. If I need you to double-click an item, I will specifically ask you to double-click that item. Double-clicking an item will often bring up different tools or options than merely selecting that item once.

▶ There are several naming conventions for VideoStudio Pro X4. You might hear it referred to as VideoStudio, VideoStudio Pro X4, VSPro, or VSX4. I will try my best to limit references to one or two of these, but if I slip in any of these names, just know that they all refer to this application.

Once you're using VSX4, your screens will look the same; however, my screenshots of anything outside the application may look a little different from yours, since I'm using Windows 7. Paths to any files though will remain the same.

Tip

Since I'll point out where you can use your own content during some lessons, it would be helpful if you already have some photos and videos you want to use organized in easy-to-find locations.

Although this book has a lot of good stuff to learn about, sometimes you may want to dispense with all my words of wisdom and just get down to business, especially if you're going through the book a second time. Therefore, the steps to accomplish all the tasks will be in numbered lists that will be easy to locate and refer to.

Installing VideoStudio Pro X4

I REALIZE THAT IF YOU HAVE read the book this far, you probably already have the VSX4 software. If you've already downloaded and installed it, you can proceed to the next topic. If you have yet to purchase VSX4 and would like to try it out on a trial basis, you can do that, too. Corel offers a free download of a 30-day, fully functional, save-enabled version. Go here to get it: www.corel.com > Free Trials tab at the top > VideoStudio Pro X4 Download Trial button.

Whether you've downloaded the trial or purchased the full version, double-click the installer icon to open it and follow all the installation instructions. Let the installer place VideoStudio in its default location. If you purchased the boxed version, insert the DVD. It will auto-start once inserted into your DVD drive. Again, follow the onscreen instructions.

If you have purchased VideoStudio Pro X4, *please* register the product. It's become commonplace to ignore this procedure with purchased software. It's always baffled me why folks don't register their expensive software investments. Registering allows you to get faster customer service and technical support. Oftentimes, you may not get service at all if you can't prove that you own the software. With the money you've poured into your computer and the prevalence of software piracy, it's important to be recognized by the software developer as a legitimate user. It takes just seconds to do so.

Again, follow the on-screen instructions when they ask for your name and serial number. Most times, clicking Register will do everything else for you automatically. You can most often opt out of any newsletters and notices if you like. I usually opt in and wait to see if they get annoying before making my decision.

CAUTION

VSX4 cannot display in any resolution below 1024x768. If you are running a Netbook, this could become an issue. On the other hand, to take the best advantage of VSX4, video editing should only be attempted on a Windows PC capable of handling complex rendering and video playback.

Launching VideoStudio Pro X4

I F YOU'VE LAUNCHED VSX4 recently, you should be able to see it in the main section of your Windows Start menu. If not, you can click on the Windows Start button > All Programs > Corel VideoStudio Pro X4 or click on the shortcut that you may have allowed the installer to put on your Desktop.

Tip

I usually don't like having a bunch of application shortcuts littering my desktop, but in this situation, since you'll frequently be using VideoStudio over the course of reading this book, I recommend leaving it on your desktop for now.

1. Launch the VideoStudio X4 application. Your first stop will be the Corel Guide window. Quit VSX4 and relaunch it.

2. This time, your first stop will be (if you haven't yet registered your software) a request to register your application with Corel (see Figure 2.1). This is designed so that you can get started on building a video project on your first launch, instead of worrying about registration.

Figure 2.1
The VideoStudio Welcome window.

3. Use the drop-down list in the lower-left corner of the Welcome screen to either register your copy of VideoStudio (recommended!!) or set it to remind you again in the near future. Clicking Continue will take you to the register form or straight into VideoStudio X4, depending on your choice.

4. Register and proceed to open VSX4.

The Corel Guide, Additional Content, and Help

SOFTWARE DEVELOPERS INVEST a lot of effort in their application's Help system. It's there for you to use. Again, I'm amazed at how many users fail to consider it when they hit a roadblock in an application. As a sales engineer (technical sales) at several software companies, nine times out of 10, I would answer a user's e-mail questions by referring them to a specific, easy-to-find item in the Help file.

You can access Help in VSX4 by pressing the F1 key or clicking the small icon in the upper-right corner of the main screen (see Figure 2.2).

▶ Hitting the F1 key will bring up VideoStudio's Help file in a browser-based window. This online access method is more commonplace these days (instead of, say, downloading or installing a PDF version with the application) because the remote version can easily be updated by the software developer to remain current. This helps you get the latest and best methods to learn features and get around difficult situations.

▶ The second choice to access Help is by clicking the same icon you use to access the Corel Guide and get the free downloadable content (see the next section). This icon is located in the upper-right corner of your screen, just to the left of the minimize (-) icon. It looks like a down arrow in a circle of dots.

Figure 2.2
Accessing the Corel Guide, Help, and Product Information.

Tip

In various locations around VSX4, you may see that same arrow surrounded by dots icon appear in orange. This indicates that new content is available, either for free or a nominal cost, in the Do More tab. Check it to see if there's something you like!

What you'll see next will look like Figure 2.3. This is the Corel Guide specific to VideoStudio. To access Help, click the large Launch Help button at the bottom. Doing so will launch VSX4's online Help section. As mentioned, this searchable area will give you access to the latest, most relevant assistance.

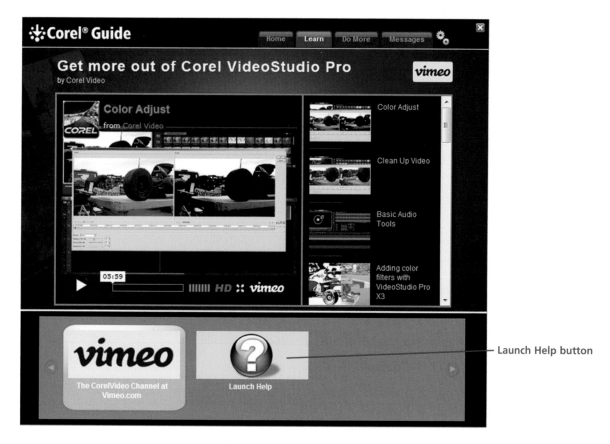

— Launch Help button

Figure 2.3
Overview of the Corel Guide.

Notice there are four tabs at the top of the Corel Guide. Begin in the Learn tab, where the Help link is located. There is also access to a number of video tutorials in this tab. I encourage you to view them at your convenience. They will play in this Corel Guide window and are great for reviews of what I'll teach you throughout this book, and maybe even give you some new ideas, too. Keep checking back for new ones!

Next, click the Do More tab (see Figure 2.4). This provides a collection of downloadable extras, such as titles, filters, audio clips, special effects, and more via several categories, many of which are free. Grab 'em! Some of the free content will be used in this book. The download and install process is quick and easy.

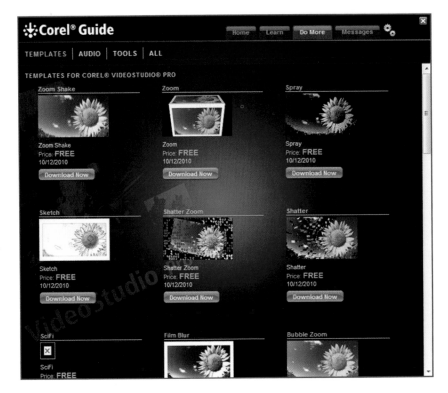

Figure 2.4
Accessing extras for VideoStudio.

So to wrap up, use Help whenever you need to, both when you want to learn more than this book will provide (which won't be much!) and when you get stuck and want to learn more about a feature or task. Using Help along with its Index and Search features will get you answers quickly!

Visit the Learn and Do More tabs frequently for the latest video tutorials and downloads.

Tip

Another excellent resource that will help you avoid the long line at tech support is the Corel online forum. This forum is almost constantly manned by experts in video and VideoStudio. One assistant is in Australia! It's also likely that you'll get multiple responses from other contributors. Go to http://forum.corel.com and choose the appropriate product from the main page. You will have to create a free account to ask questions, but you will also get an e-mail every time there's a response to your question.

Additional Product Information

You can click on the other tabs at the top of the Corel Guide (refer to Figure 2.5) to see what other assistance and product information is available to you. Click on the small icon that looks like two blue gears meshing together (shown in Figure 2.6). This provides additional choices to communicate with Corel with items such as version number, Messages Preferences, registering, or product updates.

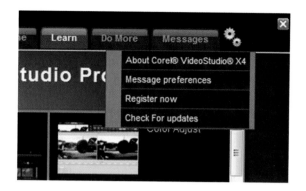

Figure 2.6
Other Corel Guide communication options.

Figure 2.5
Other Corel Guide selections.

Quick Review

▶ What company owned VideoStudio before Corel acquired it? (See "The History of VideoStudio.")

▶ Name at least one benefit of registering your copy of VideoStudio. (See "Installing VideoStudio Pro X4.")

▶ Where should your first destination be if you have a question regarding a feature or task in VideoStudio? (See "The Corel Guide, Additional Content, and Help.")

▶ Before calling/e-mailing friends/family/ Corel tech support, what is the best resource already in VSX4 to answer questions you may have on features and processes? (See "The Corel Guide, Additional Content, and Help.")

Introduction to

VideoStudio Pro X4

WELCOME TO THE HEART of this book! Now it's time to start creating and editing videos!

Of course, this is still just the introductory chapter. Just remember, baby steps. There is a lot to learn in VSX4 as a whole, so I'll use this particular chapter to give you a tour and get you comfortable with how the interface is laid out, where the tools are, and where your video, graphics, and sound assets will be stored. You'll learn the steps necessary for creating an actual video in VideoStudio, as well as the three main work areas where you'll make this happen. I'll also show you how to add basic content into a multi-track timeline so that you can begin assembling a video project.

VideoStudio Moviemaking Terminology

BEFORE YOU START CREATING a video, it's important to understand what terms I'll be using and what they refer to throughout the video-making process.

▶ **Title:** In the movie business, the term title refers to the final output—a completed movie or a finished DVD. However, for the purposes of this book, any reference to a *title* means a text title, such as "Our Vacation," "Chapter 1," "Chapter 2," and so on, not the finished product.

▶ **Clip:** Video and sound assets you'll be importing will be referred to as *clips*. Still graphics you'll be adding will be referred to as graphics, photos, backgrounds or the like, depending on what's appropriate for the discussion.

▶ **Project:** This is the VSX4 file created when you do a File > Save. It does not contain any content, but rather contains instructions on how to assemble the content, what clips (or portions of clips) to use, where to place the clip in the Timeline, what filters to apply, and so on. It contains instructions for creating the sequence of events for your movie. It's often referred to as an Edit Decision List (EDL). (Projects and how they're saved are explained further in the "Saving Your Movie" section at the end of this chapter.)

▶ **Movie:** A movie is your exported project, made up of multiple clips of videos, sounds, and titles. This could be a QuickTime movie, a Flash movie for YouTube, or a DVD movie.

▶ **Scene:** When placed on the Timeline, a scene is a combination of individual, layered clips (video with an overlaid title and background audio).

Touring the VSX4 Workspace

I

T'S TIME TO BECOME FAMILIAR with navigating the VSX4 interface, finding where the important tools reside, and what the workflow is. For what might be the first time, you'll be working with a *multi-track timeline*—a timeline with separate but concurrent tracks for video, audio, and titles.

In VSX4, the Timeline takes up half of your workspace, and rightly so. It's where you'll spend most of your time creating your movie with, if necessary, frame accuracy. A preview window and galleries of items you can use in your videos will take up the rest of your screen. Instead of working through a sequence of tasks in a sequence of windows (similar to Microsoft PowerPoint), in VSX4, almost all your work will be accomplished in one main screen, using the different panels for various tasks.

One of my favorite features of VSX4 is that necessary tools automatically become visible, depending on which asset you select. For instance, when you double-click an audio clip in the audio track of the Timeline, audio tools for editing will pop up. The same thing occurs with video clips, transitions, and special effects or filters.

Although there is a lot to know about creating videos in VSX4, the general path to getting there is the same: import your media, place and arrange it on the Timeline, and then export it in the desired format. Let's take that tour.

If the Corel Guide is still visible on top of VSX4, close that window. Or relaunch VSX4, if necessary, by clicking on the Desktop shortcut (see Figure 3.1) or through the Windows Start menu. VSX4 will open in its default view, showing the multi-track Timeline, content libraries and Preview panel (see Figure 3.2). The three main work areas are explained in the following list (with more detailed explanations following later in the chapter).

Figure 3.1
VSX4 launch icon.

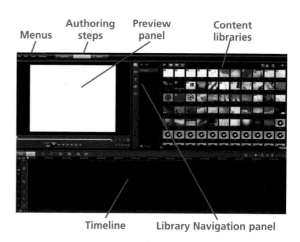

Figure 3.2
Default VSX4 interface.

The Preview panel in the upper left of the screen looks almost blank. Actually, it would be blank if it were black, but you see that's it's white with a yellow "mustard" smudge. Don't adjust your computer screen. It's displaying the first library item from the panel on the right (the top-left library item to be exact). That "smudge" is actually the first frame of a painting clip. Go ahead and click the Play button in the Preview panel to see what it is.

▶ **Preview panel:** Preview any photo, video, or audio clip that resides either in the collection of libraries to the right or in the Timeline below them. All you need to do is select the asset in its respective location to view and play it in the Preview panel.

▶ **Library Navigation panel:** Use this list to select different types of ibraries to be displayed. You can also create new sub-libraries (I call them galleries) for the first Media library, such as those for specific projects, to help you stay organized.

▶ **Content libraries:** Includes all your media, the samples that came included with VSX4, free content you downloaded from the Corel Guide, imported content used in movies, movies you exported to VSX4, and customized content you saved from the Timeline. Content libraries will not contain assets that you import directly into the Timeline (thus bypassing the library), although these assets can be placed in the library afterward.

▶ **Timeline panel:** Organizes your content for playback using multiple, concurrently displayed layers. The Timeline includes views called Storyboard, Timeline, and Audio. The top track is the background layer. As the tracks go down, clips are layered on top of the background.

▶ **Menus:** At the top left of your screen are four menus—File, Edit, Tools, and Settings. These contain many functions common to many applications (e.g., Save, Export, and Exit), as well as functions that are unique to VSX4.

▶ **Capture, Edit, and Share steps:** These are actually tabs (to the right of the menus) that represent the three main processes in authoring videos in VSX4 (and most videography software).

Tip

Click once on an asset in a library or the Timeline to view and play it in the Preview panel. Click a clip twice in the Timeline to open the tools in the Options panel.

Customizing Your Workspace

THERE ARE A FEW NEW features in VSX4 that allow workspace customizations beyond previous versions. I'll first cover existing methods, then the new ones. So that your views will match the book's screen shots, I'll stick with the default view in the end. Afterward, though, you can use any of the other views you like.

> VSX4 will force its view to fill your entire screen. There is no ability to adjust the actual screen size any smaller than your screen, at least not on a single monitor system anyway. Also remember that VSX4 needs a minimum screen area of 1024 x 768 pixels.

Resizing the Workspace

In the default workspace, there are several ways to resize and reposition each of the three (Preview, Library, and Timeline) panels. Resizing any of them will cause the others to resize accordingly so that they all still fit into your overall screen space.

To resize any of the three panels, do the following:

1. Place your cursor in the narrow area between each of the panels until your cursor changes to a double-sided arrow.

2. Hold down the left mouse button and drag right to left or up and down to adjust the relative sizes of the panels to your liking.

Let go of the mouse when you've resized the panels to the desired positions. One way to rearrange your workspace panels might be similar to that shown in Figure 3.3.

Figure 3.3
Possible workspace arrangement.

Undocking the Workspace Panels

A new feature in VSX4 is the ability to actually unlock/undock any of the three panels and freely place them anywhere you choose on the screen, even on top of other panels. To move the panels in your workspace, follow these steps.

1. Click and hold the top bar of the Preview panel, and then pull the panel away from its current docked location (see Figure 3.4). As you do so, a blue transparent rectangle will appear attached to your cursor. Moving the blue rectangle near other panels, you will see blue arrows appear at their sides.

Figure 3.4
Undocking a panel.

Figure 3.6
New panels view.

2. Move your cursor directly over the blue arrow on the far right of the Libraries panel (see Figure 3.5), then release your mouse. The blue rectangle will snap into place to indicate where you will be placing the panel. The remaining panels will move out of the way accordingly, and your workspace will be updated with the new view (see Figure 3.6).

3. From its new position, click and drag the Preview panel away from its new location and drop it anywhere in the center of the window, without utilizing any of the blue arrow drop locations (see Figure 3.7). You should now see a view very similar to Figure 3.8. Loose panels can also be resized by grabbing any corner or side.

Drag curser to here and let go to move Preview panel to right of the libraries.

Figure 3.5
Repositioning a panel.

Figure 3.7
Undocking the Preview panel.

Figure 3.8
Undocked panel placement.

4. Take a couple minutes to try placing this panel and others in different locations. Don't get freaked out when the arrangements look a tad bizarre. It may take a few tries to get the panels where you expect them to go. That's the learning process. It really does all make sense.

5. If you find a panel combination that you might like to use in the future, you can save the arrangement as a custom setting. To save your new view, go to Settings > Layout Settings > Save to > Custom #1. (See Figure 3.9.) As you can see, you can create up to three custom views.

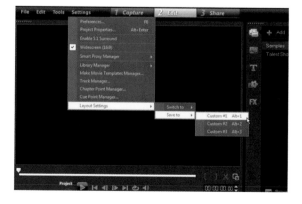

Figure 3.9
Saving a custom layout. You'll need to return to the default view so your screen will reflect what you see in the book's screen shots.

6. Go to Settings > Preferences. Select the UI layout tab at the top. Notice Custom 1 is selected. This represents the layout you just created and saved. If you don't change it, this will now be your default view whenever you launch VSX4.

7. Click the Default option, and click OK to close the Preferences dialog box.

CAUTION

It's best to have at least one custom layout setting. If you're in the default layout view and move panels around, VideoStudio thinks you're adjusting the default view. The only easy way to return to the original default view (without manually trying to return the panels to their original positions) is if you have another layout to go to first, *then* return to the default view.

Another new feature of VSX4 is its ability to expand the interface across multiple monitors. This has been a highly requested feature.

In the past this has just stretched the Timeline and content libraries to the other monitor, creating extra long panels. With the new custom layout features, panels can be placed anywhere and in any size on your second monitor.

Steps 1, 2, and 3—Capture, Edit, and Share

CAPTURE, EDIT, AND SHARE. These three steps are pretty much the order of creating videos, not only in VideoStudio, but also in other video authoring/editing applications. I mean, it makes sense, right? You first need to acquire the material to make your video (capture). Then you need to have the tools to edit your clips, making your video in that special way you would like to express your experience and style (edit).

Finally, you want to output or export your video into a useable format so you can share your favorite moments with your friends and colleagues, making sure they can see your movies in the most ubiquitous, accessible methods possible.

As the title of this section suggests, these three tasks are the main steps in the video creation process. I'll show you how VSX4 distinguishes these tasks when it comes to the work area. The tabs at the top (collectively called the Step panel) of the VSX4 screen are identified to represent these most common sequential steps in the movie making process: 1 Capture, 2 Edit, and 3 Share. These will be referred to as the Capture step, Edit step, and Share step.

▶ **Capture step:** This tab, although the logical first step in any video project, is only required for certain media and devices. You may already have uploaded or downloaded your clips onto your computer, in which case, they're already captured and converted. If your content is already accessible, you can import it into VSX4 via the Edit tab, either directly into the Timeline or into the appropriate content library.

Even though the end result is the same, there is a difference between the terms *capture* and *import*. There is also a difference between importing and merely opening files. Importing media is the simple act of bringing digitally compatible files into VSX4. These imported files are already compatible with the software and do not need to be converted in order to be used.

Video that needs to be converted, on the other hand, needs to be *captured*. Even if the files are already in some digital format (e.g., digital TV or DV tape), they still need to be "wrapped" in a format that VideoStudio can understand and work with, usually AVI.

The Capture tab, though, specializes in making it easy for you to acquire initially incompatible digital media from various methods by first choosing your source (see Figure 3.10). Once the source is chosen, VSX4 knows how to communicate with the selected device, where to find the video files, and how to convert them into a format that VSX4 can use.

#1 #2

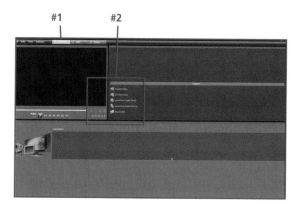

Figure 3.10
The Capture step.

▶ **Edit step:** This is the tab that VSX4 defaults to when launched and where you'll be spending the vast majority of your time in the rest of the book's lessons (see Figure 3.11). As its name implies, the Edit step is where all the fun editing stuff takes place: the movie assembly process, adding text, special effect filters, scene transitions, picture-in-a-picture, narration, and so much more. (You'll learn about these features throughout this chapter and the rest of the book.)

▶ **Share step:** This final step in the video production process is done in the Share tab. It is really just a pop-up panel that appears in the center of the Edit area (see Figure 3.12), asking you to select your choice of output methods. Is your movie destined for one of the many video file formats, a DVD, or a mobile device? Do you want to upload it to the web for a social site like Facebook, a website like YouTube, or maybe your own website? The Share Step is where you'll begin this process.

Notice that the choices don't specify any particular file format, but instead, a destination. You will be able to choose a specific file format along with options within those formats after you first choose a destination.

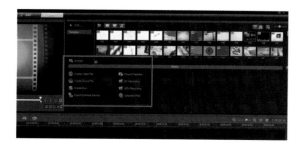

Figure 3.12
The Share step.

Figure 3.11
The Edit step.

Content Libraries

THIS SECTION WILL COVER the Edit step in further detail, starting with the content libraries. I mentioned earlier that you can bypass the content libraries and import content directly onto the Timeline. You can also take any item from the Timeline and drag it to the appropriate content library for re-use.

However, using the content libraries, instead of importing directly to the Timeline, provides many advantages. Content libraries allow you to store and organize your assets into various media categories, such as video, audio, titles, stills, and more. Importing into and storing assets in the libraries allows for unlimited re-use in your current video and any subsequent videos you create. These assets will stay there until you delete them. Each clip is represented by a thumbnail, or small photo representation. Movies you output via the Share step are also stored in the libraries after VSX4 creates them so you can easily preview them without leaving VSX4.

Deleting a thumbnail in a library will not delete the original file.

The visual method to access the various content libraries and galleries is through the Library Navigation panel in the center of your screen, between the Preview panel and content libraries (see Figure 3.13). In order, from the top down, are Media, Transition, Title, Graphic (solid background color chips), and Filter (special effects).

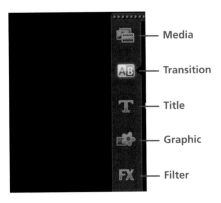

Figure 3.13
Various media libraries.

The following explains how the media libraries are laid out and organized.

▶ From the Edit tab, click the Media icon at the top of the Library Navigation panel (see Figure 3.14). It should be highlighted yellow. The media library contains video clips, still graphics (photos and backgrounds), and audio clips (music, narration, and so on). Any videos you render out (or shared) will also be added here.

Figure 3.14
Selecting the Media library.

▶ The Samples category represents all the media elements included with VSX4 or that you downloaded after installing VSX4. Using Figure 3.15 as a guide, click each of the three icons (Hide Videos, Hide Photos, and Hide Audio Files) to narrow the library collections to specific media types. When finished, turn them all back on so all the samples clips are visible.

Hide Videos Hide Photos Hide Audio Files

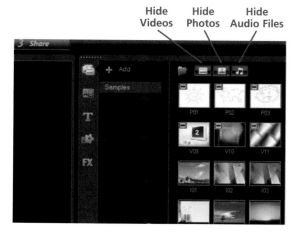

Figure 3.15
Media library view options.

▶ Click on the Transition icon to preview the selection of available transitions (see Figure 3.16). Transitions are special effects that will stylize the change from one clip or scene to another. Transitions are placed on the Timeline between any two video clips or still graphics in any of the Video or Overlay tracks.

Figure 3.16
Transition library.

▶ You may notice that only three transitions are displayed. Click on the down arrow next to My Favorites to see a list of Transition categories (see Figure 3.17). You can choose any one of the options or click All to see all of the 125+ transitions.

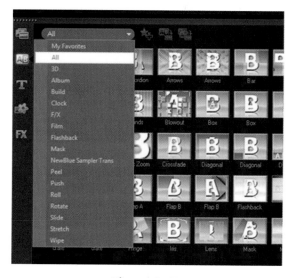

Figure 3.17
Transition categories.

Transitions can easily be added to the My Favorites list. Select any transition in any of the categories (besides My Favorites, of course). At the top, the icon with the star and plus (+) will become active. Click that icon to add your currently selected transition to the My Favorites category. To verify the addition, go to the My Favorites list to make sure it's been added.

▶ Select the T icon to open the Title library. It includes a couple of dozen customizable animated text titles (especially if you downloaded the free content) that you can drag and drop into a Title track on the Timeline and edit in the Preview panel. This collection also includes a My Favorites category. Once you've edited a title, you can also place it back into the library as a new custom choice.

Tip

In previous versions of VideoStudio, titles could only be displayed in Title tracks, and thus only on top of all other elements in a video. In VSX4, you can now use them in Overlay tracks, too, so you can create some cool layering effects with your titles. I'll cover this feature in Chapter 9.

▶ Select the Graphic icon to open the Graphic library (see Figure 3.18). This includes four galleries: Color, Object (decorations), Frame (similar to picture frames), and Flash Animation.

Graphic library Graphic galleries

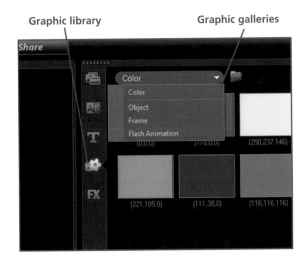

Figure 3.18
Graphic library.

▶ Colors are used as backgrounds or "blank" clips in video tracks. An example of this might be at the start of a movie where you only want a title to show on the screen. You could place the title on top of a video clip, or use a blank colored background chip and put your title on top of that instead. They make for useful fillers, as you cannot have a blank spot in the main video track.

CAUTION

You cannot leave a blank space at the start or between any two clips in the background video track. It must be filled with either a video, still, or color clip.

▶ Objects in this category are decorations and meant to be used in overlay tracks where you can place them anywhere on the stage. They can be re-sized.

Any object placed in the background video track will only occupy the entire screen. Objects added into any of the overlay tracks can take up the entire movie screen or any portion of it.

▶ Frames make for a great effect that mimic a video playing in a picture frame. You can also use them to frame still images.

▶ Flash Animations are relatively new to VSX4. These include both frames and decorations. The advantages of using Flash animations is that they are, well, animated. Flash objects also have the unique characteristic of being re-sizable without losing quality. They have a very small file size.

▶ Select the FX icon. This is the Filter library (sometimes called an *effects* library), and it includes numerous special effects that you can apply directly onto video clips in the Timeline. These effects will actually distort the video according to the customizable settings in each filter. Effects can include color corrections, weather effects, warping effects, painting effects, and many more. Many of these effects are also customizable over time through a process called *tweening*. Filters will be covered in more detail in Chapter 6.

All objects used from the Media library can only be placed into the Video track or Overlay tracks.

The Preview Panel

THE PREVIEW PANEL (see Figure 3.19), in the upper left of your screen, is exactly what its name implies. It allows you to preview content from your libraries, from content placed in the Timeline, or even audio. If you preview content from your Timeline, you can preview all the content at any point in time or just one clip from a specific track.

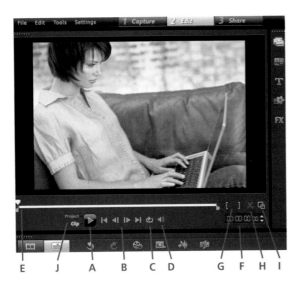

Figure 3.19
The Preview panel and its controls.

For example, if at 35 seconds into your movie, you have a video clip with an overlaid video or graphic on top of that, with a text title, and a music track, you can play all of it at the same time. It allows you to preview your entire movie. If you select just one clip in one of the tracks, the panel will only play that clip. In this section, I'll show you how to control which content and what part of that content plays.

Controls in the Preview panel are explained in the following list (see Figure 3.20). These controls will be used extensively in the next chapter.

A. **Play/Stop buttons:** Allow you to control playback of any video or animation.

B. **Rewind/Fast Forward controls:** Controls (from left to right) for rewind to start of clip, step back one frame, step forward one frame, and fast forward to end of clip.

C. **Repeat:** When the clip gets to the end, it immediately restarts and plays again. This can be toggled on or off.

D. **System volume:** Toggles audio playback on and off.

E. **Scrubber track:** The horizontal line represents the entire clip's length that will play if placed in the Timeline (it can be shortened). Use the white slider to move (scrub) the clip to quickly locate a particular location or frame.

 You can manually move the orange end points (select a library item first) to adjust the start and end points of the clip that will actually play when placed on the Timeline. The horizontal line will represent that length of time. Trimming a clip this way will not alter the original clip. It will only designate what part of that clip will be used in the Timeline.

F. **Timecode:** This stopwatch-like viewer will display the exact frame (called a timecode) that your clip is currently displaying. From left to right, the figures displayed represent hours:minutes:seconds:frames. For example, 1:25:48:15 means the clip is displaying the

Start Current End
point frame point

Figure 3.20
Scrubber controls.

frame at precisely 1 hour, 25 minutes, 48 seconds, and 15 frames from the start of the clip.

G. **Mark-In/Mark-Out:** These two brackets represent tools to mark the start and end points of a clip. You can either drag the orange markers to position a mark point or use the timecode for more precision. When a marker is positioned, click either the left or right bracket to set the start or end point, respectively, of the clip that will play in the Timeline. Using these markers will not affect the original clip.

H. **Split Clip:** The scissors tool provides a more permanent edit than the marking tools. It will cut a clip in two, making two new clips. If the clip is in the timeline, the scissors will cut that clip at the white marker, creating two separate clips in the timeline that will play sequentially (see Figures 3.21 and 3.22).

If you cut a clip that you're previewing from a library, VSX4 will create two new clips and place them in the library, in addition to the original clip. (See Figure 3.23.) Notice there are now two new clips in the Library, after you split one of the clips.

Figure 3.21
Before applying a cut.

Figure 3.22
After applying a cut.

Figure 3.23
Results of splitting a library clip.

Clips from either the Library or the Timeline can be edited in the Preview panel. Trimmed clips will not affect the original clip.

I. **Enlarge:** This toggle will display the Preview panel in a full-screen view. Once in full screen, click the icon again to return to the normal view.

J. **Project vs. Clip Mode:** This is a handy setting to use when previewing Timeline content. Select any clip in the Timeline to preview it. If Clip is selected, only that clip in that track will preview. If Project is selected, all the content at that point in time will preview. In other words, the content in all the tracks at that timecode point will play, not just the selected clip.

Isn't it amazing how VSX4 allows so many tools and actions all in the same window? It really does a good job at minimizing the use of multiple open windows and dialog boxes. The Timeline is no different. I'll cover that next.

Multi-Track Timeline

THE THIRD AND FINAL main section of the VSX4 interface is the multi-track Timeline. The Timeline is where you assemble the media clips to use in your video project. It is based on the progression of time. This line of time starts at zero on the left and progresses forward in time as you move to the right. 0:00:00:00 is the starting point. Time increases as the project plays and as the playback head moves to the right.

The biggest advantage of a multi-track timeline over a single-track one is that you can instantly view where all your media items are located in relation to each other and for how long they're present in your movie. By utilizing the Project option next to the Play button in the Preview panel, you can also see how things are layered. Although there are two Timeline views, the multi-track view is the default and is displayed when launching VSX4 into the Edit step.

The Timeline in VSX4 allows you to layer assets in your movie project. This is called *overlay* and is the term in video production that refers to placing objects on top of other objects in a layered fashion. You may have heard of Picture-in-Picture (PiP).

PiP works by laying one video clip over the top of another one. The order of tracks in the VSX4 Timeline starts from the top down, where the top-most track (the Video track) serves as a background layer. Successive layers are built on top of each other by adding objects in the tracks below the Video track.

Overlaid objects can cover a portion of the back-ground Video track or the entire track. Either choice allows you to set areas of transparency so that you can see portions of the background, or other layers, through the overlaid object.

Obviously, this layering property only affects visual elements, such as video clips, images, and text titles. Audio clips are not affected because you can't see them, but two clips playing concurrently will automatically blend, and the volume of the audio in each one can be set individually. The Voice and Music tracks are interchangeable. Voice-overs and music can go in either of the two audio tracks. You can also have audio in any video clip and adjust the volume levels of any of them.

Figure 3.24 identifies the different tracks of the VSX4 Timeline. The main Video track is the back-ground layer. It will always display at full-screen size. Overlay tracks are layers on top of the Video track background layer (PiP). Overlay tracks can be resized, reshaped, and animated, as well as have levels of transparency applied to them. All Video

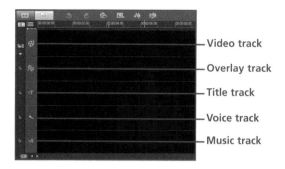

Figure 3.24
Multiple Timeline tracks.

and Overlay tracks can contain a video, photo, graphic image, or just a solid color chip.

Figure 3.25 points out tools in the Timeline that you'll be learning how to use in this and successive chapters. Following is a brief explanation of each. You'll have plenty of tasks using these tools, but feel free to try them out and see the results. Many of the tools will require content in the Timeline. Give them a try!

A. **Storyboard view:** Displays a Timeline view of assets in thumbnails, but still in the usual chronological order as the regular Timeline view.

B. **Timeline view:** This default Timeline view utilizes multiple tracks, allowing for frame-accurate clip editing and layering of multiple file types to create an elaborate video project.

Figure 3.25
Timeline tools.

C. Undo/Redo: Allows you to undo and redo previous operations.

D. Record/Capture: Shows the Record/Capture Option panel, where choices include Capture Video, Import Files, Record Voice-overs, and Take Snapshots. New to VSX4 is the ability to create stop-motion animation. Many of these tools represent shortcuts to the Capture step features.

E. Instant Project: Use this tool to insert a sample project style from a collection of templates into your Timeline. A template is a pre-designed timeline layout allowing you to replace its content with your own. Don't forget to download your free templates from the Corel Guide. You can also save your own layout as a template for later use.

F. Sound Mixer: Launches the Sound Mixer and the multi-track Audio timeline, which lets you customize your audio settings.

G. Auto-Music: This icon launches the unique feature in VSX4 that allows you to create multi-track, customized music.

H. Zoom Adjuster: Quickly zoom your Timeline in or out using a real-time, interactive slider.

I. Fit Project in Timeline: Adjusts your entire project to fit into the visible span of your Timeline.

J. Project Duration: Shows the duration of your project in timecode format.

K. Show All Visible Tracks: Squeezes all the timeline tracks you're utilizing into a visible view on the Timeline.

L. Track Manager: Opens the Track Manager window where you can insert additional timeline tracks you may need in your project.

M. Add/Remove Chapter Points: Adds/deletes chapter points at the current playback head's location. Chapter points are break indicators that are carried forward to DVD creation to create separate chapters on your disc.

N. Enable/Disable Ripple Editing: Locks and unlocks tracks of any movement of any shift in time while you insert clips into other tracks. This allows you to control the shift of tracks as you insert new content. Locked tracks will not move. Unlocked tracks will move to the right as content is inserted into other tracks, so as to maintain synchronicity.

O. Ripple Editing options: Displays menu of Ripple Editing options.

P. Individual Track Ripple Editing toggle: Enable or disable Ripple Editing on individual tracks.

Q. Auto-Scroll Timeline: Enable or disable automatic scrolling of the timeline so it follows along when a project plays.

R. Scroll Timeline Forward/Backward: Manual timeline scrolling. A scroll bar will also appear when there is content in the timeline.

S. Timecode Locations: Timecode locations along the Timeline.

The Track Manager

The default Timeline shows only a limited number of available tracks: one background, one overlay, one title, one voice-over, and one music track. This can be a limitation for many projects. Fortunately, VSX4's multi-track timeline allows for up to seven video tracks (one background and six overlay tracks), two title tracks, and up to four audio tracks.

Fortunately, you don't need to display all the tracks if you won't be using them all. The Track Manager lets you toggle their visibility and usage on and off. You can add and make tracks visible only when you need them so that they don't take up valuable screen real estate. To manage your timeline tracks, follow these steps.

1. Click the Track Manager icon on the upper-left corner of the timeline, below the toolbar (labeled with an "L" in Figure 3.25).

2. Check the boxes for Overlay Track 2 and 3 to turn them on, as shown in Figure 3.26. Click OK. Your timeline will update to show the additional tracks.

Table 3.1 specifies what library content types can be inserted into which timeline tracks. Tracks are listed on the left. Along the top are the Media library media that can be placed in the tracks.

Check these same tracks

Figure 3.26
Adding Timeline tracks.

Table 3.1 Library Content Types

Libraries

Tracks	Media	Transition	Title	Graphic	Filter
Background	X[1]	X	X	X	X
Overlay	X	X	X	X	X
Title		X	X		X
Audio	X[2]				X[3]

(1) Video and photo media only, not audio

(2) Audio media only

(3) Audio filters only (which are located in a different panel and will be covered in Chapter 6)

The Storyboard View

The term *storyboard* might be familiar to you if you've seen TV specials that discuss how a movie was made, especially animated movies, like those from Pixar or Disney. Movie studios often have a room with walls covered by scraps of paper with drawings on them. They're almost always displayed in rows. These are concept drawings of a sequence of events for an upcoming movie. Together, they're called a *storyboard*. The board describes the story, hence the name.

The Storyboard view is also available in VSX4. Utilizing thumbnails displayed in sequence, it's the fastest and simplest way to add and organize the main video track because that's all it works with: the content that you have in the main (background) video track (video clips, graphics, and the transitions between them). It is not capable of displaying overlays, additional audio (outside of what's embedded in a video clip), or titles. It is meant to lay out the main ideas for your video project.

A big advantage of starting with a storyboard, besides quickly creating a sequence of clips in a desired order, is that this can be done in very little space. Whereas placing video clips in the Timeline view will display them in reference to their duration, the Storyboard view only places a thumbnail representation (similar to content in your libraries). Therefore, you can concentrate more on the sequence of events and easily change them by simply rearranging the thumbnails.

After laying out your project concepts in the storyboard, you can then return to the Timeline view. The Timeline will take your storyboard content and convert it to the multi-track timeline format where you can add more content, such as titles and overlays, and polish your timing with its frame-accurate abilities.

You can also view any project you've built in the Timeline back in the Storyboard view. This might make it easier for you to see and rearrange the big picture, and then return to the Timeline to continue your work.

I won't spend much time discussing the Storyboard view, so in this short section, I'll show you how to operate the storyboard and take content to the Timeline. I'll also show you how to use basic content from the library. Since you'll just be using sample clips from the Media library, the story won't make much sense, but the concept will.

1. Click the Storyboard icon in the upper-left corner of the Timeline (labeled "A" in Figure 3.25).

2. Click on the Video icon to make sure the Video gallery of the Media library is visible (see Figure 3.27). You can have the other media (graphics and audio) libraries visible, too. All the video sample clips' names start with the letter "V" for, uhh, video.

Figure 3.27
Accessing the video Media library.

Figure 3.28
Storyboard view.

3. Use your mouse to drag and drop video clip V01 to the Timeline, where it says Drag Video Clips Here.

4. Follow that with clips V08 and V17 to create a storyboard sequence of three video clips. Each clip could be an hour long or a minute long, but here they only take up the space of a small thumbnail.

5. In the Timeline, drag the night scene video to the end to rearrange the order of the clips.

6. In the Library Navigation panel (between the libraries and the Preview panel), select the Transition library (the A|B icon). In the Timeline, small gray squares should appear between the video clips. These are the transition placement areas.

7. The Crossfade transition option should be visible in the default view of My Favorites. If it isn't, choose All from the Transition drop-down list. Drag and drop the Crossfade thumbnail to each of the gray squares between the video clips. Your view should look like that in Figure 3.28.

8. In the Storyboard view, double-click on the first transition. This will bring up the transitions Options panel below the Media library. This is how easy it is to access most of the options in VSX4.

9. Where you see the timecode display (currently showing 1 second), click on 01. It will start blinking to show that it is selected. Use the up arrow to change it to 2 seconds (see Figure 3.29). Repeat this for the second transition. Make sure that the second transition remains selected in the Timeline.

Figure 3.29
Adjusting transition durations.

10. In the Preview panel, hit the Play button. This will preview the selected transition only. See how nicely one scene fades into another?

11. Now select Project (to the left of the Play button). It will turn white when selected. This will ensure that the entire project plays, instead of just a selected clip. Select the Rewind button, then hit Play again. This time the entire project plays from the start.

12. Now, you'll take your project over to the more detailed Timeline view. Click the Timeline button just to the right of the Storyboard button ("B" in Figure 3.25). Notice how much more room your media takes up here than it did in the Storyboard view? Also notice that content is only displayed in the Video track (see Figure 3.30). If you were to add content in other tracks and return to Storyboard view, you would still only see content in the Video track.

Figure 3.30
Timeline view comparison.

13. Now is the point when you should save your movie, which I'll discuss in the next section.

Congratulations, you've just learned the basics of using VSX4 to make your first video! Most of what you'll be doing from here on out will be based on these initial steps. There's still so much more to do and learn though!

Saving Your Movie

WHEN SAVING A FILE, as opposed to sharing or exporting a movie, VSX4 creates a project file with the VSP extension. This file is actually an Edit Decision List (EDL).

Figure 3.31
Relink dialog box.

An Edit Decision List (EDL) is a small file that does *not* contain any content, but rather contains instructions on how to assemble the content—what clips or portions of a clip to use, where to place the clip in the Timeline, what filters to apply, and so on. These are the instructions for creating the sequence of events for your movie.

When you save a VSX4 project (File > Save), it creates an EDL with the VSP extension.

As a result, when you re-open your project, the necessary content items must be present and in their original locations with the same file names for the project to rebuild itself. If the content is not where it's supposed to be, VSX4 will ask you via the Relink dialog box (see Figure 3.31) to relocate one of the files and then attempt to automatically relink the rest of them. If you moved files to several different locations, you will continue to be asked to locate missing files until they're all found. If VSX4 asks you to locate and relink a movie or asset you purposely deleted, then you can tell it to ignore the relocation process in the same dialog box.

When it comes time to output your project, VSX4 will use your project file, or EDL, to create your DVD, movie, or audio CD. VSX4 also does a pretty good job at recovering your files if your computer should lock up or crash. Fortunately, this rarely happens on a PC (yeah, right). When you restart VSX4, it will ask if you would like to open the recovered file. However, it may not include the most recent changes you made.

After you first save and name your project file, VSX4 will auto-save it every 10 minutes. This default setting can be changed. Go to Settings > Preferences. In the General tab, you can adjust this setting under the Project area (see Figure 3.32). You can both toggle the auto-save function on and off and set the time interval of how often it saves. Adjust this setting to suit your preferences.

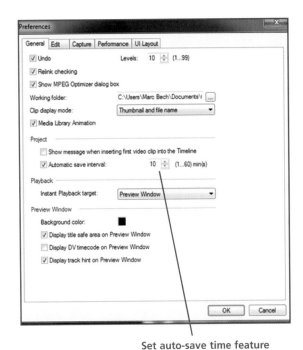

Set auto-save time feature

Figure 3.32
Setting the Auto-Save feature.

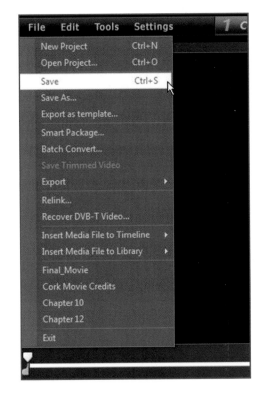

Figure 3.33
Saving your project.

To save your project, simply go to File > Save (see Figure 3.33). In the dialog box, similar to most other applications, choose a file name and location. Oftentimes in this book, I will designate a file name and location for you. To save the same project under a different name, choose File > Save As instead.

After we get serious about building video projects in VSX4, you will continue to build projects from previous chapters. Therefore, it's essential that you follow the instructions that mention saving your work. You will be naming them as Chapter 4, Chapter 5, and so forth. In subsequent chapters, you will be asked to re-open previous project to continue working on them.

Quick Review

▶ What is an EDL and why is it used? (See "VideoStudio Moviemaking Terminology.")

▶ What are the three main working panels in VSX4? (See "Touring the VSX4 Workspace.")

▶ What are the three main processes to creating a movie? (See "Steps 1, 2 and 3—Capture, Edit and Share.")

▶ Name the five content libraries. (See "Content Libraries.")

▶ What buttons in the Preview panel designate whether you see one track play or all tracks play? (See "The Preview Panel.")

Building a
Video 101

IN THE LAST CHAPTER, you learned where the main features are, how to use them, and the basics of assembling a movie. Congratulations! You're well on your way to learning VideoStudio Pro. It's not too scary, is it? Let's keep going. Now it's time to get a little more detailed on those basics and expand on the simple tasks covered in the introductory chapters. Now that you know how the application is set up and what each main area is used for, you can begin applying this knowledge to more precision editing.

This chapter will broaden your knowledge on acquiring content in the Capture step and organizing content in the various Media libraries. I'll focus on video and still image editing, as well as single and multi-trim video clip editing (so you can create multiple clips and splits from a single video). I'll also discuss saving and re-using edited clips for future use, adjusting the lengths of both videos and graphics, and cover tips on the best practices for using photos in video production.

You'll learn all this and more, so let's get going!

Setting Up Project Properties

T
HE FIRST THING YOU NEED to do is designate the screen size of your project. Will you be making a widescreen (16:9) production or a standard (4:3) production? The videos you'll be using in this chapter are widescreen, so let's make sure the project is set up for this.

1. Go to Settings > Project Properties.

2. In the Project Properties dialog box, under Edit File Format, choose MPEG Files from the drop-down list (see Figure 4.1).

3. In the lower right corner of the Project Properties dialog, click Edit. The Project Options dialog box will open.

You can choose either AVI or MPEG without much effect. MPEG will convert the files into DVD-ready content. AVI will keep the content in an untouched format and also provide you with specific window size options.

4. In the General tab, under the Display Aspect Ratio drop-down list, choose 16:9.

5. Click OK twice to close both dialog boxes.

Figure 4.1
Setting project properties.

Adding New Content

S O FAR, YOU'VE JUST WORKED with sample clips that came included in the VSX4 libraries, and you'll be using many more of them throughout the book. Now it's time to learn how to import and use clips from the included lesson files. Before you do that though, you should understand the various file types that can be used in VSX4. Not only are video files supported, but so are many animation files. Remember when I mentioned that VSX4 is not an animation application, but that it can work with outputs from animation software? You can import animation files from some Autodesk and Adobe applications along with basic animated GIF files.

I'm highly confident that VSX4 will work with your video files, but you'd be surprised at the file types it's compatible with that you probably have never heard of. The following lists describe the kinds of video, animations, and still images you can import into VSX4. Corel has always been a champion of file-format compatibility, and VSX4 is no exception.

Supported Video Formats:

- ▶ Micrsoft AVI
- ▶ 3GPP (.3GP), 3GPP2 (.3G2): Multimedia files for cell phones
- ▶ Microsoft DVR-MS (.DVR-MS): Microsoft format for storing TV content recorded by Windows XP Media Center Edition, Vista, and Windows 7

- ▶ Autodesk Animation (.FLC, .FLI or .FLX)
- ▶ Flash Video (.FLV), Adobe Flash (.SWF)
- ▶ Animated GIF (.GIF)
- ▶ QuickTime Movies (.MOV or .QT)
- ▶ MPEG (.MPG, .MPEG, .MPV, .MP2, .MP4 or .M4V)
- ▶ Ulead Image Sequence (.UIS, .UISX)
- ▶ Video Paint (.UVP)
- ▶ Windows Media Video (.WMV)
- ▶ Video Editor Project (.DVP)
- ▶ VideoStudio project files (.VSP)
- ▶ Others include .HDV, .AVCHD, .M2T, .M4V, H.264, .MOD, .M2TS, .TOD, .BDMV, .DivX*, and .RM*. (It should also be noted that special software drivers are required for the .DivX and .RM formats.)

Supported Image Formats:

- ▶ Windows bitmap (.BMP)
- ▶ Graphics Interchange Format (.GIF)
- ▶ Joint Photographer's Experts Group (.JPG, .JPEG, .JPE, .JP2 or .J2K)
- ▶ Portable Network Graphic (.PNG)
- ▶ QuickTime movies (.MOV or .QT)
- ▶ Tagged Image File (.TIF or .TIFF)

- ▶ Ulead Photo Project, Object, and Sequence files (.UFP, .UFO or .UIS)

- ▶ PaintShop Pro images (.PSP)

- ▶ RAW camera formats (.RAW, .CRW, .CR2,. BAY, .RAF, .DCR, .MRW, .NEF, .ORF, .PEF, .X3F, .SRF, .ERF, .DNG, .KDC, .D25, .HDR, .SR2, .ARW, .NRW, .OUT, .TIF, .MOS, and .FFF)

- ▶ Other supported formats include .CLP, .CUR, .EPS, .FAX, .FPX, .ICO, .IFF, .IMG, .PCD, .PCT, .PCS, .PIC, .PSD, .PXR, .RAS, .SCT, .SHG, .TGA, .WMF, PSPImage, .001, .DCS, .DCX, .ICO, .MSP, .PBM, .PCX, .PGM, .PPM, .SCI, .WBM, and .WBMP

For the next few sections, you'll be importing content into VSX4 from both the Capture and Edit tabs, then organizing it into the appropriate libraries. But first, you'll learn how to organize and manage your media libraries using the Library Navigation panel.

Names of library clips may be different once they're inserted into the Timeline. The pre-installed clips have shorter alias names applied to them. You can add alias names too just by double-clicking on the clip's title in the library and renaming them.

I mentioned this in Chapter 3, but it bears repeating for clarity. There is a difference between the terms *capture* and *import*. There is also a difference between importing and merely opening files. Importing media is the simple act of bringing digitally compatible files into VSX4. These imported files are already compatible with the software and do not need to be converted in order to be used.

Video that needs to be converted, on the other hand, needs to be captured. Even if the files are already in some digital format (e.g., digital TV or DV tape), they still need to be "wrapped" in a format that VideoStudio can understand and work with, usually AVI.

Using the Library Navigation Panel

You can use the Library Navigation Panel to create your own custom content libraries, which helps to keep different kinds of project media separate from each other. Content can be captured and/or imported directly into any custom library you create.

1. Launch VSX4. In the Edit step, select the Media library icon in the Library panel. The Library Navigation panel may or may not be open. If your view looks like Figure 4.2, click the Show Library Navigation Panel button to create a view like the one shown in Figure 4.3.

Figure 4.2
Click to open the Library
Navigation panel.

Figure 4.3
Library Navigation panel.

2. Click the + Add button at the top of the panel. While the new folder is highlighted in blue, type **Chapter 4**. If it's not highlighted, double-click it. After doing so, you will see the media library (to the right) is empty (see Figure 4.4). Let's get some content in there. Make sure Chapter 4 is highlighted in the Library Navigation panel.

Figure 4.4
A new media library.

3. Click the Browse button at the bottom of the Library Navigation panel. In your VSX4 lesson folders, navigate to Photos > Buildings. Move the Explorer window over so you can see at least part of the empty media library. Drag and drop the photo LincolnNight.jpg right into the Chapter 4 media library. If the photo does not appear, make sure that the Photos icon is highlighted at the top of the library (you can still import the photo even if it's set to hide photos). Your view should look like the one shown in Figure 4.5.

Figure 4.6
Importing from digital media.

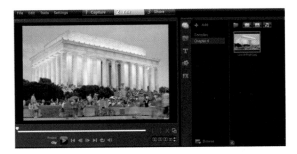

Figure 4.5
New imported content.

Importing via the Capture Tab

You've created a custom library folder, and you've already learned how to import content into it. Now it's time to use the Capture step to insert content directly into your new library. As I mentioned earlier, the Capture step is actually a little deceiving, as it includes both capturing and importing from specific sources and devices.

To import content directly into your new library, follow these steps:

1. Click the Capture tab at the top of your VSX4 screen (see Figure 4.6). In the middle of the window, select Import from Digital Media. The Import from Digital Media dialog box will appear. This dialog (probably empty at first) will eventually show folders you've previously visited.

2. Click on Select Import Source Folders. In the Select Import Source Folders dialog box that appears, navigate to Videos in your VSX4_LessonPlans folder and place a check mark next to the WashingtonDC folder (see Figure 4.7). Click OK.

Figure 4.7
Select the WashingtonDC folder.

3. Back in the Import from Digital Media dialog box, you'll see the path to the WashingtonDC folder listed. Click Start (see Figure 4.8) to preview all the video clips in this folder.

Selected content to import Click Start

Figure 4.8
Click Start to display content.

4. Place a check mark in the upper-left corner of the video called Fireworks2 (see Figure 4.9). Click Start Import at the bottom, and the importing will begin.

Figure 4.9
Import selection window.

5. Once the importing status bars show that the process is complete, the Import Settings dialog box will appear (see Figure 4.10). Make sure Capture to Library is checked. In the Capture to Library drop-down list, choose Chapter 4. Leave everything else unchecked and click OK.

Figure 4.10
Importing to a custom library.

6. Return to the Edit tab of VSX4. If it doesn't appear already, in the Library Navigation panel, choose Chapter 4 (under Samples) to view where the clip you just captured now resides. Unfortunately, the file name from the clip was not captured.

7. Click on the Fireworks clip file name. Change its name to **Fireworks2**. The name will still revert back to the captured name when applied to the Timeline. Changing the name in a library does not actually change the file name, just its reference name while working in VSX4.

8. Save your project.

It's easy to understand why you need to name the thumbnail in the library of a captured clip. After all, VSX4 doesn't know what to name any of the clips it captures, so it numbers them instead. So why does it revert back to the captured name when it's placed on the Timeline? Names of library items refer to the original file name, wherever that file is on your PC. If you rename a captured file in the folder it is captured to, *then* it will retain that name anywhere you use it.

Importing from a mobile device follows a very similar procedure, but the window looks somewhat different. When your device is connected, it will be listed in the left column, with its downloadable content displayed on the right. Ctrl-select the clips you want to import and click OK. Again, you'll be asked into which libraries you want the clips placed.

Capturing Video

This section and the next, called "DV Quick Scan," have important information to learn, but following the steps is optional, as they are not common procedures (unless you want to have fun with your webcam!). I realize only a small percentage of readers have a DV tape camcorder or the ability or desire to capture from a digital TV source (extra hardware is required). The procedure I'm about to show you is not integral to the rest of this chapter. If you have a DV tape camcorder or would like to capture a video of yourself from your webcam, this is the place to learn how to do it. Remember that capturing, as opposed to simply importing, involves converting raw video files to a usable format, then importing them into VSX4.

1. Return to the Capture step and select Capture Video, the topmost choice in the center panel.

2. If you have a DV tape source, connect it to your PC and turn on to Play. If you are unfamiliar with how to connect a DV tape source, refer to the section "Connecting Your Video Source" in Chapter 16. If your source is connected correctly, the Capture Video button will be blinking in the panel.

3. If you would like to try this feature and have a webcam, choose Webcam from the Source drop-down list shown in Figure 4.11. This list also displays the other capture options. Select the one you're able to use. I chose Panasonic DV Device.

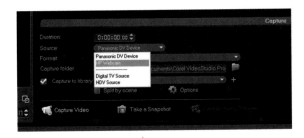

Figure 4.11
Selecting a webcam capture source.

Whichever Source option you choose, information about both your source and capturing settings will be displayed in the Information panel on the bottom portion of your screen. First on the list is the file name that the capture will be saved as. Second is the video size and quality settings. Third is the available space on your hard drive, fourth is the device name that it's capturing from, and last, the format the audio will be captured in.

4. In the Format drop-down list, choose DV if you would like the captured file to remain a basic RAW file that VSX4 can work with. It will add a "wrapper" to the file, making it an AVI file. Choose DVD to convert the file to a suitable one if creating a DVD is your goal, or an MPEG-2 file (MPG).

> You will only see the DV option if you have a camcorder connected. If you do not, the only choice will be DVD.

5. The next drop-down list, Capture Folder, will be the location where the captured videos are stored. It is important to either choose your own location or remember this location. Video files are *huge* and VSX4 doesn't always delete video files after you are done with them. Knowing where you can manually delete them will help you recover valuable hard drive space.

6. Next are your choices for representing your captured clips in VSX4. If you want them to appear in VSX4, make sure Capture to Library is checked; otherwise, they'll just be stored in the Capture folder. Then choose which media library folder to save them into. Click the plus sign (+) to add additional folders, just as you did back in the Library panel of the Edit tab.

7. Optionally check the Split by Scene box to create a separate file every time there is a video break.

8. Click the Options icon and select Capture Options. If you check Insert to Timeline, your captured video will be both inserted into the Timeline (at the end of any other clips), and, if you also have Capture to Library unchecked, the video will be imported there, too. Don't worry about the Video properties under Options at this time. Click OK to close the small Capture Options window.

9. Click Take a Snapshot to save a JPEG of the current frame and drop it into the Capture library at the top of the page.

10. If you know you want to capture all of your DV tape, starting from where the playback head is, or your webcam, click the blinking Capture Video button. When you're done, click the same button again that now says Stop Capture. Your newly captured video clips will show up in the library at the top.

11. Close the Capture Video section by clicking the X on the far right of the panel. You will return to the main capture choices, and your captured clips will be placed where you directed them.

12. Save your project.

DV Quick Scan

Regarding capturing from a DV tape, the Capture Video feature is great if you know you're going to capture straight through. But what if you would like to review and choose which scenes to capture first, before actually capturing them? This is where the DV Quick Scan feature comes in. Quick Scan will scan your tape and provide thumbnail views without actually saving any of the video. You can then select which scenes you want to save, then capture and import them into VSX4.

1. Select DV Quick Scan to open the DV Quick Scan dialog box (see Figure 4.12).

Figure 4.12
DV Quick Scan dialog box.

5. Click the Start Scan button on the bottom left.

6. You can either wait until the tape is scanned in its entirety or click Stop Scan when you're done. All the thumbnails that now appear represent separate scenes you recorded. A scene is separated by when you turned the camera to Pause or to Off and back on again.

7. All the scenes are checked by default, and they will be converted when you hit Next. If you don't want some of the scenes, Ctrl-click on the ones you do not want. When finished, select Unmark Scene at the bottom (see Figure 4.13).

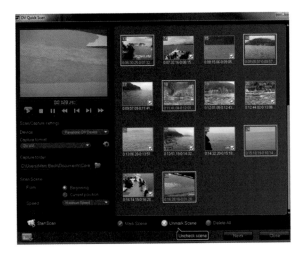

Figure 4.13
Selecting scenes to capture.

2. In the upper-left corner of the dialog box, you'll see a small preview window showing the current frame of your DV tape being displayed on your camcorder, along with the familiar controls you saw in the Edit tab's Preview panel.

In the Device drop-down list, you should see your DV camcorder listed. If it's not and if the Start Scan button at the bottom left is not blinking, your camcorder is not connected correctly. Make sure you're using a FireWire connection (not USB) and that your camcorder is on and set to play.

3. Choose your format again from the Capture Format drop-down list, either DV AVI or DVD (MPEG-2). Then choose your folder from the Capture Folder drop-down list.

4. In the Scan Scene area, choose whether you want to scan the tape from the beginning or from its current position. In the Speed drop-down list, you can select how fast to scan it at. Choose 1X if you want to view along with the scan. Otherwise, choose the Maximum Speed option.

8. Click Next. Your scenes will now be converted for use in VSX4.

9. When the clips are finished being captured, the Import Settings dialog box will appear (refer to Figure 4.10). You will have the same options that you did before of where to import the clips.

10. Save your project.

So there you have it. VSX4 provides excellent capabilities for capturing and creating video files suitable for your projects from a variety of sources. Next I'll show you how to acquire clips via the Edit tab.

Importing via the Edit Tab

Unless you're capturing and importing RAW video content, you should be importing via the Edit step. For the rest of the lessons, all the files in your Lessons folder are already in the format that you need them.

We've already practiced this procedure once, so this short section will be a reminder for the rest of the lessons. Here you'll use common importing procedures, such as locating the folder where your media resides and placing the content into custom libraries. You'll bypass importing to a library, and instead import and place content directly into your Timeline; but then you'll also set the clip up again for re-use.

To import a clip directly into your Timeline, follow these steps:

1. Go to File > Insert Media File to Timeline > Insert Video. Locate and open Fireworks1 in the WashingtonDC folder. Notice that's it's placed in your Timeline, but it's not in any of your video libraries. As I explained earlier, this is a nice shortcut, but since the clip is not in a library, it's not handy if you plan on using it again. But have no fear, you can still put it there.

2. To place Fireworks1 into a library, open the Chapter 4 media library from the Library panel. Drag and drop the Fireworks1 clip from the Timeline into your Chapter 4 library next to Fireworks2. You can also place Fireworks1 before Fireworks2, if you'd prefer to keep clips in order. Now Fireworks1 is available if you want to use it again. Better!

Tip

Any clip from the Timeline, with any number of effects or edits applied to it, can be saved for re-use just by dragging it into a gallery or library.

3. At the bottom of the Library panel (make sure the Media icon is selected), click Browse (see Figure 4.14) and return to the WashingtonDC videos folder. Pressing the Shift or Ctrl key, select both DC1 and DC2, then drag the two clips into the Chapter 4 library area. This is one method for importing clips into any displayed gallery.

Browse button

Figure 4.14
Drag and drop clips into a library.

4. At the top left of the Chapter 4 library area, click the Folder icon (see Figure 4.15).

Figure 4.15
Opening clips into a library.

One last, but boring, method to import assets is similar to the Insert to Timeline method. You can also use File > Insert Media File to Library > Insert Video/Digital Media/Photo/Audio choices. Snore.

5. In the Videos > WashingtonDC folder, select Fireworks3 and click Open. This is yet another method to acquire clips for your project. You should now have five video clips and one photo, all stored in the newly created Chapter 4 Media library. These clips are LincolnNight.jpg, and videos Fireworks1, 2, and 3, and DC1 and DC2.

6. Save your project

Alright, with the exception of a TV, you've now learned and practiced every known method of acquiring and importing content into VSX4. The next section will cover the different trimming choices that can be done to individual video clips.

Editing Video Clips

YOU'RE NOW FAMILIAR WITH getting content into VSX4: capturing RAW content, importing converted, ready-to-use content into the libraries, and also importing content directly onto the Timeline, bypassing the libraries. This section will show you how to edit your content, both in the libraries and those already placed on the Timeline.

Specifically, you'll learn how to use the Single Clip Trim and Multi-Trim Video windows, adjusting durations by changing the start and/or end points of a clip, changing the playback speed, splitting a clip by its individual scenes (if it has more than one scene), copying and re-using clips, and finally color correcting a clip. Most of these features are located in the Options panel, which launches automatically when an asset is selected, so you'll get very familiar with using this area. Let's get started.

Although you can leave a blank space in every other Timeline track, VSX4 will not let you leave a blank space between clips in the main Video track. You can, though, leave the entire main Video track empty and just work in the other Overlay tracks. Working only in Overlay tracks allows you to make video clips any size (as opposed to only full-screen) and position you like and place them over a blank background.

Makes clip fit to view

Figure 4.16
Bringing the entire project in view.

Adjusting Clip Durations in the Timeline

There's more than one way to adjust the length of a video clip. The first method you'll use is the easiest and fastest, but it also can be the least accurate—adjusting a clip after it's placed on the Timeline. You might think that all you can do is shorten a clip, but there are a couple of circumstances where you can actually lengthen a video clip.

1. You should still only have the clip Fireworks1 in your Timeline (six clips in the Chapter 4 library, but only one video clip in the actual Timeline). Click the Fit Project in Timeline Window icon, just to the right of the Timeline zoom slider (see Figure 4.16). This will make the entire clip visible in the Timeline, instead of it extending off the right edge. You should now see the right end point of the clip.

2. You can trim the duration (snip off an end) of a clip in the Timeline by simply dragging either end to shorten it, again, without affecting the original clip. Click once on Fireworks1 in the Timeline. Move your cursor over the vertical orange bar at the end of the

clip and, watching the timecode feedback attached to your cursor, drag it to the left until the clip is at the 44.00 second mark and let go (see Figure 4.17). The results are shown in Figure 4.18.

3. Save your project as Chapter 4 into your Lessons folder.

...to here. Move this...

Figure 4.17
Shortening a Timeline clip (before).

After

Figure 4.18
Shortening a Timeline clip (after).

> **CAUTION**
>
> Remember I just said you can lengthen a video clip under certain circumstances? Well, you cannot lengthen a clip longer than its original length. However, after trimming a clip in any of the Trim windows, you can return it to its original length in the Timeline by dragging the end of it back out. This will become clearer in future lessons, but basically, you can undo the shortening of a clip by dragging it back out in the Timeline.

Single-Trim Video

Single clip trimming a video segment just means taking an existing clip and changing the start and/or end point. You just did that in the last section, manually, in the Timeline. Another method is to apply this trim before adding the clip to the Timeline using the Single Clip Trim dialog box. The tools in this dialog are similar to those in the Preview panel that you learned about in Chapter 3. What's new is a Jog Wheel you can use to move a clip along.

1. In the Chapter 4 Media library, double-click the DC1 clip. This opens the clip in the Single Clip Trim dialog box.

2. Using Figure 4.19 as a guide, use either the Jog Wheel or the white Scrubber arrow (or both) to go to timecode 02.10. Click the Mark-In bracket to set the start point of this clip.

Position to here Mark-In Mark-Out

Use this... ...or this
 to position clip

Figure 4.19
Single trimming a video clip.

3. Go to timecode 08.00 and click the Mark-Out point. Click OK. The Single Clip Trim dialog box will close, the clip will be updated in the library, and the results will display in the preview window.

The original clip has not been altered at all. It still contains its original length. The only difference, as evidenced in the preview window, is that only a small portion of it will play in your project.

4. With the clip selected in the library, click Play in the preview window. You'll notice the trim marks are present in the main preview window. Drag and drop this clip from the library to the right of the Fireworks1 clip in the Timeline.

5. Save your project.

Tip

Here is an example of where you can lengthen a video clip. Because this clip, now in the Timeline, still has its original full length available to it, you can grab the right or left end and extend it, reinstating some or all of its original length. If you try this out, be sure to hit Ctrl+Z to undo it.

Split Clip by Scene

Normally, when you capture clips, they are already automatically separated by scenes into separate clips. Scene splits are designated by when the camera was either turned on, turned off, paused, and so on.

Occasionally though, you'll have a video clip that seems to have separate scenes but is still all in one clip. Maybe you would like these separated, perhaps for the purpose of adding chapter breaks or transitions in between. The Split by Scene feature in VSX4 will do that for you. Here's how it works.

1. Using any one of the import methods you recently learned, import the video clip JewelScenes into the Chapter 4 Media library, found in your Videos > WashingtonDC folder.

2. With this new clip selected in the library, click the Open Options Panel icon in the lower-right corner of the Library panel (see Figure 4.20 to open the Video Options panel.

Click to show the Options panel

Figure 4.20
Accessing the Options panel.

3. Click Split by Scene to open the Scenes dialog box. Here two scenes in this clip should already be listed in the Detected Scenes area. (If they aren't, click the Scan button in the lower-left corner). See Figure 4.21. Click OK.

Click here... ...to open this.

Figure 4.21
Scenes dialog box.

4. There will now be two extra clips in your Chapter 4 library. In addition to the original JewelScenes clip, there are now two new ones, each of which is part of the original, separated at their scene breaks. Unfortunately, they have the exact same names. Fortunately, there is an easy way to tell them apart.

5. You should have three clips named JewelScenes. Select each one and look at the preview window. The first one should show a full-length clip (indicated by the scrubber line). Each of the other two should show a section of the original, the first part, then the second part.

6. Save your project.

Changing the Playback Speed

Speeding up or creating a slow-motion video clip is usually relegated to more expensive video editing software tools. Yet this feature is included in VSX4 and is very simple to use.

1. With the Fireworks1 clip selected in the Timeline, open the Options panel and click Speed/Time-lapse. The Speed/Time-lapse dialog box will appear (as shown in Figure 4.22).

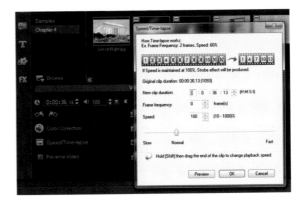

Figure 4.22
Playback speed options.

2. In the middle of the dialog box, change the Speed value to 200%. This will increase the clip's playback speed, and also shorten the clip's Timeline length by 50%. This happens because the frame rate will double and cause the clip to finish in half the time. Play to preview it. The clip now plays in half the time and the fireworks show is one giant finale! (You will play more with the Speed/Time-lapse feature in Chapter 11.)

3. Click OK. The clip in the Timeline should now be half of its original length. The library clip, though, remains unaffected.

4. Select Edit > Undo (or press Ctrl+Z) to undo the previous step and return the clip in the Timeline to its previous length.

You can also create this effect directly in the Timeline, but this time let's slow the clip down.

1. On the zoom slider on the upper-right corner of the Timeline, click twice on the minus (–) magnifying glass to zoom out and create more room in the Timeline.

2. While holding down the Shift key, grab the right end of the clip and drag it to the right until it's about double its length.

3. With the clip still selected, click Play in the preview window. It now plays slower and with a very eerie sound. The only downside is that this method doesn't allow for the same accuracy that the dialog box does.

4. Undo this step to return the clip back to its original playback length.

5. Save your project.

Multi-Trim Video

VSX4's Multi-Trim Video feature takes the Single Clip Trim feature a step further. Multi-Trim Video lets you create multiple mini-clips out of one long clip in a single process. All at once, you can make multiple trim edits to a single clip and add these to a library.

1. Place DC2 into the end of the Timeline in the same track after the other clips.

2. With DC2 still selected, open the Options panel and choose Multi-Trim Video (as shown in Figure 4.23). The Multi-Trim Video dialog box will appear.

Multi-Trim Video option

Figure 4.23
Multi-Trim Video dialog box.

3. Click the Mark-In bracket to place a marker at the start of the clip. Go to timecode 06.06 and set a Mark-Out point. This new, smaller clip will be added to the Trimmed Video tray.

Tip

As a reminder, use the white Scrub marker to go to the general frame location quickly. Then use the Jog Wheel, Previous Frame and Next Frame buttons to hone in on the exact frame you want.

4. Go to timecode 16.05 and set a Mark-In point. Set a Mark-Out at 24.28.

5. Set a Mark-In at 29.06 and Mark-Out at 35.03. You should now have three clips in the Trimmed Video tray, and your dialog box should look like the one in Figure 4.24.

Click here to preview

Figure 4.24
New Multi-Trim Video clips.

6. Click the Play Trimmed Video button to preview your three clips.

Tip

Invert Selection at the top of the Multi-Trim Video dialog box selects the clips you *did not* trim. Select this to instead use the parts of the clips you trimmed off after multi-video trimming. Sometimes it's easier to first trim off the parts you don't want to use, then choose the ones you want from what remains.

The Ad-Zapper tool in the Multi-Trim Video dialog box is a pretty cool feature. If you captured video from your TV/VCR/DVR, Ad-Zapper looks for a 2- or 3-second gap of black frames when commercials begin and end. It uses this gap to corral the ads and delete them. Because of the very short gap, Ad-Zapper default sensitivity setting is on High.

7. Click OK. The clip is now split into three pieces on the Timeline with the unwanted portions removed. Beware though that you now have three clips in the Timeline with the exact same name. Again, though, the original clip in the library is unaffected.

8. Save your project.

Copying Clips

There are two ways to use the same video clip twice in your Timeline. The obvious method is to just bring another one down from the library. The other option is to make a copy of it right there in the Timeline, and then drop the copy into its new location. Let me show you how to do the Timeline method.

1. Select the last of the three newly trimmed DC2 clips in the Timeline. Right-click on it and choose Copy. The clip will now "stick" to your curser. Move the copied clip to the end of the track, and then left-click to drop it. Double-click on it to bring up the Options panel (if the Options panel isn't already open). Check Reverse Video back in the Options panel. This will make the second clip play backward.

2. Repeat the previous step with the second DC2 clip, and then again with the first DC2 clip to reverse all the DC clips. The video should pan up the Washington Monument, then back down again. Preview the results.

3. Save your project.

Reusing Edited Clips

Just because you trimmed a video clip doesn't mean you can't trim it again and use the same and/or different parts of it somewhere else. The original information is still retained in the library clip, and you can change the part you want to use at any time without affecting what you trimmed off and used previously. In other words, you can use a trimmed clip and then trim it again to make a new one without affecting the previous one. Let me show you what I mean.

1. Click the Fit Project in Timeline Window button in the upper-right corner of the Timeline (refer to Figure 4.16).

2. Select DC1 in the library. You'll notice the previous trim is still evident in the preview window. Move the Mark-Out point all the way to the right. Insert a Mark-In point at 13:00. Drag DC1 from the library to the end of the Timeline. Although you re-used the same clip from earlier in the Timeline, you're now using a different portion of it, again without affecting the first trim you did on it or the original clip's length!

> Notice that any new edit replaces an old edit, but not the original and doesn't affect what you've already applied to the Timeline. Pretty cool, huh?

3. Return to and select the first DC1 clip in the Timeline (the second clip in the Timeline sequence), and drag it into the Chapter 4 library. You may want to close the Options panel first if it is not already closed. Now you have both versions of the clip you created available to re-use at any time.

4. Add the Fireworks2 clip from your library to the Timeline right after DC1.

Color Correcting a Clip

VSX4's advanced editing features allow you to do more than just trim a clip. One of the features in the Options panel is the ability to fix a video clip, similar to what you might do to a photograph in an image editing application. The Color Correction feature lets you adjust items like white balance, hue, saturation, brightness, contrast, and gamma.

> Color Correction has many options to choose from. White balance is the process of removing unrealistic color casts so that objects, which are white in reality, are correctly rendered white in your photo. There are several ways to tell the software how to create the best balance—designate a perfect white color in a photo (using a color picker), tell it what type of lighting was used in your photo by choosing a light type (such as shade, overcast, cloudy, daylight, fluorescent, or tungsten); use a manual temperature setting (warm to bring out reds and cool for blues); adjust individual Hue, Saturation, Brightness, Contrast, and Gamma controls; or, *my* preference, choose the Auto-Adjust options. What's great about VSX4 is that any color adjustment will be applied to an entire video clip and rendered in real time.

1. Double-click the last clip in the Timeline, and select Color Correction from the Options panel.

2. Test any of the possible settings for your personal preference. Feedback is immediate. Use the undo arrow at the lower right to return all sliders to their defaults.

3. Select the Auto Tone Adjustment check box, then from its drop-down list to the right, choose Brightest (see Figure 4.25). Click Play to preview. The results are rendered and played back in real time.

4. Save your project.

Figure 4.25
Color correcting a video clip.

Using Still Images

ADDING IMAGES TO YOUR movies is just as easy as adding any other media element. All you need to do is drag and drop a photo or illustration directly into any of the video tracks. Videos and stills are interchangeable. You can import them the same way, too, using the Browse button, drag and drop, or File > Insert Media File to Library method.

Because photos used in videos are often viewed on TV screens, and HD TVs at that, it's always recommended that you use photos with the highest resolution possible. Larger image sizes help as well.

Isn't an image's size the same as resolution? Nope, afraid not. Image size refers to the physical print size of the photo, such as 8×10 inches. Resolution refers to the quality of that photo, such as 72 dpi (dots per inch) or 300 dpi. Increasing the image size will not increase the resolution, in fact it will do just the opposite.

If you increase an image's size in inches, the same resolution will just be spread over a larger area, and the quality will drop. Think of it as placing a drop of ink on a piece of paper, then spread that dot over a larger area. It gets thinner and loses saturation. Decreasing an image's size in inches

will make the image smaller but in turn squeeze the pixels together, increasing the quality (increasing that drop of ink's concentration). Therefore, an image that's designed for a web page will not look good when projected on your TV because a web page image is designed for a much smaller viewing area. Keep this in mind when adding photos into your video projects.

Another consideration is the aspect ratio of a photo, or the width vs. height. Any ratio is fine, as long as it matches the ratio of your video project. You don't want a rectangular video interspersed with square photos, right? VideoStudio can fix this by making everything fit your project ratio. Just be aware that photos might be stretched or squeezed to fit. But at least you can preview the results before committing to using them.

Adding Photos to a Video

Handling photos or illustrations (line art) in VSX4 is exactly like managing video clips. They're imported into the same Media libraries as videos and audio clips. Back in the section "Adding New Content," you saw the list of graphics formats that VSX4 can work with. Most of your images will most likely be in the JPEG format, but it's nice to know that so many others will work, too.

1. In the Media library, Click both the Hide Videos and Hide Audio Files icons at the top. This will narrow down the library view to show only still graphics.

2. Import the photo US_Capitol.jpg from the Photos > Buildings lesson folder into your new Chapter 4 photo gallery.

3. Place the photo into the Timeline just after the first video clip.

4. Zoom into this portion of the Timeline by clicking twice on the plus (+) magnifying glass to the right of the zoom slider. Drag the right end of the clip so that the duration reads about 5 seconds (see Figure 4.26).

Figure 4.26
Extending the photo duration.

5. On the Timeline, click on the first video clip to see it in the Preview panel. Now click on the photo you just inserted. Do you notice how a black border displays on the sides of the photo? This is occurring because the shape (the aspect ratio) of the photo is different than the shape of the preview screen. You can fix this if you want.

You may or may not have a black border around your video as well. This depends on the shape of your Preview panel. As described in the section "Customizing Your Workspace" in Chapter 3, you can adjust the sizes and shapes of the three main windows in the Edit tab by dragging the bars between the windows. As a result, it's possible that the size you created is not the same shape as your video. Not a big deal, but if you want to maximize the usable space of the other windows, make the Preview panel as close in shape as possible to your video.

6. Double-click on the US_Capitol.jpg photo in the Timeline to bring up the Options panel. In the Resampling Option drop-down list, choose Fit to Project Size. If you don't mind that the photo stretches a little to fit the video window size, click OK. If you would rather leave the photo as it was, set the Resampling option back to Keep Aspect Ratio. At least you now know where this adjustment is located.

7. If you kept the Fit to Project Size option, and play the end of the first video clip as it transitions into the photo, you'll notice that both the video and the photo take up the same amount of screen space.

8. Save your project.

Tip

You can also set this resizing option as a universal default. Go to Settings > Preferences > Edit tab. Under the Image section, select Fit to Project Size in the Image Resampling option drop-down list. From then on, all images you place into the Timeline will auto-fit to your project size.

Adding a Solid Background

Occasionally, you may want to display something in your video project that either doesn't take up the entire screen and/or doesn't interfere with any background activity. You may want the viewer to concentrate only on a title or a collection of small photos scattered on the screen. The issue with this is that video editing software requires that something, anything, fill up the entire screen, as this designates the overall screen size. This is where a solid color, such as a color chip, can come in handy. These solid colored backgrounds included in VSX4 can take the place of no background, and they can be much less distracting.

Solid backgrounds can be used for many reasons, including

▶ A background for a title

▶ A blank space between any two clips in the main Video track

▶ Creating a frame around a smaller video clip

▶ A background for a montage of small, overlaid photos or video clips

▶ A pause between two scenes

The following steps will show you how to add solid backgrounds and how they're useful.

1. In the Library panel, select the Graphic library. Choose the Color gallery from the drop-down list (as shown in Figure 4.27).

Figure 4.27
Accessing the Color gallery.

Figure 4.28
Using a solid color background.

2. Grab a purple color chip (any color will do, actually) and drop it at the beginning of the main Video track.

3. Set the duration to about 10 seconds by either dragging the end out like you did previously or by double-clicking the chip to open the Options panel and setting the duration.

4. Go to the Title library. Grab any bright animated title and drop it into the Title track underneath the purple color chip (no need to edit the text). Drag the title's duration to 10 seconds (it will snap) so that it matches up with the color chip.

5. Double-click on the Title clip you just laid down in the Timeline to make it appear in the Preview panel. Then double-click on the text in the Preview panel to make it editable. In place of Lorem ipsum, type **Our Trip to D.C.** Click somewhere else in the Preview panel to exit the text editing mode, but leave the text block selected. Reposition the text block on the screen, if necessary (see Figure 4.28). Make sure Project is selected, not Clip. Rewind your movie and play to preview your animated title.

6. Return to the Color gallery and drop any color chip after the first video clip in your Timeline. Play this section. Not too exciting, right? It does, though, create a blank space if you need it. As you remember, you cannot have an actual blank space in the background Video track, so this is a way around that.

7. Double-click on the chip you just laid down to bring up the Options panel. Set the duration to 44 seconds (see Figure 4.29) to set the duration of the new color chip.

Figure 4.29
Using the Options panel to set Color Duration.

8. Select the Fireworks1 video clip in the Timeline. Drag the clip straight down into the Overlay track beneath it and let go. The rest of the clips in the Video track will shift left to fill up the blank space left by Fireworks1. The Fireworks1 clip now becomes an overlay on top of the color chip background and is now reduced to a smaller size.

9. As mentioned in Step 6, the background video clip is now an overlay clip and no longer occupies the entire screen. If not already available, double-click on the video in the Preview panel to bring up the corner resize handles. Drag any yellow corner to resize the clip. (Important! Make sure your cursor shows a double-ended arrow!) Grab the middle of the selection to reposition it so that the background is nicely sized and centered in the border frame.

Grabbing the yellow corner (instead of the green corner inside the yellow corner) will maintain the aspect ratio. You can undo any mistakes with Ctrl+Z and redo with Ctrl+Y. Your screen should look similar to that shown in Figure 4.30.

10. Save your project.

Figure 4.30
Using color as a border.

Quick Review

▶ What feature allows you to store specific project content aside from other content? (See "Using the Library Navigation Panel.")

▶ Why would you use the Capture step as opposed to just importing into the Edit step? (See "Importing via the Capture Tab.")

▶ How can you save an edited clip to use later? (See "Reusing Edited Clips.")

▶ Name at least two purposes that a solid color background can be used for. (See "Adding a Solid Background.")

Video by Numbers with

Instant Project

O KAY, SO IT'S NOT truly instant. It's not
like Cup-a-Soup, where you just add water
and it transforms into a fully nutritional
dorm room culinary delight, but it comes pretty
darn close in terms of making a movie. The Instant Project fea-
ture in VSX4 has all the ingredients to create a slideshow, video
introduction, short movie, or conclusion. All you need to add is
the hot water, uh, I mean content.

Each Instant Project uses placeholders, including backgrounds,
frames for your slides and video clips, text titles, and music.
Each media object has a set default length of time that you can
adjust if you desire, but you don't have to. You just need to swap
out the placeholder content for your own. An Instant Project is
the reverse of adding a template theme to your DVD or movie
project. In an Instant Project, the template comes first, then the
content.

Instant Projects can be used for video projects, but because of the way they're laid out, it makes more sense to use them for slideshows. Outside the intros and conclusions, all the placeholders have rather short lengths. They can certainly be lengthened, but you'll have to make sure your other tracks are set for Ripple Editing. That way, anything inserted or lengthened in the middle will move the other tracks forward accordingly so that everything stays synchronized.

Many of the placeholders also contain pan and zoom effects that add something of an animated effect to stills. Videos can be created with instant projects, too, they just requires a little more editing on your part. You'll create an "instant" slideshow first, then a short video using the Instant Project feature.

Setting Up an Instant Project

THE FIRST STEP IN CREATING an Instant Project is to chose a template. Doing so is easy, but there are a lot of options to choose from in various categories—over 100 templates total. Categories are not separated by design, but rather by function, or where you want to use them in your project: in the beginning (introduction), middle, end (conclusion), or the entire project. The middle category provides the most complex templates, so let's just jump in and try one of those.

1. Launch VSX4.

2. Open the Track Manager (see Figure 5.1). Click the Unselect All button to make sure only the default tracks are selected. I want you to see how adding an Instant Project template will automatically add the necessary additional tracks for you. The default buttons are all grayed out, indicating you can't change their setting anyway. Click OK.

Figure 5.1
Track Manager icon.

3. Click the Instant Project icon in the Timeline toolbar (see Figure 5.2). The Instant Project dialog box will appear. Using Figure 5.3 as a guide, take some time to tour the template choices in the various categories. You can preview templates in the window on the right. Especially notice the category differences. The Custom category is reserved for projects you create and want to use in the future, which you'll learn more about at the end of the chapter.

Figure 5.2
Instant Project icon.

Figure 5.4
Choosing a template.

Figure 5.3
Instant Project dialog box.

4. Let's go for it and use a rather complex template. Choose the Middle category, and then choose the template that looks like a forest background with a black border around it (see Figure 5.4). Make sure the Add At The Beginning option is selected and click Insert.

5. Save your project as **Chapter 5-slideshow**.

There are a few things to notice in the timeline. *All* necessary additional Video tracks have been added automatically. A bunch of placeholder clips for your photos have been placed at just the right increments. Notice that the background Video track is just a black color chip. You learned previously about using these, not only as blank spaces, but also as frames for when content in Overlay tracks won't take up the entire background. Something has to take up the complete background, and the black chip does just that.

> Don't freak out about the layout—this is going to be much easier to customize than it looks, I promise you! It'll be like painting by numbers. You'll only need to work in the Overlay tracks and the Title track. Changing out the background chip and Music track is purely optional, but can be done if you like.

6. Now view the structure of the template as it plays. Hit the Play button in the Preview panel and notice the different layers and timing involved. Notice what happens in the Preview panel as the playback head moves down the timeline.

Tip

If you lose track of where you saved your project file, you can still open it easily by re-launching VSX4 and choosing the file name from near the bottom of the File menu.

7. All the clips in your Timeline might be highlighted because they're all selected. Click in a blank area of the Timeline to deselect everything. Fit your project to Timeline view.

8. Double-click any of the placeholder clips in Overlay track 1 (the first track below the background). This opens the Video Attribute Options panel. You'll notice that the Picture-In-Picture filter has been added (see Figure 5.5). This filter (video effect), as a result of the Instant Project template chosen, was used to automatically create custom frames around the pictures and the reflections below them, evident in the Preview panel. (It's also a filter you can customize, but I'll cover this more in Chapter 8.)

Figure 5.5
Picture-In-Picture filter.

Now you understand how an Instant Project is chosen, how it's loaded into the Timeline, and how track assets interact with each other via overlays and video filters. The next section will cover filling in the placeholders with content.

Creating a Custom Slideshow with an Instant Project

THE FIRST THING YOU NEED to do is gather the content you want to add into your Instant Project. Since the Instant Project has everything you'll need except your slideshow photos, that's all you'll need to gather and insert. For this part of the lesson, you'll use the Landscape photos .

Follow along with these steps to learn how to create a quick, but professional, slideshow using the VSX4 Instant Project feature.

1. Go to the Library panel, and create a new folder called Chapter 5. Just like you did in creating the Chapter 4 folder, click the + Add area at the top of the panel and name the new folder **Chapter 5**.

2. Making sure Chapter 5 is still selected in the panel, click Browse at the bottom. Navigate to the Lesson Plans > Photos > Landscapes folder.

3. Shift-select all the photos and drag them into the Chapter 5 library, which should look like the one shown in Figure 5.6.

There is a second method for adding content to the template. Right-click on the first clip in Overlay Track 1 (not the background Video track) and choose Replace Clip > Photo (see Figure 5.7). This inserts files straight from your PC file explorer into the Timeline. However, as mentioned before, this method doesn't make these files available for later use via any of the media libraries.

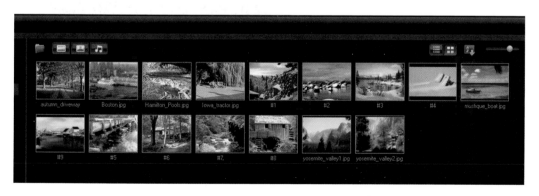

Figure 5.6
Instant Project photos.

Figure 5.7
Replacing a clip.

Place playback head here.

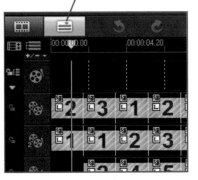

Figure 5.8
Placing an instant slideshow image.

4. Follow this next step closely, even reading it a couple times first. Put the Timeline's playback head in the middle of the first clip (named #2) in Overlay track 1 (see Figure 5.8). From the Chapter 5 library, grab the corresponding #2 photo. Hovering it over the #2 placeholder clip, press the Ctrl key on your keyboard. The info on the clip will change to +Replace clip. Let go of your mouse to replace the clip, *then* release the Ctrl key. In a couple seconds, you'll see the results in the Timeline (see Figure 5.9).

5. Repeat Step 4, adding all the other photos to their corresponding placeholders (photo #1 into placeholder #1 and so on) throughout the entire movie. Fitting the Timeline to view will help you see that you placed them all correctly. Rewind the project and play to preview. Pretty cool, huh?

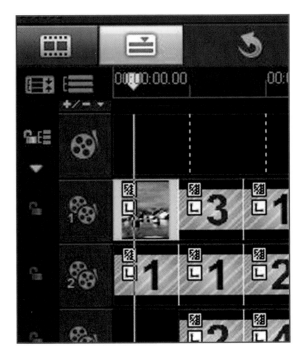

Figure 5.9
Clip replacement results.

You may have just noticed that the clips resort back to their original file names when they're inserted into the Timeline. This happens because the library only references the originals. If you were to move a clip from its original location on your PC, the library would show it as a broken link. The library needs to know where the original clip is in order to work with it. It all has to do with that EDL I discussed previously (the Edit Decision List that contains the project instructions, but not the content). If you want to change the file names in both the library and the Timeline (that is, the clips themselves), right-click the clip in the library and choose Locate on Computer. You will be taken, via the Explorer, to the clips' location, where you can rename them.

6. Save your project as **My Instant Slideshow**.

Let's now change the text titles from "VideoStudio" to something more appropriate.

1. Double-click the first clip (the first "VideoStudio") in the Title track to bring that title to the forefront. Double-click the text in the Preview panel to highlight it for editing. Drag across its length to select all (or press Ctrl+A). Type in **From Lake Tahoe** to replace the other text.

2. Although the text Edit Options panel has popped up to the right, you can bypass those tools for now (which will be discussed in Chapter 9). Instead, click once on the Preview panel outside of the text block. The text block will remain selected. Grab it and center it better, but keep it just inside the white border. Notice that the clip in the Timeline reflects the text change.

3. Slide down the third text clip in the Timeline to start at about the 46-second mark. It doesn't need to be exact, just close. Repeating Step 1, rename the text **Great Smoky Mtns**.

4. Move the second text clip to start close to the 39-second mark. Change that text to **To the . . .**

5. By grabbing the right end, extend the first and third title clips to roughly double their length, or to around 8 seconds long. The cursor will provide feedback for you.

6. Change the very last text clip (at the very end) to **The End**. Center it on the screen, but leave it at its current length.

7. Save your project. Your Timeline should look like the one shown in Figure 5.10.

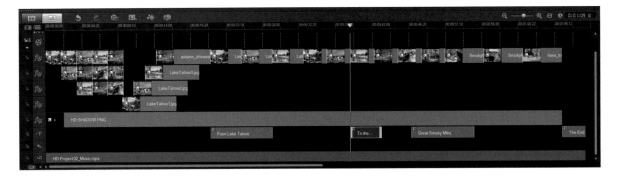

Figure 5.10
Completed instant slideshow.

8. Go to the Share tab. Click Create Video File.

9. Choose WMV > WMV HD 720 30p. Name it **My Instant Slideshow** and place it in your Chapter 5 lessons folder. Rendering this file will take about 10 minutes. When finished, it will be added to your Chapter 5 Media library and start playing automatically. Stop it if you like. Go find the file outside VSX4 and double-click on it to view in WinDVD or another movie viewer.

Tip

Since most slideshows aren't exactly nine slides long, you can modify your show by deleting any unused placeholders, or adding new sections.

Delete sections by selecting any in the Timeline and hitting the Delete key. You can also extend your slideshow by adding another Instant Project before or after the current one, and again, taking out the stuff you don't need.

Another great shortcut is to right-click on an existing clip in the Timeline, choose Copy, then move your mouse to a new location and click to drop it. Then, as before, replace the content for it, as you did in the "Copying Clips" section on the previous chapter.

Creating a Custom Movie with an Instant Project

CREATING A MOVIE WITH an Instant Project is, as you might suspect, very similar to creating a slideshow. After all, you're inserting media, just different media, but it might need a couple of extra adjustments to make it work. Replacing a video clip into a fixed length template clip will shorten that video clip to fit the template clip. You may not (probably not, actually) want that. But that can be fixed. Let's create an instant movie, but with video clips this time, and see how it differs from an instant slideshow project.

To avoid creating an unnecessarily long movie for this short section, and since I'm sure you'll get the point with just a few clips, you'll use a shorter template this time.

1. Back in VSX4, go to File > New Project. Save your slideshow again if prompted.

2. Select the Instant Project icon again. Under the Complete category, choose the template shown in Figure 5.11. It might be in a different position in your list. Once you've selected it, click Insert.

3. Save your project as **My Instant Video**.

4. Fit the project to Timeline view.

5. Open your Chapter 5 library. Make sure the Video content will be visible via the Show Videos button at the top.

Choose this category Choose this template

Figure 5.11
Instant movie template choice.

6. From the Videos > Balloon_Trip folder, import clips Balloon-2 through Balloon-7 into your Video library. Click the Hide Photos icon at the top so that only your videos are displayed. You might also see the video clip (slideshow) that you generated in the last section. You can keep it, or select it and press Delete. It will only delete the VSX4 reference to it, not the file itself.

7. As you did with the slideshow Instant Project, replace the placeholder clips with the Balloon videos in sequence. Start with Balloon-2 over Placeholder 2 in the background Video track. Drag the clip over the placeholder. Hold down the Ctrl key, then, first release the mouse, then the Ctrl key. Before trying the next clip, first read through Step 8.

8. Some of these imported clips are too short. Some are shorter than the template clips and that's a problem. Try Balloon-3. When holding down the Ctrl key to replace, instead of seeing +Replace Clip, you'll see Replace Clip (Source Duration Too Short). Each time you encounter this, cancel the replace process by simply letting go of your mouse button.

The next few steps are very precise, so be sure to read through them carefully first.

CAUTION

In canceling the replace process mentioned in step 8, be sure to let go of the mouse first to return the clip to the library. If you let go of the Ctrl key first, the clip will still be added to the Timeline in between placeholders 3 and 4. If this happens, you can undo it by pressing Ctrl+Z.

9. Right-click on Balloon-3 back in the library and choose Properties. Notice the duration is 6.206 seconds. Click OK. Double-click on placeholder 3 in the Timeline. In the Photo tab (the placeholder is a photo, not a video) that pops up in the Options panel, notice the duration of the template clip is 7 seconds. This identifies the issue I mentioned earlier: The video clip is shorter than the template clip. The template won't accept a clip that is shorter than itself. In the photo Options panel, shorten the duration of the placeholder clip to 6 seconds. Attempt to replace the clip again. You should now be successful.

CAUTION

Make sure you're swapping out the photo clips in the Timeline, not the transitions in between them. Also be aware that the Properties setting will display a clip's length in seconds and tenths of seconds, whereas the durations displayed in the Options panel is seconds and frames. One half second is about 14 frames.

10. Replace placeholder 4 with Balloon-4.

11. Balloon-5 and Balloon-6 will have the same "clip too short" issue. Repeat Step 9 to correct the issue. Look at the video clip's length first and then adjust the placeholder's length to the nearest second *below* that. For example, Balloon-5 is 5:14 seconds in length. Adjust placeholder 5 to 5 seconds and try replacing it again. Repeat the procedure for Balloon-6. Balloon-7 will not need adjusting. Stop after adding the last balloon video (#7).

12. Placeholder 8 is not needed. Select it and hit the Delete key. The transitions on either side will also be deleted.

13. Save your project.

14. Select the Balloon-2 clip in the Timeline. Extend (not move) the right end as far to the right as it will go to increase the length. This will extend that clip to its full length (albeit not that much longer). Repeat this with all the other clips you replaced. This ensures that the videos will still play their full length. This makes the placeholder lengths equal the video clip's lengths.

Tip

If you remember from previous discussions, the full clip's length is available at any time, and adjustable, on the Timeline and in the Library. The original clip is never destroyed. The length shown in the Timeline is what will actually play.

In this case, locking in the Ripple Editing feature is not important, since there are no other clips that will be affected by it.

15. In Overlay Track 1, replace placeholder 1 with the last video clip, Balloon-7. Do not adjust the duration. Notice how the video automatically conforms to the picture frame size. Play this section to preview it. See Figure 5.12.

16. As you did with the slideshow, change the text of both titles in the Title track to something more appropriate. I used "Balloon Festival" and "Safe Landings." Like last time, don't bother changing any of the text formatting,

Placing this clip... ...displays it here.

Figure 5.12
Video in a picture frame.

but feel free to reposition the text inside the thin white square. Your Timeline should look similar to that shown in Figure 5.13. Be sure to save your project.

17. As before, export your movie as WMV > WMV HD 720 30p (the Share step). Preview it in WinDVD or a similar playback application.

Figure 5.13
Instant video Timeline.

Reusing Your Custom Instant Project

A GREAT BENEFIT OF combining VSX4's Instant Project with its clip replacement (as opposed to hip replacement) capabilities is the ability to save and re-use your Instant Projects along with the adjustments you made with them. It's especially helpful if you've added customization, such as your own music track, transitions, text formats, and perhaps additional video effects.

You can import any project you create into the Instant Project template list, specifically into the Custom category, where it can be re-used as easily as using a new one. This can be helpful for business use when you need to create consistently designed videos for marketing or training.

The following steps will show how to convert any existing project into an Instant Project that you access from the Instant Project template list and reuse again and again.

1. Make sure the My Instant Video project you just created is open.

2. Go to File > Export as Template.

When you click on Export as Template, a message appears asking if you would like to save the current project. You must click Yes to proceed.

3. In the Export Project as Template dialog box, use the slider to select a frame in your movie that will be used as a thumbnail preview for the template list. I suggest selecting a frame that shows the design of the template, rather than the content itself. See Figure 5.14.

Figure 5.14
Exporting a project template.

4. Under Template Path, click the small button on the far right and browse to the destination where you want to save your templates. Choose a place where you're not likely to move it.

5. Name your template and click OK. You will see the Project Successfully Exported as a Template dialog box. Click OK again.

6. Go to File > New Project to create an empty timeline for your new template project.

7. To add your new project to the Instant Project template list, click the Instant Project icon again in the Timeline. Click the Import a Project Template icon to the right of the Select a Project drop-down list. See Figure 5.15.

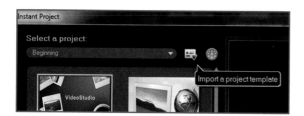

Figure 5.15
Exporting a project template.

8. Locate and open the template you just exported. You will need to open the folder of the same name of the file you saved and double-click the file inside of it. The Custom list will open and show your new instant project template. A preview of it will automatically begin on the right.

9. To delete a custom Instant Project template, right-click on the thumbnail on the left and choose Delete. You can only delete custom templates this way.

10. Click Insert to add it to a project. Fit the project to Timeline view.

So, creating a custom Instant Project is really like just saving a normal project. It looks exactly the same as the video project you just created with all its content, custom adjustments, and so on. Instead though, you save it inside the Instant Project area for organizational purposes.

Quick Review

▶ Name a few of the various kinds of template layouts available in the Instant project template list. (See "Setting up an Instant Project.")

▶ How can you change the name of a clip in the library without affecting the clips original file name? (See "Creating a Custom Slideshow with an Instant Project.")

▶ What's the downside of importing a clip directly into the timeline? (See "Creating a Custom Slideshow with an Instant Project.")

▶ What shortcut key do you hold down to drop and replace an existing clip in the timeline? (See "Creating a Custom Slideshow with an Instant Project.")

Making Some Noise
with Audio

PRIOR TO THE 1920S, silent films were almost always produced with subtitles, the universal "language" of silent films. Today, in foreign films, subtitles are present along with the regular audio. But back then, subtitles were the only choice. All that changed in 1927 with the release of the first part-talkie movie *The Jazz Singer*, followed in 1928 with the first all-talking feature *Lights of New York*. Now the "silent" part could be replaced with spoken dialogue and the ability to convey emotions and excitement. This was huge!

Audio is an important part of any video project. It adds personality and customization through music, narration, and sound effects. VSX4 allows you to have multiple audio tracks, which then lets you utilize audio from files included in VSX4, from your own collections, CDs, voice-overs recorded directly in VSX4, and music and sound effects from the included and customizable Quicktracks by SmartSounds.

VSX4 contains four fairly interchangeable music and narration tracks. Audio clips can be shortened, stretched, level-adjusted and surround-sounded. Other adjustments include playback speed, peak levels, tempo, noise reduction, and much more. With the customizable Quicktracks, you can even turn specific instruments on and off to set varying moods. A most excellent, newer feature in VSX4 is the ability to take advantage of Dolby audio techniques, including multi-track surround sound.

In this chapter, you'll learn almost all of these audio adjustments. For ones that I don't specifically cover, you'll at least know where they are so you can try them on your own. You'll learn how to manage the various audio tracks, add and edit audio from a variety of sources, separate audio from its video counterpart, create stereo from a mono audio clip, and even share an audio-only piece from your video project.

These lessons are all about sound, so you'll need an audio CD for this chapter. Grab one of your favorite music.

Managing Audio Tracks

IN VSX4, YOU MANAGE audio tracks the same way as Video and Title tracks, by using the Track Manager to select which ones to display and activate. The following steps will show you how to set up your Timeline in preparation for adding and editing audio.

1. If you're not there already, launch VSX4.

2. As you've done before, open the Track Manager from the icon in the upper left of the Timeline area.

3. Check Music tracks 2 and 3 to turn them on, so to speak. You should now have all four possible audio tracks selected. Click OK.

4. Click Show All Visible Tracks. This will give equal viewing area to all your Timeline tracks, instead of emphasizing just the Video tracks. If you see all the Timeline tracks, click the icon again, as it's a toggle

switch. Your Timeline should look like what's shown in Figure 6.1. It will also help to expand the Timeline panel vertically by stretching the window upward.

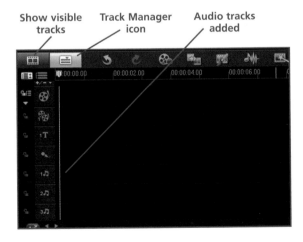

Figure 6.1
Timeline view showing all audio tracks.

Adding Audio

ALTHOUGH ADDING, IMPORTING, and creating audio in VSX4 has many similar characteristics to adding and using other media file types. However, the various sources and techniques do have differences that you need to be aware of. This section will cover choosing audio files from the included VSX4 audio samples, acquiring files from your computer, an audio CD, recording audio directly into a video clip, and splitting and using an audio clip separately from a video clip. A lot of different techniques, but all are easy to pull off.

Accessing the Audio Gallery

Just like the rest of the media libraries, the Audio gallery in VSX4 already includes a nice selection of pre-installed, royalty-free music and sound effects samples. Sample music clips start with the letter "M," and sample sound effects start with the letter "S." Did you catch the hi-tech reasoning there? You add them to the Timeline just as you would any other media clip, except they would be added to one of the four audio tracks.

> In previous versions of VideoStudio, the Audio library had a dedicated place in the Library Navigation panel (between the Preview and Library panels). Now it is the Audio gallery and is included in and accessed as part of the main Media library, along with videos and photos.

These steps will show you how to access the Audio gallery in VSX4.

1. In the Library Navigation panel, select the Media icon at the top.

2. Just to the right of the Media icon, select the Samples category.

3. Click Show Audio Files to make your Audio gallery visible. When it is yellow it is in the On position. If the audio files disappeared, the switch was off. Click it again. See Figure 6.2.

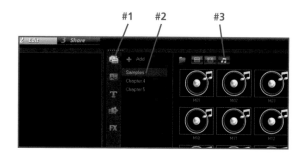

Figure 6.2
Accessing the Audio library.

4. Select a few of the clips and preview them without adding any to the Timeline just yet. Unfortunately, the clip names are not descriptive of their content. You'll get the opportunity to use some of these later in the chapter.

Adding Audio Content from Your PC

Let's review this process of acquiring audio from your PC, even though it's almost identical to adding other media files you've imported. As usual though, there's more than one way to do this.

1. Go to File > Insert Media File to Timeline > Insert Audio > To Music Track #1. (See Figure 6.3.) The clip you select will be added with its start point where the playback head is, so make sure your project is at 00:00:00:00.

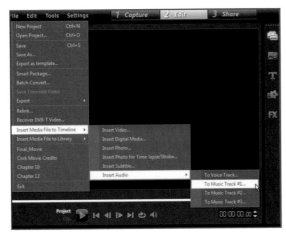

Figure 6.3
Adding audio directly into the Timeline.

2. In the Import dialog box, click on the Files of Type drop-down list and view the multitudes of audio formats that VSX4 will work with.
 Navigate to the Music folder of your lessons, select the clip called Hawaiian Music, and click Open. The music file will be inserted into Music Track 1. As you can see, the file goes into the Timeline, not into your Audio gallery. You can, though, drag it into your Audio gallery if you want, but instead, delete the clip in the Timeline.

3. Using the Library Navigation panel, create a custom library called Chapter 6.

4. Drag and drop the music clip directly into your new Chapter 6 library. It is now reusable for other projects. You could also have placed the music into the Audio gallery portion of the Media library.

> You can also right-click inside *any* Timeline track and choose, Insert Audio > To Music Track 1.

Adding Audio from an Audio CD

What's nice about using music from your CD collection is that, unlike digital media purchased online, CDs are rarely copy-protected, and the music can be easily "ripped" for use in your VideoStudio projects.

In VSX4, importing a clip from an audio CD is exactly same as importing any other media file.

1. Make sure your newly created Chapter 6 library is displayed and audio files are visible by clicking the Show/Hide Audio Files icon at the top. Insert any audio CD you like into your CD/DVD tray.

> You may have to close any dialog boxes or CD players that auto-launched on your computer before moving to Step 2.

2. In the Audio library, click the Import Media Files icon at the top, next to the Show/Hide icons. The Browse Media Files dialog box will appear. Locate and open the CD that's in your CD/DVD drive. See Figure 6.4.

Preview **Select**

Figure 6.5
Previewing tracks in the Browse Media Files dialog box.

Figure 6.4
Opening your audio CD.

3. Although the tracks may not be named by their song title, this import method allows you to select any track and preview it first in this dialog box, before you import it (see Figure 6.5). This play to preview feature is not available using the Browse method at the bottom of the Library panel. Find at least one song (or several using Shift- or Ctrl-select) you want to rip from your CD, and click Open to place them into your Chapter 6 library.

In the previous version of VideoStudio, audio clips were placed in both the Library and the Timeline. Thankfully, the new method only imports clips into the Library.

Adding Voice-Over Narration

All is not lost if you forgot to add some appropriate (or inappropriate) commentary into your video while you were shooting it. In VSX4, you can add narration anywhere in your project afterward. The best part is that recording it separately means it will go into a separate track from the video where you can edit it, or even delete it and try again.

There are several things to consider before record-ing directly into VSX4.

▶ Turn off the TV and eliminate any outside/background noise, if possible.

▶ Use the recording level meter in the Adjust Volume level window to test and adjust the volume of your voice.

▶ Will you just be using the built-in micro-phone on your laptop? If so, get as close to it as possible, but don't yell into it. Talk normally.

▶ Do you have an external microphone or a headset with a recording arm that you can connect to your PC? If so, use it, and again, first test the recording levels.

▶ Recording levels can first be adjusted to get within the correct range via your PC's Control Panel. Operating systems may vary, but go to the Control Panel > Sound > Recording, and select the recording device you are using. Recording levels should be adjustable there.

Tip

You can also separate existing audio from a video. I'll show you how this is done later in the chapter.

Following are the steps to record your voice as a narration directly into a video project.

1. Click the icon in the library to Show Videos. From the Chapter 4 library you created, insert Fireworks2 into the main Video track starting at the beginning.

2. Move the playback head in the Timeline to around the 5-second mark. Click the Record/Capture Option button in the Timeline toolbar (see Figure 6.6). In the pop-up window, click the Voice-over icon in the upper right.

Figure 6.6
Record a voice-over.

3. The Adjust Volume dialog box is simple. Use it first to test the recording level by speaking normally into your recording device while watching the bars spread out from the mid-dle. If the bars get farther than halfway and start turning red, the level is too high. (See the preceding list for tips.)

4. Click Start and record a short 3- or 4-second introduction to the fireworks show, such as, "Welcome to the fireworks show from the steps of the Lincoln Memorial!"

5. To stop recording, press the Esc key or the spacebar. You're welcome to try a couple times until you get it right. I did. Use Ctrl+Y to undo each one you don't like.

6. Your recording is automatically placed in the Voice track of the Timeline. Rewind, select Clip, and play the selection to preview.

7. If you don't like it, click the undo icon in the Timeline and try the steps again. If you do like it, preview it again, but with Project selected in the Preview panel to test the combination of your voice and the fireworks. (There is a really good chance that the fireworks clip has drowned out your narration. Don't worry, you will fix this later in the chapter.)

8. Drag the new audio clip into your Chapter 6 library to use later. Select the label under the thumbnail, and rename it **Fireworks voice-over**.

9. Save your project as Chapter 6.

Adding Audio Using Auto Music

Corel has partnered with the audio technology and content company SmartSound to include a collection of royalty-free music clips using their product called Quicktracks. There are several great features in Quicktracks. First, any clip can automatically trim, or even extend, to your project's length in a natural, realistic manner. Second, these clips can be edited for style, tempo, genre, and more. Some even allow you to choose which instruments in the clip you want to play, setting the mood, so to speak. These features are collectively referred to in VSX4 as the Auto Music.

In this section, you'll select and add some Auto Music clips, but you'll actually edit them a little later in the chapter.

Click the Auto Music icon in the Timeline (see Figure 6.7). The Auto Music panel pops up over the library. There seems to be a lot going on here as far as choices go, so let me explain them. The five drop-down lists allow you to choose different audio clips and then variations thereof. They are separated in a hierarchical fashion: Scope > Filter > Subfilter > Music > Variation.

Figure 6.7
Accessing Auto Music.

Let's start with a look at the Scope drop-down list. (For the purposes of this discussion, make sure to keep Owned Titles selected, as choosing another option will affect the appearance of the other lists.)

Feel free to click Play Selected Music at any time to preview an Auto Music clip.

▶ **Owned Titles** include all the Quicktrack audio clips that were included with your copy of VSX4.

▶ **SmartSound Store** allows you to preview clips from the company SmartSounds, then purchase and install them right into this panel.

▶ **Music Multi-layer** displays clips that will allow you to toggle different instruments on and off to set various musical moods. Clips with this ability in the Music drop-down list are designated by asterisks.

▶ **Music Single-layer** are clips without the instrument editing ability.

▶ **Sound Effects** are functionally self-explanatory. These need to be purchased separately, though, from the sample SmartSounds that come included with VSX4.

Options in the Filter list let you isolate clips by Album, Composer, Instrument, Intensity, Keyword, Release Date, Style, or Tempo. Setting the Filter choice will alter what's available in the Subfilter, Music, and Variation lists. Leave the choice at Style for now.

The Subfilter list lets you narrow down the Filter choices and will affect what options are available in Music and Variation. Options in the Music list result from your choices in the previous filtering lists, and those choices affect what's available in the Variation list. The options in the Variation list depend on your choice in the Music list.

The following steps will show you how to choose and apply a SmartSound.

1. Click the Auto Trim check box to make the audio clip fade out naturally at the end, no matter what length you make it. This is one of the key benefits of using Quicktracks.

2. Select the clip, Scope > Owned Titles, Filter > Intensity, Subfilter > All –5 Intensity(s), Music > The Great Escape, and Variation > Persevere (as shown in Figure 6.8).

Figure 6.8
Add this variation of the Great Escape clip.

3. Rewind your project. Fit your project to Timeline view.

4. Click Add to Timeline from the Auto Music options panel. It will add this clip to Music track 1. You'll notice that the audio clip is the exact same length as the project's length. The Auto Trim check box is the reason for this. Play it to preview. You may notice the music is difficult to hear over the fireworks. You'll fix this in the "Clip Volume Control" section later in the chapter.

5. Save your project.

CAUTION

Quicktrack clips can only be added to Music track #1. If you want to use more than one Quicktrack clip, move the first clip to another audio track, leaving the first track available for a new Quicktrack to be added.

Splitting Audio from a Video Clip

Splitting (or separating) the audio portion from a video clip allows you to either delete it (thus muting your video and shrinking the file size), or edit the audio by adjusting volume levels or adding filters and effects separately from the video clip it came from. You can also shift the location of the audio clip along any of the audio tracks, in essence, making the audio start before the video starts or have it end after the video ends. (This is explained further in the Tip on J and L cuts on this page.)

Although it may not make sense, any audio split from a video can *only* go into the Voice track, not a Music track. I think, technically, it's because it happens to be the first audio track under the Video tracks. You can move it afterward to another track. Because of this, the Voice track needs to be clear to perform this video/audio split operation. Therefore, you might need to move whatever is in the Voice track down to another audio track, before splitting a video's audio portion in order to make room.

The following steps will guide you through the process of splitting the audio portion from a video clip.

1. In the Timeline, move the voice-over clip (not the music clip) straight down to a lower, empty Music track. Make sure you move the voice clip straight down to keep it in the same time location.

2. Double-click the Fireworks2 video clip in the Timeline to bring up the video Options panel.

3. Choose Split Audio. The audio track of the Fireworks2 video clip will now be in the Voice track of your Timeline. See Figure 6.9.

4. Save your project.

Tip

Special effects can be performed by applying what the industry calls *J and L cuts*. These are adjustments that separate the audio portion of a clip so that it can be shifted either to the left or to the right on the Timeline, independently of the video clip. (You'll often experience this when watching a movie or TV show, hearing a waterfall or a car revving, for example, before it actually appears on screen.)

The shapes of the letters J and L represent the shape of the video vs. the audio portion at the beginning and end of the clip in the Timeline. The J represents the audio that starts before the video, and the L represents the audio that extends beyond the end of the video clip. It depends on which way you move the audio in relation to the video along the Timeline.

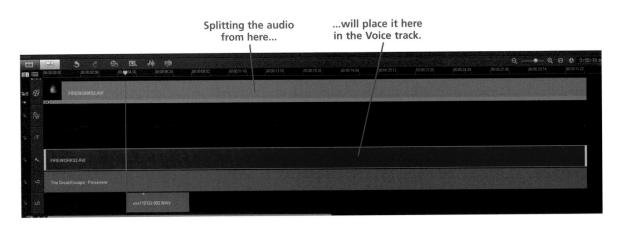

Splitting the audio from here...

...will place it here in the Voice track.

Figure 6.9
Timeline view of a split audio clip.

Editing Audio in the Main Timeline View

SOME AUDIO EDITING IS accomplished in the Music & Voice panel. These include volume adjustments, setting a fade in/fade out, and applying audio filters. I'll explore the first two here. Audio filters will be covered later in the chapter.

Adjusting Clip Volumes

Adjusting audio clip volume levels lets you set the volume of individual audio clips, improving the mix of your multiple audio, video clips, and overall project volume levels. This can be useful if, say, the fireworks are too loud and don't allow you to add a voice-over or music track.

These steps will show you how to manually adjust the overall volume level of an audio clip.

1. Double-click the audio clip in the Voice track that was split from Fireworks2 to bring up the Music & Video panel.

2. Open the volume control meter by clicking the down arrow to the left of the Fade-In icon (see Figure 6.10). Decrease the level to about 50%. You can either type in the amount or lower the vertical slider. Click outside the field to set the value.

3. Repeat Step 2, but instead increase the volume of the Quicktrack music clip to 200%. This will put the fireworks and music on a much better mix where you can hear almost equal values of each. Do not change the volume of your voice-over yet.

Double-clicking a Quicktrack in an audio track will display the Auto Music options instead of the Music & Voice panel, but they both will have a volume control meter.

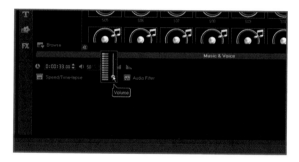

Figure 6.10
Accessing the Volume meter.

4. Play at least part of your project to preview the new audio settings. Save your project.

Tip

You can bypass the Volume meter and type a specific numeric value into the field next to the meter. The benefit of using the meter, though, is the peak level feedback you get if you go too high. The field will go from green to yellow to red as levels increase.

Trimming Audio

Trimming audio is done in the same way as trimming video. The following steps, although you won't apply them to the project, will show the various methods for trimming audio clips in the Timeline.

1. Fit your project to the Timeline view.

2. Grab the *end* of any audio clip and shorten it by dragging to the left (see Figure 6.11). Undo.

3. Grab the *start* of any audio clip and shorten it by dragging to the right. Undo.

4. Double-click The Great Escape music clip to bring up the Auto Music options. In the timecode (above the Scope drop down), highlight the number 33. Type in 15 to shorten the clip's time to 15 seconds. Tap your Enter key to lock it in. As you can see, there are many similarities between trimming audio and trimming video. But there are still other ways to adjust the length of an audio clip.

Figure 6.11
Shortening an audio clip.

Stretching Audio Clips

Wait, what? You can stretch an audio clip? Actually in VSX4, you can! Adjusting audio playback length might be necessary or desirable when wanting to match it to the length of a video clip. Logic says you shouldn't be able to, but there are two ways to do this:

▶ Use a Quicktrack. These "smart" sound clips are designed to end fluidly, no matter what the length.

▶ Adjusting playback speed between 50% to 150% will change the length without noticeable changes in pitch. It will instead play a clip at a slower tempo, which will still sound (mostly) natural.

> **CAUTION**
>
> You cannot adjust the playback speed of a Quicktrack clip.

These steps will show you how to stretch certain audio clips.

1. Double-click the Fireworks audio clip in the Timeline. In the Music & Voice panel, reduce the volume of the clip to 0 (mute) so it won't interfere with the next steps.

2. Fit project to Timeline view. Play the last few seconds of the project, and notice how the Music track fades out naturally.

3. Double-click The Great Escape music clip in the Timeline. Shorten its length to 15 seconds. This will cut the length by about half. Play the last few seconds of the music clip to notice that it *still* fades out naturally, even though it's been shortened.

4. In the Timeline, drag-stretch The Great Escape audio clip out to the end of the project. Play the last part of the project again. Notice how, again, it fades out naturally. This is one of the beauties of Quicktracks.

5. Mute the music track, as you did the Fireworks audio in Step 1.

6. Double-click the voice-over clip in the Timeline you created.

7. Select Speed/Time-lapse. Time-lapse does not come into play with audio tracks, but playback speed does. These two features just happen to be bundled together. Change the Speed setting to 150%. (See Figure 6.12.) Click the Preview button.
 Notice that although its tempo is faster because of the increased playback speed, the pitch remains the same, in other words, no chipmunks! You can alter playback speed from 50% to 200% without noticing any pitch change.
 Change the speed setting to 50%, and preview it again. That should lull you to sleep!

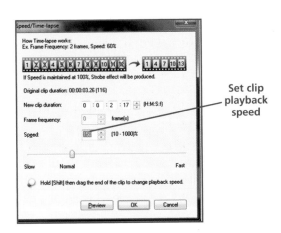

Set clip playback speed

Figure 6.12
Adjusting a clip's speed.

8. Click Cancel to return the Speed setting to 100% and leave the Speed /Time-lapse window. Play the voice-over again to make sure it plays normally.

9. Return Fireworks audio level back to 50%, and the Music track audio level back to 200%.

10. Save your project.

Adjusting Audio Fade In/Fade Out

Background music that starts and ends gradually is commonly used to create smooth transitions between clips, the same way that video clips oftentimes fade out and the next one fades in to eliminate abruptness. Since the Quicktrack we added has this effect built-in, we'll apply a fade on the Fireworks audio instead.

Simple audio fades are easy using the Music & Voice panel. More complex fades can be done in the Sound Mixer. You'll play with the Sound Mixer a little later in the chapter.

1. Double-click the Fireworks audio clip to bring up the Music & Voice panel.

2. In the Music & Voice panel, click both the Fade-In and Fade-Out icons (see Figure 6.13). Preview the start and end portions of your project. It might be a little tough to notice any differences, since it's rather quick, but preview it anyway. I'll show you where the actual settings take place and how to adjust them shortly.

Figure 6.13
Fade-In and Fade-Out controls.

Setting the Mood in Quicktracks

Quicktracks not only contain the ability to auto-fit audio clips to any length, but some of the tracks are multi-layered, giving the ability to turn on and off different instruments (or layers) to control which ones play. You can control layers through specific instrument choices or preset mood settings.

If you've ever worked in a photo editing application that allows you to work with objects on different layers, this feature is similar to that. When you hide a layer in the photo application, certain objects will temporarily disappear in your photo or illustration. In the multi-layered Quicktracks, hiding a layer mutes an instrument or group of instruments.

1. Return to the Auto Music options by double-clicking on The Great Escape music clip in the Timeline.

2. Choose Scope > Music Multi-layer. In the Music list, your choices are now narrowed down to those with asterisks in front of them. These are the customizable, multi-layered choices available to you.

3. In the Filter list, choose Composer. Open the Subfilter list. Do you know any of these people? Me neither. Go back and choose Filter > Style instead.

4. Choose Subfilter > Orchestral, Music > Feature Presentation, Variation > Majesty. Click the Play Selected Music button in the panel to preview. Ah, so soothing!

5. Select the Set Mood icon.

6. Move the Strings slider to the left to turn them all the way down. Click the Play button in the dialog box to preview the change (see Figure 6.14). You can play around with the other instrument settings, then click the Play button to see how different levels change the sound and the mood.

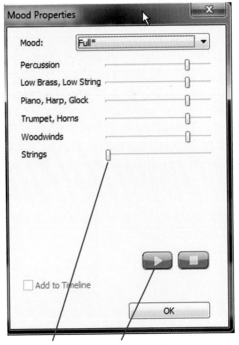

Adjust this... ...then preview.

Figure 6.14
Setting the mood.

Now let's experiment with different settings.

1. Return the Strings to the previous setting in line with the other instrument levels. Turn Trumpet, Horns all the way down. Preview again. Nice, huh? And easy, too! Click OK.

2. Delete the music in Music Track 1 (not the Fireworks audio!) to make room for a different Auto Music track. Rewind your project to the beginning.

3. The Auto Music panel should still be open. If it is not, click the Auto Music icon in the Timeline toolbar to re-open to it. Choose the following settings in the Auto Music panel: Scope > Music Multi-layer, Filter > Instrument, Subfilter > All-12 Instruments, Music > Clear Vision, Variation > Soar. In the Mood Properties dialog, choose Drums & Bass from the Mood drop-down list at the top. Preview it, then click OK.

4. In the Auto Music panel, click Add to Timeline. Increase the Volume level to 200% so it can be heard above the noise of the fireworks.

5. Save your project.

Editing Audio in the Sound Mixer

THE MUSIC & VOICE PANEL contains a selection of basic audio clip editing features, which are oftentimes sufficient, as long as the edit pertains to the entire clip. What if you want to make more precise adjustments? How about multi-point adjustments? This is where the Sound Mixer comes in handy. The Sound Mixer allows for more precise control, including editing volumes at multiple points along the timeline, as well as stereo and surround sound effects.

The Volume level on regular audio clips (as opposed to Quicktracks) in VSX4 is handled by adjusting the height of a horizontal line that runs the length of the clip in the Timeline. You can place a "pin" anywhere along that line to lock the volume in place, while still allowing for adjustments all around it. Move the line up to increase the volume or down to decrease it. Moving the line gradually down to zero at the end creates the fade-out effect you're now familiar with. Increasing it at the beginning creates a fade-in.

This is also where you can create stereo audio by designating which channel plays individual audio tracks. An advanced Dolby 5.1 Surround Sound feature even allows an audio track to "swim" between two or more channels at your discretion.

These steps will show you how to add precision volume adjustments to audio clips.

1. Click the Sound Mixer icon in the Timeline toolbar to go to the Audio view. (See Figure 6.15.) Audio in all the tracks is represented by a straight horizontal line. This indicates that volume levels are at 100%. In the actual audio tracks, you'll see both the horizontal volume indicator line and actual audio waveforms below that. Audio waveforms designate very precise audio levels at any point in time. The wider the vertical reach, the louder the audio. (See Figure 6.16)

Figure 6.15
Accessing the Sound Mixer area.

Timeline audio
waveform indicator

Audio volume/fade
controls

Timeline audio
volume indicator

Figure 6.16
Timeline Audio view.

2. Click Show All Visible Tracks to expand the Track view. Select the Fireworks audio clip in the Timeline to display the audio options.

3. Select the Attribute tab in the Options panel. In the Attribute tab, you can see that clip volume control and Fade-In/Fade-Out controls are located here, too.

4. See the horizontal lines running down the middle of all the clips? A highlighted clip's horizontal line will be pink. Clips that are not highlighted will be a pale yellow/green.

These lines indicate volume levels. A line down the middle indicates a volume level of 100%. A higher line indicates a volume level above 100%. A lower line, a level below 100%. These lines are often referred to as *rubber bands* because of the rather elastic properties they contain.

In the selected Fireworks audio clip, look at the pink rubber band part on the far left. It's upward path from the bottom indicates the volume's gradual fade-in. In the Attribute panel, click the Fade-In control to turn it off and notice the visual change.

The point where the volume changes direction is called a *keyframe*. Keyframes can be added very easily, and you'll be applying them here and in other locations in your projects going forward.

Keyframes can also be used to indicate other changes, such as for animations. In this audio rubberband situation, they work like pins to hold the line in place while level changes can occur on either side of it.

5. On the far right, where the fade-out begins, drag the second to last keyframe "pin" and move it straight left to make the fade-out more gradual and longer time-wise (see Figure 6.17). The exact location need not match the screenshot. Make sure the rest of the rubber band remains level by gently adjusting the pins up or down.

Keyframe

Figure 6.17
Adjusting a fade effect.

Using a combination of the zoom buttons and the bottom scroll bar, zoom into the portion of the Timeline that shows the voice-over clip. Let's lower the Music track's volume where it coincides with the voice-over so that you can hear the voice-over a bit better. Select Music track 1. As opposed to previous methods that laid down volume level keyframes (pins) automatically, in the following step, you'll add these keyframes manually. (You should read through the steps before proceeding.)

1. Using Figure 6.18 as a guide, in the Music track, click once to place a keyframe at both the start and end of where the voice-over below it starts and ends. Your cursor will turn into an up arrow when it's over the right spot.

2. Place another keyframe just before the first keyframe and just after the second one you just placed.

3. Move the two center keyframes down as far as they will go. (Do not drag down too far, or you will drag the keyframe off the track and delete it. If this happens, click again on the rubberband to replace it.) You have just caused the music to gradually and temporarily mute while you speak, then raise back up to 100% afterward.

4. Preview your changes and save your project.

Figure 6.18
Adjusting volume levels with keyframes.

Duplicating an Audio Channel

Audio files sometimes separate the vocals from the background or music and put them in different channels (stereo). The Duplicate Audio Channel feature in VSX4 allows you to create a stereo effect from two mono clips. Instead of having two audio clips play in both channels, you can make each play in a separate channel. Unfortunately, it's not as easy as just telling which channel you want an audio clip to play from (right or left). Although not that difficult, you need to use the special Duplicate Audio Channel feature.

First, you'll duplicate an audio clip so it plays in two tracks at the same time. Next, tell each one to only play from one channel (left or right). Then mute one of the tracks so only one of the channels plays (left or right). Do the opposite to another audio clip playing at the same time so it plays out of the other channel, and you'll create stereo audio, with one clip playing out of one speaker and the other clip playing from the other speaker.

Confused? Let's try it and see if we can eliminate that confusion.

1. While still in the Sound Mixer panel, select the music clip in Music track 1. In the Attribute tab, check Duplicate Audio Channel and select the Left radio button (see Figure 6.19).

Figure 6.19
Duplicating an audio channel.

2. Now select the Fireworks audio clip in the Voice track. Repeat step 1, except this time choose the Right radio button. If you play your movie in a stereo environment, the music will now play from the left speaker and the fireworks from the right.

3. Save your project.

Now wasn't that easy? I think it was quicker to do it than it was to explain it! But, you get the idea now? Good, let's move on.

Creating Stereo from Two Mono Tracks

Not only can you separate and isolate an entire track into one channel, but with the Surround Sound Mixer tab, you can alter the adjustments over time, interactively and in real time, to create an effect of audio repeatedly traveling from one speaker to another. Let's try this feature and others in the Surround Sound Mixer tab.

1. Still in the options panel, select the Surround Sound Mixer (SSM) tab next to the Attribute tab.

2. Rewind your project and select the Fireworks audio clip. The Voice track will now be highlighted in the SSM tab (see Figure 6.20). Play your project (as opposed to a clip) and watch the three VU meters (VU stands for Volume Units) indicate the volume changes in Music track 1 when playback gets to the voice-over clip. This resulted from the volume level changes you made earlier.

Voice track VU meters

Figure 6.20
Surround Sound Mixer tab.

3. With the playback head somewhere other than over the voice-over, move the Volume slider (left-most VU meter) in the SSM panel up or down (see Figure 6.21). When you do so, notice the keyframe that's created and placed according to your Volume setting.

Move this... ...to adjust this.

Figure 6.21
Adding audio keyframe using volume adjustment.

4. Undo (Ctrl+Z) until the new keyframe disappears. I just wanted you to be aware of the other level adjustment method.

5. Open the Settings menu at the top of your screen. Make sure Enable 5.1 Sound is disabled (*not* checked). This will add additional audio playback options beyond stereo.

Rewind your project, and select the Fireworks audio clip. You're now going to make the audio in this track move back and forth between the right and left channels, in real time, while it actually plays. To do this, you'll be moving the big red dot in the middle of the speaker "room" on the Surround Sound Mixer tab (see Figure 6.22). Be sure to read through these steps in their entirety first. Also, make sure that Project is selected (this won't work with Clip). Don't worry that your Fireworks audio clip is no longer selected in the Timeline. It is still selected in the SSM panel.

Tip

A red dot in the Surround Sound room indicates the Voice track is selected. If it's blue, a Music track is selected.

Select this... ...to move this dot.

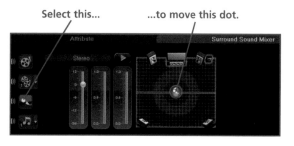

Figure 6.22
Real-time stereo adjustment.

1. Place your cursor over the red dot in the SSM tab. Press the spacebar to play your project. While your project plays, slowly move the red dot back and forth. Do this for the entire clip. Do it slowly. You might actually be able to hear the audio move between your speakers as you perform this operation.

2. Click the spacebar at any time to stop the process, or you can let it go until the end.

3. When finished, the track's rubber band will be littered with keyframes (as shown in Figure 6.23), indicating changes in channel playback location. Rewind and play your project to preview it. You should hear the audio move from left to right to left, and so on. You will also see the stereo indicator move back and forth when you preview it.

Figure 6.23
Surround sound audio adjustment.

4. Undo once with Ctrl+Z and save your project. The next section will expand on this SSM feature in a more advanced way.

Tip

Luckily, choosing Undo will undo this entire process, instead of just removing one keyframe at a time.

Using 5.1 Surround Sound

VSX4 and the Dolby 5.1 Surround Sound feature take audio channel mixing to a whole new, higher level. It works similarly to the real-time stereo mixing you did in the last section, but instead, allows for interactive audio mixing of up to six separate channels. Of course, you will need to have an actual surround sound system set up in order to take full advantage of this feature. At least you can still go through the motions of how it's done and save it for surround sound playback.

1. Go to the Settings menu and select Enable 5.1 Surround. Click OK to the message box.

2. Select Music track 1 in the Timeline, which is the Quicktracks clip. In the SSM tab, the bottom-left Music icon will be selected no matter which of the three available Music tracks are chosen. It represents all of them. You can select a different Music track though by clicking the down arrow to the right of the Music icon (see Figure 6.24). Keep it at Music track 1.

Figure 6.24
Selecting a different Music track.

3. Instead of just adjusting stereo channels by moving the indicator back and forth, you'll now adjust center speakers and sub-woofers of your surround sound system by moving the indicator *all* around the "room." Mouse over the two VU meters to the left of the Surround Sound room to see an indication of what each one adjusts (see Figure 6.25). These two extra VU meters adjust the extra speakers in a surround sound system.

Center speakers VU meter Sub-woofer VU meter Dolby 5.1 Surround Sound room

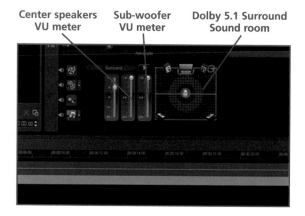

Figure 6.25
Surround Sound adjustments.

4. As you did in the "Stereo Adjustments" section, make sure that Project (not Clip) is selected. Place your cursor over the blue dot in the center of the Surround Sound Mixer room and press the spacebar to play your project. This time, though, move the blue dot in a circular motion around the room.

5. Continue until the project is finished playing. Rewind and play to preview, noticing how the blue dot now moves around the room, simulating true surround sound!

6. Leave the Surround Sound Mixer panel by clicking on the Sound Mixer icon in the Timeline toolbar and return to the Timeline view.

7. Save your project.

Applying Audio Filters

AUDIO FILTERS IN VSX4, although perhaps not nearly as fun to apply and view as video filters, still provide important tools for audio repairs and some special effects. Audio repairs can come in very handy for both casually fun videos and business presentations. Less than optimal quality video may not be a project killer, but poor audio can be. Pops, clicks, hisses, and hums can be annoying and irritating to your listeners.

Many of the audio filters in VSX4 have options for customization. Many of the filters are provided by NewBlue, a third-party software provider who develops add-on tools for medium and high-end video production. Having them included in VSX4 for audio and video effects at no additional charge is a major bonus for you.

Following are some steps to try a few of the Corel and NewBlue audio filters.

1. Open the Options panel for the Fireworks audio clip by double-clicking it in the Timeline. In the Music & Voice panel, click the Audio Filter icon. (See Figure 6.26.) The Audio Filter dialog box will open.

2. Select Echo in the Audio Filters area, and click Options. Under the Defined Echo Effects drop-down list, choose Long Repeat. Click the Play button in the Echo dialog box to preview. Scary, huh? Repeat and preview with the Stadium choice. Click Cancel twice to close the dialog boxes. (See Figure 6.27.)

Figure 6.26
Select the Audio Filter option.

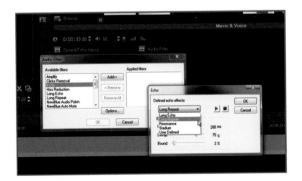

Figure 6.27
Setting the Echo audio filter.

3. Select and play just your voice-over clip in the Timeline. It could use some polishing, but let's have some fun with it first. With it still selected, open the Audio Filter dialog box again. Choose Pitch Shift and then Options. Crank it to one end and preview. Repeat with the other end of the spectrum. Remember how adjusting the speed of this clip previously did not change the pitch one way or the other? With this audio filter, you can change the pitch. Click Cancel.

4. Select NewBlue Audio Polish and click Options. Click the question mark (?) to bring up helpful instructions on how to use it and what it affects. You can repeat this with each of the NewBlue audio filters to quickly learn more about what to recognize in an audio file that the NewBlue (and the VSX4 filters for that matter) can reduce or completely fix for you. Close this help window.

5. Back in the NewBlue Audio Polish window, click the P next to the question mark to view and try the selected presets for this filter, previewing each in the same window.

6. Find a setting to your liking and click OK. Click Add to add this filter to the list on the right. Click OK to close the window and apply the effect.

7. Save your project.

> **CAUTION**
>
> You cannot add filters to Quicktracks audio.

Exporting Audio-Only Files

PERHAPS YOU HAVE A VIDEO recording of an important lecture, or you mixed some great audio pieces together in your video project and would like to save just the audio portions for a podcast or CD. Using the Create Sound File feature will allow you to isolate all the audio tracks as one and export them as a dedicated audio file.

1. Go to the Share tab at the top of the screen.

2. Select Create Sound File. Open the Save As Type drop-down list. Here you will see three options where you can save your output:

 ▶ **MPEG-4 Audio Files (.*mp4):** MPEG-4 is designed to deliver DVD-quality video at lower data rates and smaller file sizes. In this case, choosing this type will only apply the features to the audio portion.

 ▶ **Microsoft WAV files (*.wav):** Though a WAV file can hold compressed audio, the most common WAV format contains uncompressed audio in the linear pulse code modulation (LPCM) format.

 ▶ **Windows Media Audio (*.wma):** A proprietary technology that forms part of the Windows Media framework. Microsoft claims that audio encoded with WMA sounds better than MP3 at the same bit (sample) rate. Again, that's what Microsoft claims. . . .

3. Save your file as MPEG-4. Double-click the file in the place where you saved it to preview the results.

Quick Review

▶ What do multi-layered music clips in the Quicktracks collection allow you to do? (See "Setting the Mood in Quicktracks.")

▶ How do you make a mono audio track into a single-channel stereo track? (See "Duplicating an Audio Channel.")

▶ In the Sound Mixer view, what is the item called that when placed on the timeline, allows you to change the direction of an audio clip's volume? (See "Editing Audio in the Sound Mixer.")

▶ What feature allows you to create active stereo and multi-speaker arrangements? (See "Using 5.1 Surround Sound.")

Keeping It Unique with

Video Effects

Now that you've learned how to assemble video and audio clips and edit these assets, it's time to have a little fun with them. This chapter will cover how you can apply special effects that will give your projects a uniqueness all their own. You'll expand your knowledge on using special effects by adding transitions between clips and fading clips on entrance and exit, as well as adding the Pan & Zoom effect to photos.

Pan & Zoom allows you to better integrate photos into a project by giving them an animated look. You'll learn about video overlays, sometimes called Picture-In-Picture, and even chroma key effects like what the weatherman uses on TV when he points to the weather map. (He's not actually standing in front of the map, but standing in front of a large blue or green screen.)

Adding Transitions

I'VE ALREADY TOUCHED ON transitions somewhat. Transitions are used to, umm, transition from one clip to another, eliminating sharp scene breaks. Of course, you rarely see these effects in movies. Hollywood is more apt to use audio J cuts instead, where the audio for the next scene starts before the video does. But transitions are certainly acceptable and almost expected in home and business video projects. Transitions are an easy way to add effects to your movie. Their application can be made even easier by automating the process. Most of them are customizable, too!

Although you've added transitions in previous chapters, these steps will show you a few more methods and tweaks you can use when applying transitions.

1. Open the project you created in Chapter 4. Click Show All Visible Tracks so that the top two video tracks expand somewhat. If it does the opposite, click it again.

2. Move your Timeline to where all the short clips occur (see Figure 7.1). Feel free to zoom in a little to make them all fit the Timeline view.

3. Go to the Transition library (see Figure 7.2). Select All from the gallery drop-down list.

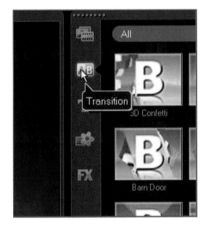

Figure 7.2
Accessing transitions.

Figure 7.1
Current Timeline view.

4. If it isn't already there, add the Crossfade transition to My Favorites. In the All gallery, select the Crossfade transition thumbnail. Transitions are generally in alphabetical order. You'll see a preview of it in the Preview panel. Click the Add to My Favorites button (see Figure 7.3). The Crossfade transition will now appear in the My Favorites list in the gallery drop-down list. Add the MaskE transition in the same way. Add two or three more transitions to My Favorites. You can also right-click on any transition and select Add to My Favorites.

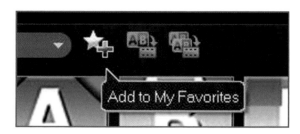

Figure 7.3
Adding a transition to My Favorites.

5. From the gallery drop-down list, go to your My Favorites list. Select the Crossfade transition. Just to the right of the Add to My Favorites icon, click the Apply Current Effect to Video Track icon. A tooltip will appear when you pause your mouse over it to indicate that you have the right icon selected. Your Timeline now has the Crossfade transition applied between each of the video clips. Feel free to preview a section of your Timeline.

Did you notice that your project became a little shorter? This occurs because the ends of your clips need to overlap just a bit so that one clip can blend in with the next one. In other words, it's necessary to see one clip fade out at the exact same time the next one is fading in, hence the necessity to overlap.

6. Select the very first transition in the main Video track, after the first text title. (You may need to zoom in a bit to see it better.) Delete it.

7. Play the section displayed in Figure 7.4 (around the 00:01:52:00 mark). Notice how the transition actually interferes with the natural flow between the two clips? It flickers. Select and delete the transition shown in Figure 7.4. Preview this section to see the new, smoother difference.

8. Save your project as Chapter 7A.

Figure 7.4
Delete selected transition.

Play the last part of the section of the Fireworks1 clip in the Video Overlay Track 1. Notice that it ends abruptly and overlaps with the next clip. Let's see if we can fix that, too.

1. Double-click the Fireworks1 clip in the Timeline to bring up the Options panel. Open the Edit panel and shorten the clip to 41 seconds.

2. Open the Graphic library from the Library Navigation panel by clicking the icon under the Title icon. Go to the Color gallery.

3. See the same color chip you used as a background in the Video track? Drag and drop the same colored chip into Overlay Track 1 at the end of the Fireworks1 clip. See Figure 7.5.

Add transition

Figure 7.6
The added transition.

4. Drop the Crossfade transition between the end of the Fireworks1 clip and the new color chip. The new color chip should now end at the exact same time as the one in the main Video track. See Figure 7.6. Play this portion to preview it. It should play a lot smoother now.

Add color chip

Figure 7.5
Adding a color chip.

Tip

Steps 2 and 3 were made easier because the default length is 3 seconds for color chips and 1 second for transitions. The length for each can be edited, of course.

Transitions can also be added automatically any time two clips are overlapped in the Timeline.

1. We need some more content for this section, so create a custom library called **Chapter 7**. Then import the videos Jewels1 through Jewels3 into the Chapter 7 library from the Videos > WashingtonDC folder.

2. Go to Settings > Preferences > Edit. Under Transition Effect, in the drop-down list, choose a default transition you like. I chose MaskE because it's also in My Favorites. Click OK. This will designate which transition is used in the next step.

You can also check Automatically Add Transition Effect, which will add a transition every time you place two clips just *next* to each other in the Timeline. However, this is not necessary for the current overlapping procedure. I keep this unchecked unless I have a specific project I need it for.

3. Making sure you only have Jewel1 selected in the Chapter 7 library (instead of all three), add it to the very end of your project into the background Video track. Zoom into the new clip. Add Jewel2, but do so while slightly overlapping on Jewel 1. Your overlap will determine the length of the transition effect. Refer to Figure 7.7 and the next tip. Try and create an overlap of 1 second. The MaskE transition will automatically be added between the two clips.

Figure 7.7
Auto-transitions when overlapping clips.

Tip

When you overlap the clips, an additional number will appear in parentheses next to your cursor. Each number represents a frame: for example, 01.08-00 means an overlap of 1 second and 8 frames.

4. Repeat the previous step with Jewel3 by overlapping it with Jewel2. Return to the Transition library. Highlight the MaskE transition in the My Favorites gallery to preview it. Notice how it performs. In the Timeline, double-click on the MaskE transition (zoom in if it'll help select it) you just auto-applied. The Options panel will open.

5. Click the Customize icon and change the selection in the Path drop-down list from Fly Right to Slither. (See Figure 7.8.) Click OK, then preview this change. Unfortunately, you cannot set this customization as the transition's default, nor add this customization to all the transitions at once.

6. Save your project.

Customize icon

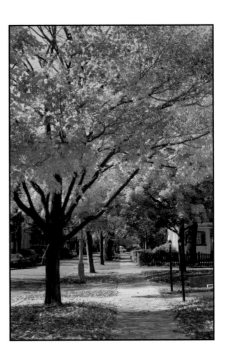

Figure 7.8
Customizing a transition.

Adding Overlays (Picture-In-Picture)

VIDEO OVERLAYS, COMMONLY called *picture-in-picture* or PiP in the TV world, are videos placed and played on top of other videos. These produce layers in a movie, much like an image editing application might create layers of images and objects for a unique effect. Where PiP implies a video taking over just one corner of the screen, video overlays don't have this restriction. Overlays can take over the entire screen and can even contain invisible parts that allow the background layer, or other overlay layers, to show through. (This latter effect is called *chroma key* and will be discussed in the section "Applying a Chroma Key Effect" later in this chapter.)

Overlays can be of any size, which may completely cover the background Video track. You can also do many of the same things to an overlay clip that you can to a background clip, including adding borders, effects, and filters. Unique features that you can apply to an overlay clip include such items as transparencies, masks (making only certain portions transparent), and animating the overlay around the screen. Let's try these.

In this section, you'll add overlay objects and learn how to integrate them into a scene.

1. Go to File > New Project. This time you'll be using some nice HD clips. Make sure your Chapter 7 library is selected and all three Show Media icons at the top are active (yellow).

2. Click the Import Media Files icon at the top, instead of the Browse import feature. Locate the Videos > Balloon_Trip folder.

3. In the Browse Media Files dialog box (yes, I know it's confusing that it says "Browse" when you're not actually in the Browse feature), choose All Video Formats from the Files of Type drop-down list. Import all seven of the video clips (Shift-select all of them) and click Open. (See Figure 7.9.)

4. Return to the same Browse Media Files dialog box as in step 3. Choose All Image Formats from the same Files of Type list, and import all six images into the Chapter 7 library.

5. Selecting All Audio Formats, repeat again to import the one audio WAV file.

Tip

A shortcut for importing all the formats is to choose All Formats in the Browse Media Files dialog and select all (Ctrl+A), then click Open.

Choose this... ...to access these.

Figure 7.9
Selecting file import formats.

6. Add HD-Travel_Start.wmv to the Timeline's Video track. Zoom to fit. Save your project as **Chapter 7B**.

7. Add the intro family.jpg into video Overlay Track 1, so its end aligns with the end of HD-Travel_Start.wmv.

8. Put the MAP.jpg in the same Overlay track right before the intro family.jpg. Drag the start of the MAP clip backward until its length is 4 seconds long (see Figure 7.10). Preview the results. It doesn't look so impressive floating right in the middle of the screen, does it? Well, we can actually alter the shapes of the photos so they fit onto the TV screen in the background.

9. Place the playback head in the middle of the first overlay clip (MAP.jpg) and select (click once) the MAP photo in the Timeline. The MAP photo in the Preview panel should have eight yellow sizing handles surrounding its frame. (Note that the *corners* have small green handles *inside* the larger yellow squares.)

10. In the Preview panel, click and drag the clip to reposition it so that its upper-left corner fits into the upper-left corner of the TV screen (not the TV frame, but the screen inside it). See Figure 7.11. The upper-right corner is already where it needs to be.

Green skew handles inside yellow resize handles

Figure 7.11
Positioning the Overlay track.

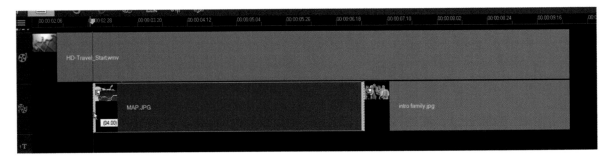

Figure 7.10
Extend MAP.jpg back to 4 seconds.

11. To reshape the rest of the map to fit inside the TV screen, reposition the three small green squares to fit into the nearest TV screen corners. Be sure to grab the green squares *inside* the yellow squares. The green ones are the skew handles. The yellow handles are for resizing only. See Figure 7.12.

> Your cursor will turn into a single arrow when using the green handles for skewing, and turn into a double-headed arrow when using the yellow handles for resizing.

Figure 7.12
Use the green handles to skew image frame.

12. Figure 7.13 shows the finished placement. Notice how the green squares become larger as they leave the comfort of their yellow square partners. To see the results more clearly, select Project in the Preview panel. That will hide all the handles so you can more easily see the results. You'll need to do this frequently for accurate adjustments. Select MAP in the Timeline, or Clip in the Preview panel, to return and continue editing. It might take a few tries to get the positioning the way you want it, so don't despair.

Now you need to do the same manual re-sizing to the intro family photo. Or do you?

Figure 7.13
Skewed image to fit.

Copying Attributes

We all love the copy and paste feature, right? VSX4 goes a step beyond copying and pasting objects, clips, and so on, by also being able to copy attributes from one clip to another, thereby saving multiple steps of reapplying the same size, shape, position, and other options. This is a newer feature that will come in very handy for you.

1. Right-click on the MAP clip in the Timeline and choose Copy Attributes.

2. Right-click on the intro family clip to the right of MAP and choose Paste Attributes. Bam! The intro family photo should now be placed inside the TV screen in the exact same location and shape as the MAP illustration.

Animating an Overlay Clip

One of the many advantages of putting assets into an Overlay track is having the ability to move or animate this smaller video window around the screen. This section will show you how to place your overlay clip onto a path that it will follow over time. You cannot create your own path from scratch, but there are quite a few preset paths to choose from.

1. Zoom the Timeline out a couple times. Add another copy of the MAP image from the library to the Timeline, at the end of the HD-Travel_Start clip in the background layer. Follow that with the videos Balloon-2 and Balloon-7, but do not overlap them. (See Figure 7.14.)

Figure 7.14
Current Timeline view.

2. In Overlay Track 1, drop Balloon-5 so that it starts at the same time as Balloon-2. Follow that with Balloon-4 and Balloon-3. Using the feedback adjacent to your cursor, like you did when overlapping to add a default transition, overlap Balloon-4 onto Balloon-5 by 1 second to add your default transition. Do the same thing with Balloon-3 onto Balloon-4. (See Figure 7.15.) The background Video track and Overlay Track 1 should now end at the same time.

Overlap by 1 second
to add transition

Figure 7.15
Overlapping video clips.

3. One at a time, right-click each of the three clips you just put down in Overlay Track 1. Notice that the first clip has Fade-Out checked, the next one has both Fade-In and Fade-Out checked, and the third one has Fade-In checked. This is due to the transitions you added. Do not uncheck them.

4. Select Balloon-5 in the Timeline. Using the yellow resize handles in the Preview panel (*not* the green skew handles), resize the clip to about the size you see in Figure 7.16. Position it to the lower-left corner area of the screen. Remember to stay inside the *safe zone* (the thin rectangle inside of the Preview panel).

Figure 7.16
Resizing the overlay.

Keeping graphics and text within the safe zone will guarantee full viewing on all TV screens. The safe zone area, indicated by a thin border line, occupies the center 90% of the screen, giving a 5% border all around. Action safe zones are narrower, and title safe zones are even narrower, by 5% each. Luckily, with the advent of better quality and flat panel displays, this issue has been much reduced. A 10% safe zone for everything will usually be sufficient.

5. Right-click on the resized clip in the Timeline and choose Copy Attributes. Paste attributes to Balloon-4 and Balloon-3.

6. Reselect Balloon-4 and position it to the top center of the Preview panel and position Balloon-3 to the lower right. When you select any one of them, the others will disappear, since none of them plays at the same time relative to the others.

7. Double-click Balloon-5 in the Timeline. In the Attribute panel, under Direction/Style, choose the Enter and Exit directions, as shown in Figure 7.17. Also, click both the Fade-In and Fade-Out icons. Apply the same choices to Balloon-3 (the last one).

Figure 7.17
Direction and fade animation settings.

8. For Balloon-4 (the center one), select Enter from the bottom left, Exit to the bottom right, and then select Fade-In and Fade-Out *and* both Rotate options (see Figure 7.18).

Figure 7.18
Rotate animation settings.

9. In the Preview panel for Balloon-4, notice the horizontal blue bar? This represents the pause duration where the clip is not moving, the duration between its entrance and exit. Adjust the orange end points to extend them about halfway to the left and right ends. This will make the clips enter and exit more quickly and remain in place longer (see Figure 7.19).

Figure 7.19
Set the pause duration.

10. Rewind and play this newly edited portion of your movie. It might be a little jerky with everything that's going on, but your final project will render at full speed. (You'll export a movie at the end of this chapter that will play normally.)

11. Save your project.

> In the Attribute panel, except for filters, the options you see can only be applied to an overlaid clip.

Adding Borders to Overlays

Adding borders to items in an Overlay track is akin to adding a picture frame (which you'll do later on). Although perhaps not quite as decorative, it does help to differentiate the clip from its background.

1. Double-click Balloon-5 in the Timeline. Select Mask & Chroma Key in the Attribute panel. The Mask & Chroma Key options contain additional features beyond the "weatherman" feature. The first adjustment sets clip transparency, the second adjustment creates a border, and the third lets you choose a border color (see Figure 7.20).

Transparency Border Border color

Figure 7.20
Mask & Chroma Key panel.

Figure 7.21
Choosing a border color.

2. There are three ways to enter either a transparency or border thickness value.

▶ Change the value by typing it directly into the field.

▶ Use the arrows to the right of each field to move the values up or down incrementally.

▶ Use the slider to the right of the incremental field.

For Balloon-5, enter a value of 3 for the border thickness. The resulting change in the preview window will be immediate, showing your new border.

3. Click the color chip just to the right of the Border fields (it should currently be white) to add a border color that accents the clip. Choose a color from the Corel Color Picker (see Figure 7.21). It's quite extensive in its choices. Click OK to any dialog boxes.

4. Repeat the previous steps to add borders for clips Balloon-6 and Balloon-4. Be sure to add a border thickness along with your border color.

> **CAUTION**
>
> Do not copy and paste attributes to the other two clips, as the clip's current location will transfer as well as the color.

Pan & Zoom Effects

PANNING AND ZOOM EFFECTS are a great way to add motion to still images. Take the History Channel for example. Many of its episodes include footage from before the era of video, when much of modern history was recorded on film or can only be depicted in photos and illustrations. So how do you appeal to an audience used to seeing motion on TV, the computer, and handheld devices? Simple—make the pictures move! While zooming just allows you to emphasize a particular part of an image, panning *and* zooming entails moving across the face of an image to gradually reveal the story behind the picture.

The Pan & Zoom dialog box (shown in Figure 7.22) is similar to what you'll see when customizing video filters in the next chapter, so learning this here will give you a great head start. This is probably the most complex area of VSX4, so if you can conquer this, you'll be able to handle anything else in the book.

The Original panel on the left is where you'll set up visual cues and settings. The Preview panel on the right lets you see the results of your settings from the left side. The timeline below the panels is similar to your video Timeline, allowing you to view results at different points in time. The icons

Figure 7.22
Pan & Zoom dialog box.

above the timeline allow you to drop keyframes so that your effect can change direction and/or attributes at that point in time. The Pan & Zoom dialog box will have different features, depending on the effect you choose.

In the Original panel, the dotted-line bounding box with the yellow corners represents the current full screen view in the right Preview panel. To aid in explaining how this dialog box works, click on the playback head and drag it to the right to about 00:00:02:00. You will now see three crosses. There are two white crosses that represent the start and end of the pan and a red cross, which represents the current playhead position along the path and stays centered in the image. As the playhead travels along the path, you will notice that the dotted line bounding box pans across the image and changes size. This is translated to the right panel to show the pan and zoom. Understanding what's happening here will help you make the necessary changes to achieve the results you desire.

The rest of this section will guide you (gently, I hope) through the process of setting up pan and zoom effects in VSX4. It can be complicated, but follow the steps precisely and perhaps read through each step before executing it.

1. Open the Track Manager. Activate Overlay Tracks 2 and 3. Click OK. Make sure the photo gallery is visible in your Chapter 7 Media library.

2. Center your timeline where the last three overlays you just placed are. In the Chapter 7 library, click the Show Photos icon, if not already selected and add the photo overlay1.jpg to Overlay Track 2 starting at the 16 second mark. (See Figure 7.23.) Extend it to a length of 4 seconds (by dragging the end out or using the Options panel). Add overlay2.jpg after overlay1 and extend it to 4 seconds. Repeat again with overlay3.jpg.

Figure 7.23
Setting up a Pan & Zoom effect.

3. As you've done recently, overlap photo overlay2 onto overlay1 for 1 second to again add the default transition. Repeat by overlapping overlay3 onto overlay2.

4. In the Preview panel, select and resize overlay1 in the same way you did the three overlaid video clips. Place the overlay in the bottom *center* of the preview screen. Add a white border with a value of 3 by double-clicking it in the Timeline and selecting Mask & Chrome Key.

5. In the Timeline, copy the attributes of overlay1 onto overlays 2 and 3.

6. Double-click on overlay1 in the Timeline. Go to the Edit panel and check Apply Pan & Zoom. In the drop-down list just below the check box, select the last choice in the second row. Click outside of the selection area to accept this choice. (See Figure 7.24).

Figure 7.24
Choosing a Pan & Zoom preset.

Choose this preset

7. For overlay2, choose the first Pan & Zoom option in the second row. Click Customize. The Pan & Zoom dialog box will open (see Figure 7.25).

8. Let's use the tools to exaggerate the current animation. Rewind the animation back to the beginning. In the Original panel, resize the bounding box so it covers only the Mom's face. Adjust the red cross to center the box better. Move the other crosshair to set the end view. Each time you click a white cross, it will convert to the red cross, because the clip moves to that frame and because the red cross represents the current frame. Use the Preview panel as your guide (see Figure 7.26).

Figure 7.25
Pan & Zoom position indicators.

Figure 7.26
Adjusting a Pan & Zoom starting point.

9. Rewind and play to preview. Click the Play button to both start and stop the pan effect. Click OK when finished previewing to close the Pan & Zoom edit window.

10. Double-click overlay 3, check Apply Pan & Zoom, and then go to Customize again. Click the Go to Last Frame button (refer back to Figure 7.25) on the far right just to the left of the Play button.

11. Narrow the bounding box to focus on the family's faces (see Figure 7.27). Reposition the red cross so you see all four family members. This will create an animation opposite of the one in Overlay 2. Preview it, then click OK.

12. Rewind your project and preview your work to this point. Save your project.

Figure 7.27
Adjusting a Pan & Zoom end point.

Adding Embellishments

EMBELLISHMENTS IN VSX4 allow you to add design interest to clips, scenes, and stills. They can take on several forms and functions. You have decorations (about 35 of them) that are similar to Christmas ornaments and fun, scrapbooking-like clip art—objects you could scatter around your screen to add some personal touches.

Embellishments also include picture frames (43 or so). Picture frames have the great feature of being a mask. Think of it as a Halloween mask, where the cut out eye holes allow you to see what's on the other side. Place any of the picture frames in an Overlay track, and any part of it that's white (the eye holes) will be transparent, letting the underlying content show through.

Flash animations (about 70) include both animated decorations and animated frames. Flash animations are what's known as *resolution-independent graphics*. You can make them any size or shape you like, and they will still look great—no pixilation, no jagged lines, and no jagged edges.

Also included in this category are the color backgrounds (chips) you applied in Chapter 4. Frames and objects are pretty self-explanatory, so let's add a couple of Flash animations instead.

1. First, you'll need to extend the MAP image in the middle of the Timeline's background Video track while ensuring all the clips in the other tracks move forward accordingly; otherwise, they'll be out of sync when you add a clip to any of the other tracks. Click the Enable/Disable Ripple Editing icon (see Figure 7.28), and all the open padlocks underneath it will light up.

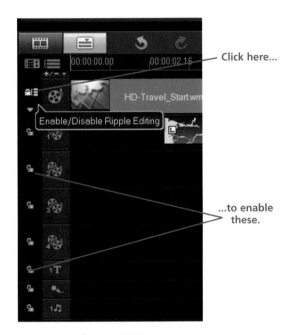

Figure 7.28
Enabling Ripple Editing.

2. Click the small down arrow under the Ripple Editing icon and chose Select All from the list (see Figure 7.29). All the padlocks will then lock up. This will ensure all the tracks move to the right when a clip is inserted into the middle of the Timeline.

3. Double-click the MAP image in the main Video track (not the Overlay track). In the Photo tab of the Options panel, set the length to 6 seconds and hit Enter. All the other tracks should've moved to the right accordingly. If not, undo and re-visit Steps 1 and 2.

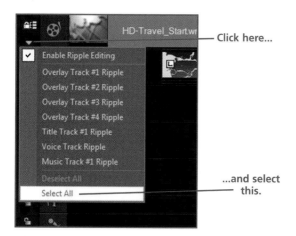

Click here...

...and select this.

Figure 7.29
Enable Ripple Editing on all tracks.

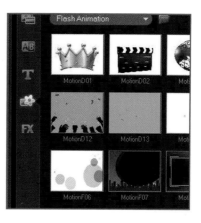

Figure 7.30
Select the Flash Animation gallery in the Graphic library.

4. Close the Options panel. Select the Graphic library, then select the Flash Animation gallery from the drop-down list (as shown in Figure 7.30).

5. Place MotionD05 (the compass) into Overlay Track 2 (leaving Overlay Track 1 empty) directly under the MAP image. Adjust it to be the same length as the MAP image in the Video track. In the Preview panel, size MotionD05 smaller and place it into the upper-left corner. Make sure to keep it within the safe zone. (See Figure 7.31.)

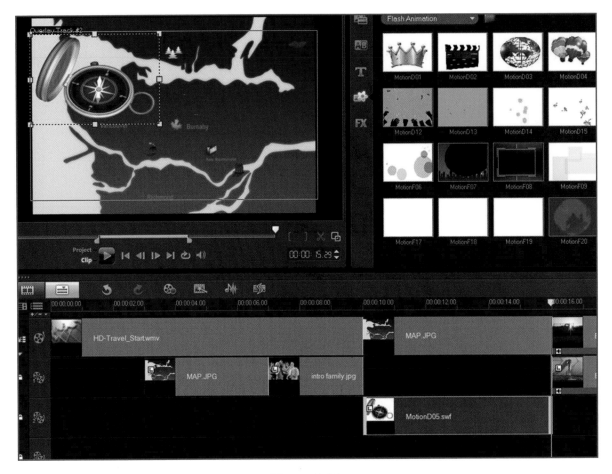

Figure 7.31
Adding a Flash animation.

6. Repeat step 5 with MotionF02. Place this decoration in Overlay Track 3 directly under, in-line with, and with the same duration as MotionD05. Do not adjust its size.

7. Rewind this section and preview. Nice, huh?

Tip

You can create and add your own decorations. Using the same Import icon you use for other media, you can import objects and frames of various file formats, including JPG, GIF, BMP, PNG, and PSP files. You can also import a Flash SWF into the Flash Animations gallery.

Applying a Chroma Key Effect

A CHROMA KEY EFFECT IS A fancy term for setting a transparency (a mask) based on color. You might be familiar with the terms blue screen and green screen. This technology is commonly used in the movies and on news programs to project an image or video onto a different background, giving the illusion that someone or something in the foreground is part of the background, intending to show that it's all one image, when it's really not.

Most Hollywood or TV productions will put up a solid blue or green wall in the background, and then tell the computer to place a different image anywhere that blue or green color appears. In the weatherman's case, it's the weather map. In a movie, it might be an alien planet's landscape or outer space. Any objects in the foreground will remain visible unless they also contain that same background color. If they do, they will also be transparent. (Wear a blue shirt against a blue screen and your torso will become invisible.)

Using a computer, the two layers (foreground and background) are combined and broadcast together on a single layer. VSX4 can create this effect. The challenging part for you, if you want to use this effect, is to shoot a video that has a solid color background that can be selected to be transparent. The background can be any color, not just blue or green. A nice feature of VSX4 is that you can select a range of a color, so the transparent color doesn't have to be the exact same color value throughout the entire background. This helps when you lack the budget of a Hollywood movie stage.

Let's see what effect you can produce with the clips you have so far. The trick is to find a clip with a smooth, solid-colored background. The clip you apply a chroma key effect to must reside in an Overlay track.

1. Double-click the last clip in Overlay Track 1, Balloon-3, to bring up the Options panel. In the Preview panel, move the clip to the upper-left corner, but stay within the safe zone. It'll be better to view the clip on this part of the background.

2. In the Attribute panel, click Mask & Chroma Key. Check the Apply Overlay Options box. Make sure that Type > Chroma Key is selected.

3. VSx4 will automatically choose what it thinks the color is that you want to be transparent, and it will apply the chroma key effect immediately. To make sure it selects the correct color, click the eyedropper (next to the Similarity color chip) and click on the sky in the overlay clip. Click the eyedropper tool again to turn it off. (You might see that too much of the background has become transparent. You'll fix this next.)

4. The best results will come from choosing a range of the eyedropper's selection. It's really selective on a per-image basis. To the right of the eyedropper, use the slider/input field to enter a value of around 15. You might need to use the eyedropper after this to click on the sky again. Once again, this is different for every clip and depends on where you click the eyedropper. Feel free to adjust the settings until you get the desired effect. See Figure 7.32 for the desired results.

5. Save your project.

Tip

To get the best chroma key effects in a low budget situation, try hanging a solid color sheet as a backdrop, remembering that the color of anything in front of it cannot be the same color as the backdrop, or in that color's range setting. If that happens, parts of the foreground, including your subject, will also become transparent.

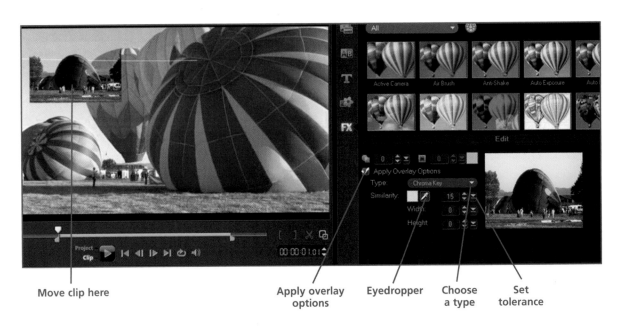

Move clip here Apply overlay options Eyedropper Choose a type Set tolerance

Figure 7.32
Setting a chroma key transparency.

Applying a Mask Effect

A MASK EFFECT IS SIMILAR to a chroma key effect, but it's a predesignated transparency style instead, similar to a picture frame. Place the frame on an Overlay track and only what's inside the frame (the white parts) will automatically show through. It's not unlike the Flash animation frame you applied earlier in this chapter. You can also create your own mask frames in applications like PaintShop Photo Pro or Photoshop. (See the "VideoStudio" section in Appendix B for a short video tutorial on creating a mask frame.)

To apply a mask effect to your video, follow these steps.

1. Double-click on Balloon-5 in the Timeline (Overlay Track 1).

2. In the Attribute panel, select Mask & Chroma Key. Check Apply Overlay Options. In the Type drop-down list, select Mask Frame (see Figure 7.33).

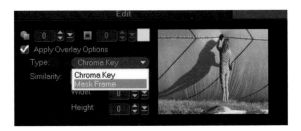

Figure 7.33
Selecting Mask Frame.

3. From the list that shows up, scroll to preview the many choices, then choose one you like. Select one to apply to the clip. See Figure 7.34. (Any attached border will be deleted.)

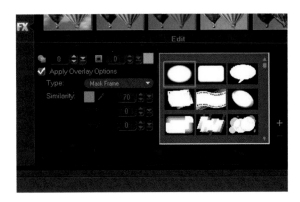

Figure 7.34
Select an option from the Mask Frame list.

Tip

Clicking the plus sign (+) in the lower right lets you add a mask of your own. So, once you create one in PaintShop Photo Pro or Photoshop, this is how you would import it. The minus sign (−), or delete mask frame, is only available for ones you've imported, not any of the default ones.

4 Skipping the clip that has the Chroma Key effect, apply mask frames to Balloon-4 and all three photos under that in Overlay Track 2.

5. Save your project. You'll be adding more to this project in future chapters. You should now have two saved files from this chapter, Chapter 7A and Chapter 7B.

6. Go to the Share tab, and choose Create Video File. Select WMV > WMV HD 720 30p. After it's finished rendering, open and play the file so you can see how the results of your hard work play at the proper speed and fluidity.

Quick Review

▶ What's the easiest way to re-use attributes from one clip and apply them to another? (See "Copying Attributes.")

▶ What's a great way to add motion to a still image? (See "Pan and Zoom Effects.")

▶ Name the four types of decorations available in VSX4. (See "Adding Embellishments.")

▶ What are the pitfalls to avoid when creating chroma key effects? (See "Applying a Chroma Key Effect.")

Chemistry Experiments with
Video Filters

THIS IS THE CHAPTER on video filters that are located in the Filter library, identified by FX in the Library Navigation panel, as opposed to the previous chapter on video effects.

Why did I name this chapter the way I did? Video filters, unlike video effects, can be layered and mixed together for different results that can be greater than the sum of the individual elements, akin to a chemistry experiment. Even the order in which they're layered will affect the final results.

Filters are effects you apply to clips to change their style or appearance. Filters can be creatively applied to enhance your clips or used to correct flaws, such as making a clip look like a painting or improving its color balance. You can apply multiple filters to a clip. Rearranging the filter layers, or the order in which they're applied, will affect the final result. A filter on the top layer of the filters list will alter the clip differently than if it were on the bottom layer. (This has nothing to do with Timeline tracks behaving as layers.) You can also toggle applied filters on and off to preview their effect or combined effects. Only checked filters will be applied in the final rendering process, so you can experiment using all kinds of possibilities.

The effects you'll work with in this chapter are all in the Filter library. Because there are so many, I won't explain them all, but you'll get to use some of the pretty cool ones, such as AutoSketch, Lensflare, Picture-In-Picture by NewBlue, Old Film, and some cool weather effects. Feel free to try the rest of them on your own. Luckily, the animated previews give you an excellent idea of what to expect from them, and applying and previewing them requires just a couple of steps.

Video filters are very easy to apply. All you do is drag the thumbnail choice from the Filter library and drop it directly onto any video or still clip in the Timeline. Double-click that clip to bring up the Options panel, and the filters you applied will be listed, rearrangeable, editable, and customizable.

Using Key Frames

I'VE TOUCHED ON THE IDEA of using key frames a couple times already, but I'll cover it in more detail now as a better understanding of them becomes even more important in this chapter. A *key frame* (also described previously as a *pin*) is a particular frame on a timeline that designates where an animation, or effect, will start or end, as well as how it might change attributes at that frame by then heading in another direction or setting. Key frames can be any number of frames apart (such as 5, 10, or 20). There is always a key frame at the beginning and at the end of an effects timeline.

After key frames are designated, an animation software application, or a special team of artists (in-betweeners or tweeners, for short), will then create the frames in between, so that the sequence will progress from one key frame to the next while keeping the motion looking natural. This allows the head artists to concentrate on the key aspects and turning points of a story, and pass on the minutia to someone else or, in VSX4's case, your computer.

In VSX4, you'll place key frames wherever and whenever you want a filter to change direction. This directional change can be for any number of reasons, such as an actual direction, color, size, shape, or other factors that affect your video clip.

AutoSketch Filter

The AutoSketch filter was new to VideoStudio Pro X3 (version 13), and it is amazing! This filter, working with still images or videos, will animate a trace of the image over time. Then it fills it in with color. The shorter the clip, the faster it draws. The longer you stretch the clip out, the slower it will trace. It's also customizable for color, shade, pen width, and accuracy.

1. Open project file Chapter 7B and resave it as Chapter 8. Make sure the Options panel is closed for now. This will allow you to view more of the Filter library content.

2. From the Chapter 7 custom library, add Balloon-7 again to the end of the Video track. You'll have two of them in a row.

3. Now you'll need to move some of the overlay clips so they don't get in the way of what you'll be doing next. Shift-select all six overlay clips under Balloon-2 and Balloon-7 (Balloon-5, -4, -3, overlays 1, 2, 3). Move them forward in time, down the Timeline, so that the beginning of Balloon-5 lines up with the start of the second Balloon-7 (see Figure 8.1).

4. Select the Filter library from the Library Navigation panel. Choose All from the gallery list (see Figure 8.2).

Move these tracks down the Timeline

Figure 8.1
Adjusting the Timeline.

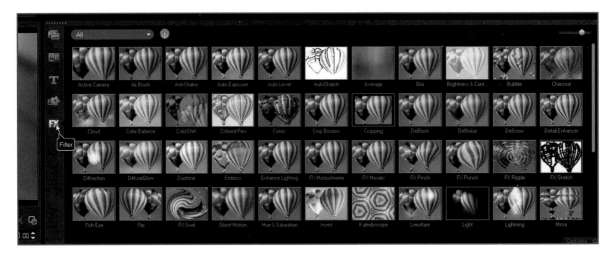

Figure 8.2
Selecting the Filter library.

5. From the Filter library, drag and drop the AutoSketch filter (remember, they're in alphabetical order) onto the first Balloon-7 clip in the Timeline.

6. In the Preview panel, click Play to view the results. (Because you just edited a single clip with your filter, the clip should be selected by default.)

 Although Balloon-7 is a video clip, the AutoSketch filter will use only the first frame of the clip as the basis for its tracing and treat the entire clip as a still image, based on that first frame. In other words, the video itself will not play, just a sketch of the video using only the first frame.

7. Go to the Attribute panel for Balloon-7 (in the Options panel). The AutoSketch filter you applied is in the list of applied filters on the left. Click Customize Filter (see Figure 8.3) to be taken to the AutoSketch customization window.

Figure 8.3
Video filter list in the Attribute panel.

This window is similar to the one you used in the last chapter to edit the Pan & Zoom effect. The differences are the custom settings at the bottom left. But the viewing windows are the same, with the Original view on the left and the Preview window on the right that shows how your settings will be applied. The Preview panel should start out blank, as the filter hasn't begun sketching anything yet. Playback controls are under the Preview panel, and key frame controls are under the Original window on the left.

8. You can test the different settings on the lower left, such as Accuracy, Width, and Darkness, but the one I find most useful and noticeable is the Color setting, which changes the tracing pen color.

Click on the black color chip, and the Corel Color Picker will open. In the top row, click the blue color chip, then choose a light to medium shade of blue in the main panel. (See Figure 8.4.)

Figure 8.4
Choosing an AutoSketch color.

9. Click OK to close the color picker window. Click the Play button to preview the effect in the Preview panel. Click OK again and preview the clip in your Timeline. You can change the filter to use another color value if you like.

10. Save your project.

Tip

In the lower right of the Corel Color Picker, you'll see a Web Safe check box. This is the value given to Internet browser colors that were used back in the era of 256-color (8-bit) displays, and are written in HTML code. When setting the background color of a web page (among other graphics), coders and web design software applications will use these values to set the colors.

Check the Web Safe box under the Hex value and watch the colors in the main panel change. Some of the color chips are replaced with ones that are web-browser compatible, or what's called *web safe*. There are 216 colors considered to be web safe. The rest (the difference between 256 & 216) were used for the computer's operating system.

This is a feature left over from the golden days of 8-bit (256 color) computer displays. Although most designers still use web-safe colors for items like backgrounds, text, and buttons, embedded photos and videos don't need to adhere to this palette. Therefore, you're welcome to ignore this feature.

In conclusion, Corel has a habit (neither good nor bad) of keeping old features just in case platform shoes and disco make a comeback.

Lensflare Filter

L ENSFLARE IS OFTENTIMES an unwanted characteristic of bright light reflected or scattered around inside your camera lens. Most commonly, this occurs when shooting into the sun—when the sun is in the frame or the lens is pointed in the direction of the sun. This artifact can be eliminated by using a lens hood, umbrella shade, or similar device.

Lensflare filters, on the other hand, are purposefully used to add sparkle to a photo or video clip. They can be used to add sparkle on a lake, or add reflections from the sun, stars, streetlamps, or Christmas lights.

To add sparkle to a video clip, follow these steps.

1. From the Filter gallery, drop the Lensflare filter onto the clip Balloon-2 (the pickup truck) in the Timeline's main Video track. (It might make it easier to find the filter if you first close the Options panel.)

2. After applying the filter, re-open the Options panel by double-clicking the clip in the Timeline. In the Attribute panel, open the Lensflare preset drop-down list (under the applied filter list), and double-click the first choice in the second row (as shown in Figure 8.5).

Figure 8.5
Preset choices for filters.

3. Click Customize Filter, which will open the Lensflare dialog box. With the playback head at the beginning of the Timeline, in the Original panel, move the cross mark (in the upper-right corner) right onto the top of the sun, inside the front windshield of the truck. The Preview panel on the right should update accordingly.

4. In the options area in the lower-left corner, choose 35mm Prime for Lens Type, and set Intensity at 50, Size at 50, and Extra Strength at 300 (see Figure 8.6). These are just artistic suggestions, so in the future you can choose your own. For now, though, use these settings.

5. Above and to the left of the Timeline, click the Reverse Key Frames icon. This will reverse the entire sequence, make the sun appear dimmer (instead of brighter), and set the filter at a speedier, exaggerated mode.

6. Click OK and preview this portion of your project, using the Clip play feature. Notice how the sun seems to set much more quickly than normal.

CAUTION

Occasionally, adjusting one custom setting will change another one unexpectedly. They can still be changed back again. Just make sure your desired settings are set the way you want them before you click OK.

7. Save your project.

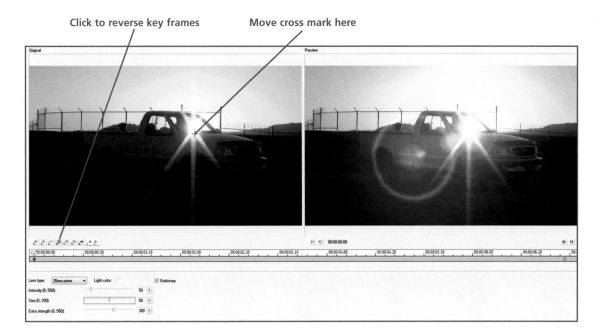

Click to reverse key frames Move cross mark here

Figure 8.6
Lensflare filter customization.

Picture-In-Picture Filter

YOU'VE ALREADY DONE Picture-In-Picture (PiP) effects by laying down clips in the Overlay tracks. So why is this any different? Several filters from a third-party software developer, NewBlue, are now included in VSX4. One of them is an excellent PiP filter that adds almost infinitely adjustable 3D geometry, shadow, and reflection features. It takes the video overlay feature in VSX4 to a whole new level, by expanding beyond just the overlay part.

These steps will show you how to apply and customize the NewBlue Picture-In-Picture filter.

1. First you will need to move a couple of clips to get them out of the way. In the timeline, Shift-select overlays 1–3 in Overlay Track 2. Move them to Overlay Track 1 and center them under the first Balloon-7 clip in the main Video track. Delete Balloon-5 in Overlay Track 1. Move Balloon-3 (currently at the end of Overlay Track 1) and center it under Balloon-2. Center Balloon-4 under the last Balloon-7 clip. Your Timeline should look like the one shown in Figure 8.7.

> Moving clips around the Timeline will not affect any filters or effects you've applied to them, except for how they might interact with the clips in the tracks below them.

2. In the Filter library drop-down list, select NewBlue Video Essentials II. The only choice is Picture-In-Picture. Drop this filter onto the last clip in Overlay Track 1 (Balloon-4).

3. In the Preview panel, make sure the desired clip is labeled Overlay Track 1. Right-click the clip in the Timeline and choose Fit to Screen (as shown in Figure 8.8). Fit to Screen will allow the effect to utilize all the screen space it needs (including reflections), even though, as you see, the actual picture in the picture only needs a portion of the screen.

Figure 8.7
Timeline view after adjustments.

Make sure overlay is chosen Choose Fit to Screen

Figure 8.8
Picture-In-Picture clip placement.

4. In the Options > Attribute panel, click Customize Filter to launch the NewBlue Picture-In-Picture Edit window (see Figure 8.9).

5. Did your eyes get huge? Yes, there are a lot of possible mind-boggling settings. But there are also a lot of presets to choose from to make it easy. In the bottom portion of the window, select the Gentle Reflection preset.

> Just as in the VSX4-specific effects and filters customization windows, NewBlue filters also allow for animated adjustments using key frame points where settings can change at any point in time (frame) for such items as direction, rotation, color, transparency, and the like.

6. Select Play to preview. Watch both the Timeline and several of the small dials to the left change direction. Notice how these parameters change over time—and at the key frame in the middle of the Timeline, it will change again, but in the opposite direction. Click Play again to stop the playback.

Figure 8.9
NewBlue Picture-In-Picture window.

A new feature in VSX4 allows you to preview NewBlue filters in both the NewBlue customization window and the main screen's Preview panel at the same time.

7. Rewind the Timeline back to the beginning. Set the Rotate X field to –60.0. Try using the manual rotate dial. This is great when you want to preview possible choices. After trying that, type –60 into the field directly under the dial, then hit the Tab key. Set Rotate Y to 60.0. Click the Tab key to set. Preview it again.

8. Forward the Timeline to the end and set the same fields to the same numbers from step 7. Rewind and preview the clip again. Notice how the values in this window interactively update. Also notice that because the settings are the same at the start and at the end, the effect appears to loop and play without any abrupt changes, even when it restarts. Click OK to close the NewBlue customization window.

9. Preview this portion in the main Preview panel and save your project.

Because of all that is going on, your project may not preview these combined effects very well, but when you save your video file at the end of this chapter, everything will come together and play very nicely.

Old Film Filter

I JUST WANT TO SLIP THIS simple one in because it's cool and used frequently in broadcast TV. Add a Pan & Zoom effect with this one, and you have another something from the History Channel. This filter adds items like different shades of sepia tones, film scratches, jittery affects, or dust and variations in lighting. As you'll see in this section, Old Film filters are great for making modern photos and videos look aged, giving them the appearance of days gone by, the times of black and white film, and even silent film.

These steps will show you how the Old Film filter can take a modern photo and easily age it by 100 years.

1. Since the image you're going to use has nothing to do with a balloon trip, save your current project and open a new project by selecting File > New Project.

2. In lieu of creating a library just for one image, import the image Iowa_tractor into the Chapter 7 library from the Photos > Landscapes folder.

3. Place the image into the Timeline and extend the duration to 15 seconds (see Figure 8.10).

Figure 8.10
Add an image to use the Old Film filter.

4. From the Filter library, choose the Camera Lens gallery. Drop the Old Film filter onto the Iowa_tractor clip.

5. In the Options > Attribute panel, from the drop-down preset list, double-click the second choice in the first row. Click Customize Filter to edit this particular preset in the Old Film Customization window.

6. Set the Scratch setting to 100%. Click the Go to Next Key Frame icon (see Figure 8.11). Since there are no key frames anywhere in the middle, and as key frames are automatically placed at the start and end points, clicking on this icon will take you to the very end of the Timeline. Set the Scratch setting to 100% again. This will maintain the same setting throughout the entire clip. Click OK.

7. Right-click on the clip in the Timeline and choose Auto Pan & Zoom so you can add an animated effect to the still image.

8. In the Options panel, go to the Photo panel. In the preset choices list under Pan & Zoom, double-click the last one in the second row, and then click Customize again.

Figure 8.11
Go to Next Key Frame button.

9. In the Original panel, move the red cross down so that the dotted line between both crosses is as horizontal as you can get it. The tractor should be centered better in the photo. Use Figure 8.12 as a reference.

Figure 8.12
Pan & Zoom Start view.

10. Move to the end of the Timeline by clicking either the Go to Last Frame icon or Go to Next Key Frame icon. If you have trouble finding the right one, remember that pausing your cursor over an icon will display a tooltip that tells you what its function is. Center the tractor again as you did in step 9 (see Figure 8.13).

Figure 8.13
Pan & Zoom End view.

11. Preview your new settings by hitting the Play button in the Pan & Zoom window. Follow the crosshairs as they move across the Original panel to see exactly what's happening in the Preview panel. When you're satisfied with your settings, click OK to close the Pan & Zoom customization window.

When you have a clip (video or photo) selected that has a filter applied to it (and with the Options panel open), you will only see filters applied when the Attribute tab is selected. You will not see them in the Photo or Video tabs.

Also, in the customization window, if you have multiple filters applied to a clip, you will only be able to see and edit the filter you're currently customizing.

When you have Project selected in the Preview panel of the main window, all filters and effects will be visible.

12. In the main preview window, rewind and preview the clip. Since you only have one clip in your timeline, it won't matter if you have Project or Clip selected. And, bamm, the History Channel!

13. Save the project, and name it **History Channel** if you like.

Applying Multiple Filters

VSX4 LETS YOU APPLY UP to five filters to a single clip. VSX4 has some great weather effects, including clouds, lightning, wind, and rain that, when combined, can produce quite a storm. Let's see how much trouble you can get into trying some of these out. Your plan is to create a progressively worsening storm at the balloon festival.

1. Reopen your Chapter 8 project. Move Balloon-4 to the end of Overlay Track 1 and center it under the first Balloon-7 clip. (See Figure 8.14).

2. Double-click on the second (last) Balloon-7 clip in the main Video track. In the Options > Attribute panel, make sure that Replace Last Filter is *not* checked. Since you'll be combining and creating a video chemistry experiment using and mixing multiple filters, you don't want each new one you add deleting the previous one.

3. Open the Darkroom FX gallery from the drop-down list at the top of your Filter library. Add Brightness & Contrast to the clip. Go to the Special gallery in this same library. In the following order, drop the filters Cloud, Lightning, Rain, and then Wind onto the clip.

4. In the Options > Attribute panel, click the "eye" icons next to all the filters except for Brightness & Contrast to hide them temporarily (see Figure 8.15). If you see the "eye" next to the filter name, the filter is activated. Click the eye to turn filters off. It's a toggle switch. Click it again to turn them back on.

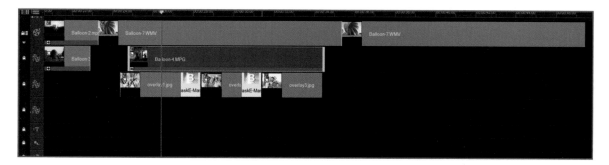

Figure 8.14
Move Balloon-4 under first Balloon-7 clip.

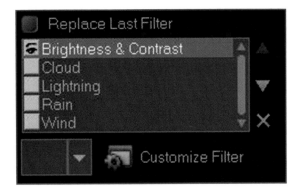

Figure 8.15
Turning off selected filters.

5. Select the Brightness & Contrast filter in the list and select Customize Filter. At the first key frame, set the Brightness to 0 (in the middle of the slider, *not* all the way to the left). At the end, set Brightness all the way to the left (−100). Preview the clip in this Preview window. It looks too dark at the end, but the other filters will help reverse that somewhat. Click OK.

6. By clicking the eye icons again in the filter list, hide the Brightness & Contrast filter and show the Cloud filter. From the Cloud presets drop-down list, double-click the first one in the last row and preview it.

7. Hide the Cloud filter and show the Lightning filter. In the presets list, choose the second one in the first row. Preview this one.

8. Hide the Lightning filter and show the Rain filter. Choose the last preset in the second row. Go to Customize Filter.

Click the Advanced tab in the lower left. At the first key frame, set Wind Direction to 100 (the rain will be heading into a direction of 100 degrees, or about 7 o'clock). Set Speed to 50.

Go to the last frame and set Wind Direction to 180 and Speed to 100. This will give the impression of a harder driving, horizontal rain.

While you're still at the last frame, return to the Basic tab. Move the Density slider to around 6000. Preview to see how the wind direction of the rain changes gradually over time. Because of the render power it needs to create these effects, it may not play at full speed in Preview mode. Click OK.

9. Hide Rain and show Wind. Choose the first preset in the second row.

10. Turn on all the filters by turning on all the "eye" toggle icons.

11. Preview Clip (not Project) in the Timeline. Notice that the effect of the Brightness & Contrast filter is not very evident, as it doesn't get very dark at the end like you had set it. Select the Brightness & Contrast filter in the filter list, and click the down arrow on the right side of the list until the Brightness & Contrast filter is all the way at the bottom of the list. Preview the clip.

12. To preview it again in full screen view, click the Enlarge icon (see Figure 8.16). Looks to me like this balloon festival needs to be cancelled! Select the Enlarge icon again in the larger window (or hit the Esc key on the keyboard) to return to the regular sized view.

Figure 8.16
Click Enlarge to preview at full screen.

Before you output this project, let's add a soundtrack.

1. Rewind your project back to the start, then click the Auto Music icon in the Timeline's toolbar. Choose the following: Scope > Owned Titles, Filter > Album, Subfilter > Core Foundations, Music > Clear Vision, and Variation > Rain.

2. Check the Auto Trim box, and then Click the Add to Timeline icon.

3. Preview your project from the beginning and then save it.

4. Click the Share tab at the top of your screen.

5. Output your movie in the same format as you did at the end of Chapter 7. Choose Create Video File and select WMV > WMV HD 720 30p. Preview it to see all your applied filters and effects occur in real time.

With over 65 video filters in VSX4 to choose from and the presets and customization abilities that come with them, the resulting choices are practically endless. Although I couldn't cover all of them, you did learn how to choose them, order them, use easy presets, and edit specific parameters using key frames, an important tool in any video editing application containing animation capabilities.

Feel free to read through this chapter again and use your own clips to experiment with any of the other filters available. Remember, you'll never destroy any of your original content. Have fun!

Quick Review

▶ What are key frames used for? (See "Using Key Frames.")

▶ What do you do if you want to reverse the playback of a video filter? (See "Using Key Frames.")

▶ What are some of the advantages of using the NewBlue video filters in VSX4? (See "Picture-In-Picture Filter.")

▶ How many filters can you apply to a single video clip? (See "Applying Multiple Filters.")

▶ When you're applying multiple video filters, what's the easiest way to test one out without involving any of the others? (See "Applying Multiple Filters.")

Making Statements
with Titles

I TOUCHED ON TITLES EARLIER in the book, but it needs to be reinforced here in the chapter that covers the topic. Titles, when using the term in video editing, can mean one of two things, and as a result, it can be confusing. You on the other hand, will become familiar with both meanings, and will know which one is being referred to in each instance (or at least in this book).

Text titles can be used interchangeably with movie titles. A movie title is a separate, single movie. For example, Netflix may advertise that they have over 10,000 Titles. Of course, they are referring to the movies themselves, not text titles. You can import and combine several movie titles (or captured clips) into VideoStudio, but the output will be another title. Yikes!

Text titles (within a movie) are text features applied in separate tracks (layers) in the Timeline. These can be a simple stationary phrase such as a title, subtitle, or a moving phrase, such as a rolling title (e.g., credits). To relieve any confusion regarding the meaning of titles, any titles I discuss will be text titles only. Movie titles have and will be referred to as videos, movies, and so on.

Previous to this version of VSX4, text could only be placed into one of two Title tracks. These Title tracks were always the top layers of any movie, on top of any other video or graphic elements on the Timeline. You could have one title on top of, or pass over, another one, but this type of interaction could not occur with any other visual. New in VSX4, text can now be placed in any track but audio, including Overlay tracks, and thus interact with any other visible element in your movie. Now you can have text pass behind a photo or video overlay, too!

In this chapter, you'll learn to create titles from scratch as well as use titles from the included samples; then you'll edit both by adding and customizing title effects and filters. You'll learn the huge difference between the single and multiple titles options, as well as learn what's possible now that you can use titles intertwined in Video and Overlay tracks. I've even included a secret trick on how to create the famous *Star Wars* vanishing title. Lastly, you'll learn how to create subtitles and what they can be used for.

Ready? Let's make some statements.

Title Rules

THERE ARE SEVERAL THINGS you'll need to know about placing titles in VSX4. These rules actually apply to all video editing, even in TV production. These rules involve where you place your titles on the screen and how they're formatted. This section explains these considerations.

Title Safe Area

There is a safe zone for graphics and action. When you double-click any item in an Overlay track, the Preview panel displays a white border just inside the edges. This zone borders the inner 90% of the window. That's your action, graphics, and text safe zone. True, anything placed in the background Video track will automatically extend beyond this zone to the edges, but important graphics and action should remain inside the zone whenever possible.

Font Considerations

Fonts are also an important item to consider when incorporating titles. The following information might make your eyes roll into the back of your head, but there are two ways TV signals are displayed: interlaced and progressive. You might be familiar with TVs that are available in 720p, 720i, and 1080i, and so on? The "i" stands for interlaced, and the "p" stands for progressive.

Interlaced monitors display only alternate horizontal fields at a time, odd, then even, then odd, and so forth. They do it so fast, though, you can't see the difference unless objects are moving very fast or thin lines appear. When that happens, you might see a flicker effect. The Hertz rate (Hz) determines how often these fields are refreshed per second (the higher the rate, the better). This is why when

you pause some TVs or take a photo of a TV screen, you see unmatched horizontal lines. When you shoot a video of a TV screen, you see flickering horizontal lines. These lines often move up or down the screen. This happens when the capture rate of the video is different from the field refresh rate of the TV. The rates are out of sync.

A progressive display receives the entire field all at once. If you pause, capture, or photograph a progressive field display, the image will contain both fields at once and produce a complete image. You can probably guess that a progressive signal is more desirable than an interlaced one (and why products using it are more expensive). Why do I bother to mention this? Since most displays still use the interlaced choice, the type of fonts you use will become an important consideration.

VSX4 allows you to use any fonts that are on your system. Because of the interlaced field issue, you want to avoid fonts that have any thin (especially 1-pixel) horizontal lines. If you use these types of thin, wispy fonts, your title will flicker when displayed on an interlaced screen because one field will display it, but the next one will not. Next time you watch TV, especially commercials, closely watch for thinner fonts, as they may flicker ever so slightly. Of course, once you see this effect for the first time, you'll be looking for it all the time, won't you?

You don't have to worry about this issue when your project will be displayed on a progressive field TV screen or your computer. All modern computer displays are of the "p" variety and are referred to as *progressive scan displays.*

Creating a Single Title

IN THE TRACK MANAGER, you have two Title tracks available to you. With VSX4, you can also use titles in any of the Overlay tracks. As with other media elements, such as videos, graphics, and audio, you can choose from either the samples that came included with VSX4 (or that you downloaded through the Corel Guide), or create your own. Let's start by learning how to create your own from scratch.

1. Launch VSX4 and open your Chapter 8 project. Save it as **Chapter 9**.

2. Open the Track Manager, then check both Title tracks to make them active. Click OK.

3. Make sure all your tracks are locked down for Ripple Editing. They should still be locked from the last time you worked on this project. If not, refer to Figures 9.1 and 9.2 as a review.

Figure 9.1
Enable Ripple Editing.

Figure 9.2
Enable Ripple Editing on
all tracks.

4. Go to the Graphic library > Color gallery and add a black color chip to the beginning of the main Video track. All other clips should move forward accordingly. If they don't, revisit step 3. The chip will default to a duration of 3 seconds, which is fine.

5. Zoom into your Timeline to see the color chip sufficiently (see Figure 9.3). Make sure the Timeline's playback is at the very start.

Figure 9.3
Prepping to add a title.

6. Click the Title library icon to display all the built-in, pre-animated, and customizable text title choices (see Figure 9.4).

7. Where it says "Double-click here to add a title," click where you would like to start entering your text, in this case, just above the "c" in "Double-click." As a result, the text insertion point will show up onscreen, and the Text Options panel will pop up with the Edit panel at the forefront.

 Most of the options are pretty self-explanatory with familiar text formatting tools, such as font, color, justification (left, center, right), spacing, rotation, and effects like borders, shadows and transparency. You'll notice radio buttons for Single Title and Multiple Titles, with Multiple Titles selected by default. Select the Single Title radio button for now. Set your text insertion point again by clicking in the preview window where you want to start typing your title.

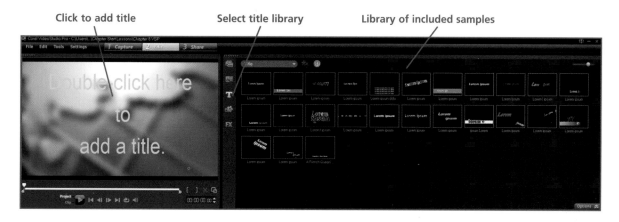

Figure 9.4
Accessing the title text feature.

8. Type in **Our Summer Balloon Trip**, pressing Enter after each word so you have four lines of text all in one text container. Click and drag your cursor back over the text to highlight it. This will allow you to set the formatting using the tools in the Options > Edit panel.

9. Using the T drop-down list (which shows all available fonts), choose a font that has at least a medium thickness. Fortunately, the list also displays examples of what the font looks like (see Figure 9.5). I chose a thick Futura font. If you don't have this one, I suggest Arial Black or something similar. Select the Align Center option above the T font list. Your title will center itself relative to the entire window.

10. Select a light blue or light green font color by clicking the small white color chip under the T font list. Next, choose a font size of 46 and set the line spacing to 100.

11. Click and drag to select just the words Summer and Balloon and make them a darker green. This shows that you can format individual words (individual letters, too!) in a single text block. Your text might look something like what's shown in Figure 9.6. If it doesn't, it's okay; you may have chosen a different font. Adjust the formatting options until your title looks similar.

Figure 9.5
Choosing a font for your title.

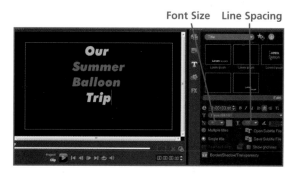

Figure 9.6
Example of a single title.

Creating Multiple Titles

USING THE SINGLE TITLE option means you can only have one text box at any point in time in the same Title track. In other words, you can have multiple titles in a single track, but only if they don't overlap. Adding the extra Title track (for a total of two) meant you could overlap only two titles at most. In past versions of VideoStudio, one quirky feature that helped folks get around the two title (and thus only two overlapping titles) track limitation was that you could have multiple titles within a single title clip. But now in VSX4, there are two ways to have multiple titles that go beyond the two title track limitation. One way is to use the new feature of inserting titles in the Video track and any Overlay tracks. The other is the older way, which is still available, using the Multiple Titles feature. I'll show you how that feature works.

This section will teach you how to add titles in a way that's similar to adding single titles, but then also adding multiple ones, using the same time frame (the same clip) and in the same track. Let's continue the steps from the last section.

1. After typing, click in the window, but outside the text to deselect the text block. Oh wait, you can't. It remains active with the insertion point still blinking where you left it. Click Project, instead of Clip. That will deselect the active text block in the Preview panel and place the text clip in the Timeline the same default length as the color chip. Title blocks also default to a time of three seconds.

2. Double-click the text clip in the Timeline. Try to reposition the text block in the Preview panel. Hmmm, you can't do that either. All it does is reselect the text for editing. Click Project again. (I really am about to make a point here!)

3. Rewind your project to the beginning. With the Title library selected, you'll see the familiar "Double-click here to add a title" instructions. If you create another title, it will only go into the second title track. Click Undo. What you've encountered are the limitations of the Single Title option.

4. Double-click on the title you created in the Timeline. In the Options panel, click the Multiple Titles radio button. Click Yes to the alert box. The previous title you made is now surrounded by a smaller border, indicating it's no longer taking up the entire screen and there is now room for additional titles. See Figure 9.7.

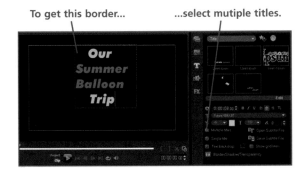

Figure 9.7
Setting up the Multiple Titles option.

5. In the Preview panel, double-click to place another insertion point directly under the other text (but above the safe zone border) and type **Vancouver, Canada**. Using the same tools as you did for other text, format the new line to something different.

Tip

If you select a text block once in the preview window, formatting will change the entire text string. If you double-click a title, formatting will only affect text you have first drag-selected.

6. Deselect the text, reselect it and position it under the other text (click titles once to select and move, twice to edit the text itself). Even though you still have Align Center selected, the new text only aligned itself relative to the new text box, not the entire preview window. Another characteristic of multiple titles is that each is its own customizable text block, independent of any others and of the Preview window.

So, just when you might think that having only two Title tracks is a limitation, you find out that you can actually have as many titles as you want in a single Title track. I recommend just keeping multiple titles selected as I can't think of any instance where you'll need the limitations of the single title setting.

Tip

Although it seems that you can create as many titles as you'll need using just one title track, where you will want to take advantage of the two available tracks is when you want to have them occur at two different time frames but still overlap. For example, you might want one title to display from 0 sec to 5 sec and another one from 3 sec to 8 sec. You'll need to use two tracks for that.

Customizing Your Own Titles

AS YOU CAN SEE FROM THE previous section, using the Multiple Titles option is the way to go. You don't even have to take advantage of it each time, but keeping it selected will ensure that it's readily available. Let's continue taking advantage of the Multiple Titles feature. This section will show you how to add some cool text formatting and maybe even a little animation.

1. Click once to select the top Our Summer Balloon Trip text group. In the Alignment area of the Edit tab, click the up arrow in the top row. This will place the top line of the text at the top center of the title safe area.

2. Click the Border/Shadow/Transparency icon (see Figure 9.8). Click the Shadow tab. Select the Drop Shadow option (second "A" from the left). Adjust X & Y to 7.0. Click the color chip and set the shadow color to white. It will appear gray, since its transparency

is mixing with the black background. Keep all other settings the same. Click OK.

3. Go to the Options > Attribute panel. The Animation radio button should already be selected. Check Apply to activate it. A whole slew of animation choices will appear.

4. In the adjacent drop-down list, choose Pop-Up. In the preset list, choose the first option in the last row. (See Figure 9.9.) Preview your clip. When finished, double-click on the clip in the Title track.

5. Next to the preset drop-down list, click the Customize Animation Attributes icon (the one showing a double-T). In the Unit list, choose Character. Leave Pause at No Pause. Under Direction, choose the down arrow (at the top). Click OK. This will designate the title's anima-tion on entry and will only apply to the "Our Summer Balloon Trip" portion of the title.

Use this alignment choice

Figure 9.8
Advanced title formatting.

Figure 9.9
Animation settings.

6. Add the same animation preset to the Vancouver text by checking Apply, choosing the Pop-Up option, and the first choice in the last row in the preset list. In Customize Animation Attributes, choose the up arrow (at the bottom).

7. Preview your text block. Notice that, because these two text blocks are in the same clip in the Timeline and utilizing the Multiple Titles feature, they both complete their animations at the same time. Save your project.

Tip

You can use grid lines to help you position and line up text. Near the bottom of the Edit tab, check the Show Grid Lines box. The small icon to the right of the check box will open an options window where you can set choices, such as grid size (spacing), grid type (solid, dash, dots, and so on), grid line color, and whether or not you want your items to snap to the grid lines for increased precision.

This grid feature is also available for any objects placed in an Overlay track, except that the grid is accessed via the Alignment icon in the Attribute tab of the Options panel.

Adding Title Effects

ALTHOUGH YOU CAN APPLY any video filter to a title, VSX4 has special effects just for titles. A cool feature of this is that you can apply an effect or filter along with the animation, so you can really go wild. But although you can apply separate formatting and animations to each title in the same multiple titles track, you cannot do so with a filter/effect. A title effect, just like a video filter, is applied by dropping it on the clip in the timeline, so it affects everything in that clip, including the multiple titles that might be in there. Let's see what happens when you apply filters to titles.

1. In the Timeline, select Balloon-2 (the pickup truck). Go to the Title library, but do not choose one of the samples. Going to the Title library makes the Preview panel active for adding text.

2. Making sure the clip is at the beginning, create a title near the bottom of the Preview panel that says, "We're Finally Here!" Click outside the text box to deselect it, but keep it selected for positioning and formatting. The formatting and animation will default to your last settings.

 Feel free to format the title as you like. I used the same font and color as the first word in the first text block at the project's start. Increase the font size to about 55 so it fits across the stage. If your text extends too far, lower the font size a bit until it fits. Set the alignment to the bottom center.

3. In the Attribute panel, click the Filter radio button. Title effects will now appear in the Filter library. Drop the Oil Paint filter onto the clip in the Timeline that you created in step 2. Make sure Replace Last Filter is not checked. Do the same thing with the Zoom Motion filter.

I realize that there may be confusion with regard to filters vs. effects. Selecting the Filter radio button in the Attribute tab to activate the Title Effects gallery of the Filter library can sound counter-intuitive. Just understand that the terms *effects* and *filters* in many cases can be used interchangeably. What I've attempted to do is call the icons and libraries as they are titled in the VSX4 software.

4. In the Attribute panel, move Zoom Motion to the top of the list. Preview your project in this portion. Because of the complexity you've added, it may preview slowly. You can just move the playback head manually to see how it looks at various points. It will, of course, play fine in your exported movie.

5. In the Timeline, stretch the duration to match the length of Balloon-2. Your Preview panel should look similar to the one shown in Figure 9.10 at the end of the clip. Save your project.

Figure 9.10
Applied title effects.

Using Sample Titles

AS WITH MANY FEATURES in VSX4, there is an alternative for those of you who lack either the time or creative ability to make titles from scratch. The Title library has about 35 pre-made titles, all with stylized formatting and built-in animations that can still be customized to your liking. Perhaps the formatting isn't so tough to set yourself, but the animations can be. With the next steps I'll show you the benefits of using the title samples that came with, and that you downloaded to, VSX4.

1. Make sure Ripple Editing is still enabled and that all tracks are locked. Add a black color chip in the background Video track between Balloon-2 and Balloon-7. Extend its duration to 6 seconds.

2. Drop a Crossfade transition at the start and end of the chip. Under the Balloon-2 clip in the background Video track, move Balloon-3 so that Balloon-2 and Balloon-3 start at the same time.

3. Go to the Title library and select the Lorem Ipsum title. Oh wait, they *all* say Lorem Ipsum. Okay, use what should be the 19th title in the library, the one with the white horizontal stripe and blue text on top. Add it to the Timeline right after the title you just made.

4. Extend its duration to 4 seconds to match the end of the color chip.

5. This sample is also a multiple title, meaning you can format different portions of it separately. Double-click the word "Lorem" in the Preview panel. Change Lorem to "Away. . ." and change Ipsum to "We Go!" Preview the project in this area. Although you can change the formatting and animation style, leave them all untouched here. No sense in messing with perfection. Your views should look like those shown in Figure 9.11.

Figure 9.11
Applied sample title.

Using Titles in Overlay Tracks

AS MENTIONED PREVIOUSLY, a new feature in VSX4 is that you can now place titles in any track but audio tracks. This gives you the ability to extend beyond the previous limitation of only having two title tracks (even though the Multiple Tracks option helped). This includes the background Video track, Overlay tracks, and of course, the Title tracks themselves. The following steps will show you how to work with titles in other tracks.

1. First of all, I need you to adjust the position of some Timeline clips again to make room for the next title addition. In the Timeline, move the overlay clips 1–3 from Overlay Track 2 straight down to Overlay Track 3. Move Balloon-4 from Overlay Track 1 to Overlay Track 2.

2. Move the playback head to the start of the first Balloon-7 clip. Select the Title library. Drag the very first choice from the gallery and add it to Overlay Track 1 so that its start aligns with the start of the first Balloon-7.

3. Go to the Attribute tab and uncheck Apply so there are no animations applied to this clip.

4. Double-click somewhere in the center of the Preview panel and type **Family**. Select the text for formatting. In the Edit tab, to the right of the font selection drop-down list and just above the Alignment area, is the Select a Title Style Preset drop-down list. Click it and choose the first option in the fifth row (see Figure 9.12). This will set the font, color, and border for this title. These presets only add text formatting styles, not animation styles, such as you might obtain from the Samples library.

5. Notice that the text block in the Preview panel has resize handles. Instead of guessing and reguessing a font size, click and drag one of the *yellow* corner handles so that it's about half the size of the preview screen (see Figure 9.13). Position the text in the center of the window by clicking the center alignment choice in the Edit panel.

6. Move the Family title clip in the Timeline from its current position in the Title track straight up to Overlay Track 1 at the start of the first Balloon-7. Extend its length to match the length of Balloon-7.

7. First preview the title clip, then preview the project at this section. Save your project.

Figure 9.12
Applying a preset title style.

Drag to resize

Align to center of screen

Figure 9.13
Current title view.

Creating a *Star Wars*–type Title

NEW TO VERSION X3 OF VideoStudio was a rolling credit type style, though it does not have a *Star Wars* animated text style, where the text appears to fade into a vanishing point at the top. I know we *all* want that feature! There is currently no way to edit the rolling credit field or any other text gallery object to do this, but there is a way around it.

In this section, I'll show you how to create a movie that can then be re-imported and tweaked to make a *Star Wars*–type rolling credit.

1. Create a new project.

2. Open the Title library. Drag the sample that resembles a rolling credit (shown in Figure 9.14) to the start of your project. (It's the one that shows multiple lines of text moving vertically from below the bottom of the screen to past the top of the screen.)

 Because of the new feature in VSX4 of adding titles to almost any track, you can drop the title right into the background Video track. Do that. Because your Timeline is empty, this clip will, by default, go to the beginning of the background Video track.

 Because of the effect it contains, this clip extends longer than the default 3 seconds. Extend it to 20 seconds long instead.

Add this title to the Timeline.

Figure 9.14
Rolling credit selection.

3. Double-click the clip in the Timeline to select the title in the Preview panel. Change the font size to 30. Double-click it in the Preview panel to edit the text. Now click and drag to select all the text so that what you do next will replace it.

 Type in something to the following effect. You may have to click outside the text box and move it up occasionally to continue adding additional text. Just make sure that afterward the text box is centered onscreen. The rolling effect will take care of the rest.

 Your most dramatic effect will result from text that reaches all the way across the screen, so use long names! You can also press the Enter key to lengthen it by adding more lines. Here is an example:

The End

A (your name) Limited Production

Producer
(your name)

Director
Supercalifragilisticexpialidocious

Assistant Director
Supercalifragilisticexpialidocious's Assistant

Starring
The Rebel Alliance
A small cast of real actors
A large cast of fake actors
and a
Bunch of other People

(Add more if you like…)

4. Choose Align Center, then preview the clip. Cool, huh? But you're not done yet. It scrolls, but it doesn't *Star Wars* scroll. Go to the Share tab and choose Create Video File. Select WMV > WMV HD 720p. Name it **StarWarsText** and save it in your lesson plans folder.

5. Save your project as Scrolling_Title, close it and re-open your Chapter 9 project.

6. Add a black chip to the end of the main Video track. Extend it to a length of 20 seconds.

7. As a result of sharing your video, your StarWarsText movie is already in the video library. Drag it to the first Overlay track under the color chip. Adjust either clip so the lengths match up.

8. Select the Star Wars clip in the Timeline so that it highlights in the Preview panel. Click on one of the top green skew handles. Your cursor will again be a single arrow instead of a double arrow. If you click and move the wrong one, hit the undo arrow in the Timeline toolbar.

Pull each green skew handle at the top corners (only!) horizontally about 2/3 of the way toward the center yellow resize handle. Your screen should look similar to what's shown in Figure 9.15.

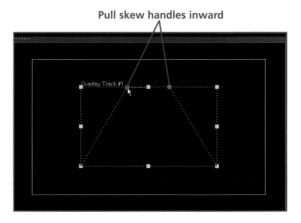

Figure 9.15
Skewing the text window.

9. Right-click inside the clip in the Preview panel and choose Fit to Screen. This will make sure the scrolling text fills the screen for maximum effect.

10. Rewind and preview this portion of your project. Pretty cool, huh?

You might be wondering why the background color chip was necessary and why you couldn't just put the Star Wars file into the background Video track. The reason is because you can't reshape/resize anything in the background layer. By default, anything in the background Video track must fill the entire screen. Adding the color chip was the perfect fix for this situation.

Creating and Using Subtitles

YOU PROBABLY ALREADY know what subtitles are. They were first used in silent films before the time of talkies. They're used today in foreign language films so that the viewer can understand what's going on in a film where the language is well. . .foreign. Subtitles are also used to describe other sounds that indicate action, such as clapping, crowd cheering, thunder, and so on. These are not to be confused with dubbed movies where the audio is someone speaking in a language you understand while the onscreen lips move to another language. (Think old Godzilla movies. . . .)

Subtitles are akin to captions on photographs and can be used for captions on video, too. When using image editing software to add captions to photos, you just have to type in the caption. The software will then automatically place the captions in the exact same location and use the same format for each of the images. Most don't give you a choice of text formatting options either. Subtitles in VSX4 are handled the same way, except that you're using text on video clips and you can customize the formatting. Type in what you want to say, and VSX4 will place the subtitle in the same screen location in each scene. This location is usually centered on the lower one-third of the screen. (The *lower third* is actually a TV production term for a graphic placed in the lower area of the screen, though it's not necessarily the entire lower third as the name suggests.)

The subtitling feature in VSX4 still requires you to create the titles with the desired duration and timeline locations. You then select the titles and save them as a special subtitle file. When re-importing them, VSX4 will use the timecode settings it saved with the subtitle file to place the titles in the same time locations where they were previously laid. In this case though, they'll all be placed in the same positions on screen and you can set different text formatting for each movie you import them into.

This feature works best with longer movies, where the process and time required for batch formatting and precise placement outweighs doing it manually. There are also specific applications for working with subtitles, including Subtitle Workshop by URUWorks that supports the VideoStudio subtitle format (VSF).

Since the lesson videos have little or no dialog, the subtitles you'll create will actually be more like captions, or descriptive phrases, but this is still easier than manually placing text in the exact same spot each time.

First though, you'll need to do some Media library housekeeping.

1. Open a new project.

2. Expand the Library Navigation panel by clicking the Media library icon at the top. Right-click on the Chapter 4 folder and select Rename. Change its name to Washington DC. Change the name of the Chapter 7 library to Balloon Trip.

3. Notice that in the Balloon Trip library, there are three video clips that would be better organized if they were in the Washington DC library, namely the videos Jewels1–Jewels3. Shift-select all three of them (or use Ctrl-select, if they're not sequentially located), then drag and drop them directly into the Washington DC library (see Figure 9.16).

Moving items among different libraries will not break links to them in your movies. This only occurs if you moved the locations of the original files on your PC. Library items, if you remember, are just links to the originals. When you move them to a different library, the links are updated.

The rest of this section will cover setting up a subtitle file for export, then re-importing and applying it to the Washington DC video clips.

1. Go to the Washington DC library and import Washington D.C. videos Jewels4–6. If you like, you can now rearrange the library items so they're in order.

2. Place the Jewel clips (1–6) into the empty Timeline in order. Save this project as **MySubtitles**.

Tip

You can Shift-select or Ctrl-select all the library clips you need and drop them all at once on the Timeline.

Figure 9.16
Moving library items.

3. The next several instructions will ask you to place titles at distinct locations for precise amounts of time. As you did in the previous chapter, to add each text clip, select the Title library icon in the Library panel to initiate the text tools, then double-click in the Preview panel where you want to insert the text. In this case, you want your text to start in the lower-left corner, but it really doesn't matter where you type. The subtitle format will place them correctly in the end.

Tip

When you type, all the formatting from the last time you added text will be used on your new text. Text settings remain until you change them. You don't need anything fancy for subtitles. You want them simple and easy to read. Besides, you can change the formatting when you re-import the subtitles file. Therefore, this time you don't need to choose any of the title samples.

After you place your text insertion point in the Preview panel and before you start typing is when you want to set the formatting. That way, the new formatting will be applied to all your subtitles.

4. In the Options panel > Edit tab, set the font to something common, like Arial. Set the font color to something that will contrast well in any scene, such as black or white, and then choose a small font size, like 12. Set the text justification to Align Left, the line spacing to the smallest setting of 60, and keep the rotation at 0.

5. Go to the Attribute tab. Make sure that Apply is *not* checked under the Animation radio button. Text filters are not carried over from previous text entries, so that setting is irrelevant.

6. Make sure your project is at the start and type your first text: **A French Queen's Diamond Earrings** (see Figure 9.17). Set it for the exact duration of the Jewels1 video clip, and start at 00:00:00. Click in the Timeline to set the title and view it more easily.

Grab the end of the clip in the Timeline and stretch it to the right until it "snaps" to the end of the video clip at 0:00:06:22. Preview the clip to see that all effects are turned off.

Figure 9.17
First subtitle entry.

7. Type in your next subtitle entry: **Crown and Necklace Gifts from Napoleon**. Start: 0:00:11:00. Duration: 0:00:25:00. Use the Preview panel to set the start point (see Figure 9.18). Set the duration by dragging out the end (see Figure 9.19).

Figure 9.18
Clip start time.

Tip

A method to set start and duration values is by manually moving the Timeline clip. Grab the center of the clip (not the end) in the Timeline. As you move it, the timecode number you'll see is the timecode where it will start. To adjust the duration, click and drag the end of the clip. The timecode that appears will then be the duration.

Figure 9.19
Clip duration.

The timecode location in the Preview panel may differ by one frame from the timecode in the Edit tab.

8. Type in your next text: **37.8 Carat Chalk Emerald**. Start: 00:42:16. Duration: 00:11:00.

9. Type in your next text: **Diamonds are a Girl's Best Friend!**" Start: 01:07:00. Duration: 00:11:24.

10. Type in your next text: **Mackey Emerald and Diamond Necklace**. Start: 01:32:00. Duration: 00:18:27 (the end of the clip Jewels5). Preview the project to check for errors.

11. Fit the project to the Timeline. Shift-select all the titles in the Timeline. In the Edit panel, click Save Subtitle File. Name it **Jewels_ subtitles**. Choose English from the language drop-down list (though you can choose a different language to translate to *if* you have that language's font on your system). Save it to your lessons folder. Click Save.

12. Delete all the titles in the Timeline. Rewind your project to the start. This will make room to import and place the new subtitles file. Click Open Subtitle File in the Edit panel. Locate the file you just saved. Before you click Open, you see that you have several formatting options right here that can then be applied to all the text blocks at once.

 Change the font if you like, but realize you don't have the luxury of seeing an example of it before you do so. If you have Futura, change it to that. Change the font size to 18 and line leading to 100. Keep the font color white, and add a black glow shadow. Set Import: To Title Track Number 1 in the list at the very bottom. Click Open. Click OK to the alert box.

There are two benefits to formatting subtitle text before you actually import it. First, it will apply the same formatting to all the text clips in the file so you won't have to do it manually, one by one, after they're placed in the timeline. Second, you can change the formatting to better reflect the background you may be using it for.

Figure 9.20
Finished subtitle.

13. Preview the results. Notice the consistency of the formatting and onscreen placement. (See Figure 9.20.)

14. If necessary, open the Title library again and close the Options panel. Drag the very first subtitle up into the Title library and drop it. By doing so, you now have a library item that is preformatted for future subtitles. You could have also added to a custom library.

 Drag this new Title library item back to the Timeline and drop it at the end of the last subtitle. Extend it to the end of your project. Notice that it's conveniently placed in the

same location and is formatted the same as all the other subtitles. Change the text to say **Ka-Ching!** You may have to adjust the horizontal positioning of the text block.

Subtitles and video captions, as you've now seen, can be a chore to create. Although there are tools out there that specifically work on this feature, VSX4 has the basic tools to do it as well. With a little planning and practice, this tool can be very useful in giving your videos a more consistent, professional look. Not bad for a software application that costs less than $100!

Quick Review

▶ What factors should you consider in creating titles? (See "Font Considerations.")

▶ How many titles can you have at the same time in a single text track? (See "Creating Multiple Titles.")

▶ What new feature in VSX4 provides an added level of title customization? (See "Using Titles in Overlay Tracks.")

▶ What are subtitles used for? (See "Creating and Using Subtitles.")

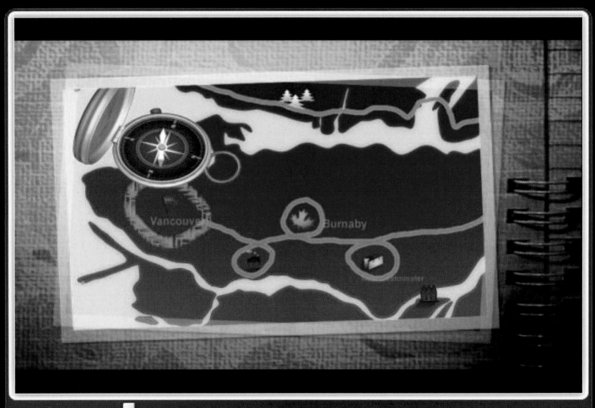

Project
Clip

00:00:17.29

Getting Your Monet on with the
Painting Creator

THE PAINTING CREATOR, introduced in version 12, might possibly be the most unique feature in any video editing application that costs less than $100. The name Painting Creator doesn't even do the feature justice. The Painting Creator allows you to actually draw, write, and/or paint on actual video frames!

Painting on video frames is a common feature in the high-end world of video production. The term is referred to as *rotoscoping*. Rotoscoping is an animation technique in which animators trace over and add graphics to live-action film, frame by frame. The word came from a device called a *rotoscope*. Originally, prerecorded live-action film images were projected onto a frosted glass panel, and then additional graphics were drawn by an animator onto the glass. These two images were then combined to create the final frames. This projection equipment was called a rotoscope. The process is still referred to as rotoscoping, but you can now apply this same process using the VSX4 software instead.

What Is the Painting Creator?

VSX4's PAINTING CREATOR is a feature that allows you to record painting, drawing, and writing strokes as an animation or still, to use as an overlay effect, or as a substitute for a background graphic or video on any Video track.

The Painting Creator contains an art studio full of drawing tools, including pencils, crayons, paint brushes, airbrushes, markers, and more. Once you create a "painting," it will then be rendered out to a file that's added to your media library, which you can then use in your video projects.

The Painting Creator does have some limitations. You can only use one frame as a reference on which to paint. In other words, you cannot paint on a video clip as it's playing. If an object is not moving, it's not an issue. This is very difficult, though, if you want to paint a mustache on someone walking across the room or flames coming out of a moving car. Something to consider.

On the plus side though, you can animate any painting you create and overlay it onto any timeline clip or as a standalone background. The Painting Creator will actually record your painting strokes and play them back as an animation. This chapter will show you how it all works.

To get started, you'll need to open the Painting Creator. Go to the Tools menu at the top of your screen and choose Painting Creator, as shown in Figure 10.1.

Figure 10.1
Launching the Painting Creator.

The Painting Creator Window

This section will introduce you to the Painting Creator window (see Figure 10.2). (Remember that you can pause your mouse over any tool to see a pop-up description.) Understanding the Painting Creator tools, how and why they're grouped the way they are, and what they do will make this chapter much easier for you. This section outlines each Painting Creator tool and its purpose. As before, feel free to click on each one and test it out. (Just don't click OK. This will create a painting that we're not quite ready for yet.)

A. **Canvas/Preview window**: This is where you will do your actual painting and drawing using the painting tools on the top of the Painting Creator window. A slider in the View controls (see "F" in Figure 10.2) will adjust the opacity level of the background. The background image can be of the current Timeline view or other choices.

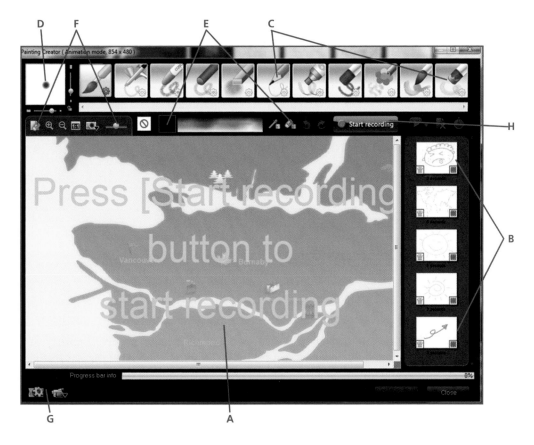

Figure 10.2
Painting Creator window.

B. Art library: (See Figure 10.3 for more detail.) This shows the paintings and animations you've created (1) in the Painting Creator. The tools at the top of the library allow for playback (2), deleting any item (3), and adjusting the clip's duration (4).

Number 5 denotes an item that can't be deleted (built-in samples). Number 6 specifies the item as an animation, as opposed to a still painting. Right-clicking on a library item will also display several of these tool choices for you.

C. Brush panel: This is your box of art supplies. They include, from the left, Paintbrush, Airbrush, Crayon, Charcoal, Chalk, Pencil, Marker, Oil Paint, Particle, Drop Water, and Bristle. When selecting an art tool from the Brush panel, both the tool and the blue gear in the lower-right corner of the thumbnail will become highlighted. Click on this to see a drop-down list of custom settings you can apply to the art tool. See Figure 10.4 for an example.

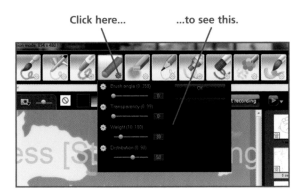

Click here... ...to see this.

Figure 10.4
Art brush adjustments.

D. **Brush Thickness adjuster**: (See Figure 10.5 for more detail.) Use these interactive sliders to set the width (1) and height (2), then view the size and shape of your brush (3). If you click and lock the small padlock (4) in the lower right, you will adjust both height and width at the same time, maintaining the aspect ratio as you resize it. The Oil Paint and Bristle brushes do not have the size locking ability, so using the padlock with those will only create brushes with the same height and width.

Tip

A shortcut for resizing the brushes and maintaining the aspect ratio is to hold down the Shift+Ctrl+Alt keys while adjusting the brush thickness.

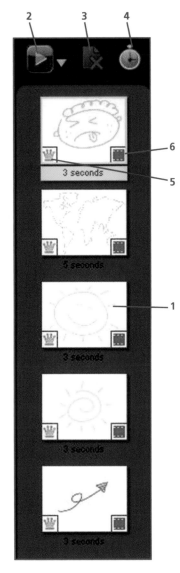

Figure 10.3
Art library details.

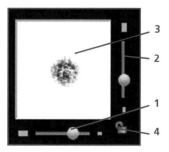

Figure 10.5
Brush Thickness adjuster.

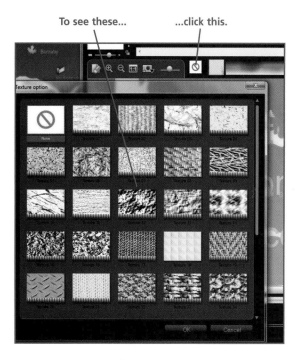

Figure 10.7
Texture option selector.

E. **Color palette**: (See Figure 10.6 for more detail.) Click a color (1) to change your brush to that color to draw/paint with. The color you select will be displayed in the small square to the left (2). You can also click the same color square to select a color from the usual Color Pickers you've used before in VSX4.

Figure 10.6
Color palette details.

Click the Texture option square (3) to the immediate left of the color square to choose a texture to paint with (see Figure 10.7). Painting with textures will respond to any brush you select (dry or wet media). Combine a color and a texture to paint with a colored texture.

Just to the right of the Color palette is the Eyedropper tool (number 4 in Figure 10.6). By default, it is unchecked. If you mouse over the Color palette, your cursor will still change to an eyedropper. The eyedropper indicates that you can choose a color from the palette to draw with.

Something different happens though when you select the Eyedropper tool itself—a red check will appear next to it, indicating that it's been selected.

When you select the Eyedropper tool to the right of the color palette, you can also choose a color from anything in the Painting Creator Preview window. Beware though that the color selected will be affected by the transparency setting of the background image.

Just to the right of the Eyedropper tool is the Eraser tool (5). Click the icon (a red check will appear again) to convert your mouse to an eraser. You can use the interactive Brush Thickness adjuster to change the eraser size too. Be sure to click it again to turn it off when you're done, or you'll keep on erasing.

F. **View controls**: In this tab of controls (see Figure 10.8 for more detail) are from the left, the Clear Preview Window tool (1), Zoom In (2) and Zoom Out (3), Actual Size view (4), Background Image Option button (5) and the Background Image Transparency slider (6).

Figure 10.8
Painting canvas View controls.

One click of the Clear Preview Window tool will clear the entire canvas of your painting, much quicker and easier than using the eraser tool in many cases. Beware that this process cannot be undone.

The Zoom tools work in preset increments to zoom into and out of your painting.

The Background Image Option dialog box (see Figure 10.9) includes options on what background you'll be using as a reference to rotoscope over. The first option, Refer to the Default Background Color, is set by choices explained in the "G" entry of this list. Current Timeline Image comes from whatever is being viewed in the Preview panel of the main VSX4 screen.

Customize Image allows you to reference a separate image, perhaps one that's not even included in your VSX4 project. Click the small Browse button (three dots) adjacent to the empty field to locate your image. Choosing this option will activate two other options at the bottom. The last choice, Auto Rotate Image According to EXIF Information,

means it will rotate the photograph according to information stored inside the photo itself (metadata) that was created and added when the photo was taken.

Figure 10.9
Background Image Option dialog box.

G. **Preferences and Settings**: (See Figure 10.10 for more detail.) Click the left icon to access the Preferences dialog box (see Figure 10.11). Default Macro Duration sets the length of your Painting Creator animation, anywhere from 1 to 15 seconds. (You can also change the duration of any individual item in the Art library by right-clicking on its thumbnail in the library.)

To the right of Preferences is the Settings icon. Use this to set the default drawing mode to either Animation or Still mode. Still mode allows you to create a static painting; Animation mode will record your brush strokes and create an animation out of them. Leave it in Animation mode because it's easy to change an animation into a still, but not the other way around.

Preferences Settings

Figure 10.10
Preferences and Settings icons.

Figure 10.11
Preferences dialog box.

H. Start/Stop Recording: This button toggles on and off the recording process of whatever you paint or draw in the Preview window. It's unique in that it only records actual paint strokes, not the time it takes to change brushes, colors, and so on. This way you can take your time without feeling rushed to create your artwork.

Setup for Using the Painting Creator

BECAUSE THE PAINTING CREATOR is a painting and drawing feature, it would be advantageous to use a drawing tablet with a pen and tablet device to create your art, such as one from Wacom. So if you have one, by all means hook it up.

The next thing you need to do is place the playback head in the Timeline onto the frame you want to display in the Painting Creator Preview window. The frame you select (remember that you can also choose images from external sources) will be carried into the Painting Creator window and

used as a reference for you to paint on. A reference frame is optional, though; you can just paint on a blank canvas, too.

The next few steps will set up your art studio for the painting process that comes after it.

1. In VSX4, open the Chapter 9 file and save it as **Chapter 10**. Make sure your custom library, Balloon Trip, is open. This will ensure that any paintings you create will be saved there automatically.

2. Temporarily, move the two Motion overlays (D05 and F02) underneath the main track's MAP image, over to the left. See Figure 10.12. (You only want the MAP image as a reference.)

3. Place the playback head anywhere along the main track's MAP.jpg image (between the 13- and 19-second marks). You should only see the MAP image in the Preview panel.

Move clips down to line up the ends.

Figure 10.12
Move the Motion overlay clips to the left.

Creating and Applying Painting Creations

NOW THAT YOU NOW KNOW where all the Painting Creator tools are and what they do, you can really get down to business. So let's get you actually painting something and incorporating it into your video project!

Tip

If you possess (or can borrow) a pen-based drawing tablet, I highly recommend using it. A Wacom tablet or similar device will put you into a much more suitable creative environment, where using the various brushes will feel much more realistic.

VSX4 will recognize the Wacom tablet and install an additional settings icon in the bottom-left corner of the Painting Creator window (see Figure 10.13). There, you can toggle basic Wacom tablet controls for brush size, brush transparency, or both. When either of these options is enabled, your tablet will reference those attributes you've set in the tablet's preferences.

Figure 10.13
Wacom tablet settings.

The following steps will show you how to paint an animated path on the MAP image showing the route the balloon trip family took on their adventures.

1. Make sure the Timeline playback head is still somewhere over the MAP image and that the Painting Creator application is open. In the Brush panel, choose the Paintbrush (first brush on the left).

2. Lock the brush size aspect ratio by clicking the padlock on the Brush Thickness adjuster.

Tip

If you forget to lock the brush size aspect ratio and find that you accidentally created an odd sized brush, simply lock the padlock and adjust the size again. It will automatically return the brush to an even horizontal/ vertical size so that you can start over.

3. Size the brush to around 11. As you make an adjustment, the brush size will be displayed adjacent to the brush tip.

4. Choose a blue or green color. This will contrast nicely on the MAP image.

5. Set the Background Transparency slider to about 1/3 from the left side. See Figure 10.14.

6. Click the Start Recording button in the upper right area. You don't need to start drawing right away. The Painting Creator only records your paint strokes, not the duration that the Start Recording button is active.

Tip

You do not have to start drawing just because the recording function is on. The Painting Creator does not record based on time, but rather on what you actually draw, so you can take your time to get it right. It will not record anything you undo, so you can undo and redo any stroke or clear the entire screen and restart. A stroke is considered a single line you lay down, not the entire painting. It will record anything you erase, though, as that is considered a paint stroke, so keep that in mind. You can also practice painting before doing any recording.

7. Draw a path similar to the one shown in Figure 10.15. If you make a mistake or want to start over, use Undo or click the Clear Preview Window icon (also Ctrl-N). You can redo your drawing as many times as you like without having to stop recording. It will only record the final drawing you make.

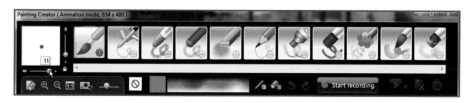

Figure 10.14
My brush settings.

Start End

Figure 10.15
Recording your drawing.

8. To highlight the final destination, change your brush size to about 20, and change the color to red.

9. Using the tool to the right of the Background Image Transparency slider, add a texture to your brush, something with a very tight pattern. It will show up better on a paint stroke.

10. Draw a circle around Vancouver that connects to the end of the path you just created. The texture you chose will be reflected in the paint stroke.

11. Click Stop Recording. Your painting is immediately added to the Art library on the right. However, it has not yet been added to your video library outside of the Painting Creator. Notice that the drawing shows only the paint strokes and does not include the background map. Remember that the background image used in the Preview window is only there as a reference. Because of this, many paintings can be reused on different backgrounds or as standalone paintings, if you like.

12. Right-click on your new Art library item (which is at the bottom of the list) and choose Change Duration. Change it to 6 seconds. (The default length is 5 seconds and the maximum length is 15 seconds.)

13. Click the Play button above the Art library to preview what you've created. After you play the painting, it will clear the Preview window so you can create another one if you like. It's not ready to be included in your video gallery just yet, but this gives you a chance to see if you like what you made. If you don't like it, right-click on the item in the library and choose Remove Gallery Item, then start over again. Remember that you can also use the Clear Preview Window tool before stopping the recording to try again, too.

14. Click OK. This will render the painting to a file compatible for use in your VSX4 Timeline. The Painting Creator application will then close and save your painting to the video library you currently have open, in this case, your Balloon Trip library. Give the application a couple minutes to save your file.

Tip

When in the Painting Creator, clicking OK while any gallery item is selected will render that item to the currently open library.

15. To change the file name, click the name in the library under the thumbnail and type in **Map_Painting**.

Similar to other media elements, the name you apply to a Painting Creator file in your library is not kept when you put the clip into the Timeline. It will instead resort back to the original file name, but only in the Timeline.

CAUTION

16. From your Video library, place your new painting clip directly beneath and in sync with the MAP image in the main Video track. It should already be the same length as the MAP image (6 seconds).

17. Move the two clips (MotionD05 and MotionF02) that you previously set aside back to where they were, in line with the MAP and Map_Painting clips (see Figure 10.16).

Move clips back to the right. Place painting file here.

Figure 10.16
Timeline view with painting inserted.

18. Preview this section of your project. Nice, huh? Shall we do another one? That was a rhetorical question, by the way. . . Save your project.

19. Near the end of your Timeline, drop the DSC03700 image (the single hot air balloon) to the main Video track right before your *Star Wars* rolling credits. Extend its length to 10 seconds.

20. Double-click the balloon image to open the Options panel. In the Photo panel, make sure that Resampling Option is set to Fit to Project Size. See Figure 10.17. This is a convenient situation where changing the aspect of the image doesn't make it look strange.

Double-click the image Choose Fit to Project Size

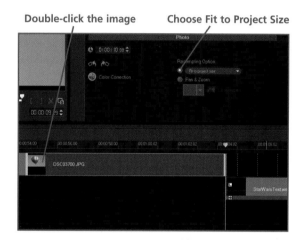

Figure 10.17
Adding and resizing a Timeline image.

21. Place the playback head over the image, just as you did with the MAP image, and launch the Painting Creator application again.

22. Stick with the same Paintbrush tool, choose white as your color, and a brush size of about 11.

23. Click the small gear in the Paintbrush's thumbnail to access the brush settings. Set the Soft Edge to around 75. You can only use the slider, so just get as close as you can. Click OK.

24. Click Start Recording and outline the balloon similar to what's shown in Figure 10.18. As before, your recording will play back in the order that you paint. Therefore, what I did was first outline the balloon, then outlined the stripes of the balloon, scribbled inside them, then wrote the words as a finale. If you make a mistake, use Undo. If you use the Erase mode (unlike undo or restart), be aware that it will record the process of erasing (unless you want that, of course).

Figure 10.18
Balloon painting.

25. Click Stop Recording. Right-click on the new item in the Painting Creator library and change the duration to 10 seconds. Click Play to preview.

26. Click OK to render your new painting and save it to the same Balloon Trip library.

27. Back in the main VSX4 view, rename your new painting **Balloon_outline**.

28. Place your new clip under, and in-line with, DSC03700. Preview this section.

Quick Review

▶ What is Rotoscoping? (See "Chapter 10 Introduction.")

▶ Name the two types of Painting Creator files you can make (See "What Is the Painting Creator?")

▶ Name at least five different brushes available to draw with. (See "The Painting Creator Window.")

▶ Describe the process of creating and adding a Painting Creator file to your video library? (See "Creating and Applying Painting Creations.")

▶ To prevent starting all over again, what should you do if you make an error when painting? (See "Creating and Applying Painting Creations.")

Stop-Motion Animation and Time-Lapse

Photography

THE TWO FEATURES THAT are covered in this chapter are brand new to VideoStudio Pro X4, again, adding amazing functionality and just plain fun for an application costing less than $100. You may or may not be familiar with these terms, so I'll take some time to explain them before discussing how they're applied in VSX4.

What Is Time-Lapse Photography?

TIME-LAPSE PHOTOGRAPHY IS the process of making something that normally moves and changes very slowly seem to occur much faster. This is done by taking a series of photos over a long period of time (e.g., hours, days, or longer) at intermittent intervals (e.g., every 1 min, 30 minutes, or once a day).

Stringing all these photos together in a timeline and playing them back at normal video speed makes whatever you shot over that long time period condense into just a few seconds or minutes. Think of the blooming of a flower that normally takes an entire day occurring in only a minute's time. You can set up a time-lapse system to record the snowfall from a blizzard accumulating in a few seconds when it actually took a day or more. A common thing to shoot is a normal day from dawn to dusk and then the night's lights as they come on and the moon rises.

Time-lapse can be taken with either a regular photo camera or a video camera. Obviously, you want to use a digital camera, so the files are ready to use without any conversion needed. Many photo cameras have the ability to take a photo holding the shutter open for an extended period of time. This is commonly called time exposure photography and technically called *long-exposure photography*. By holding the shutter open long enough for an object to move, you can create the effect of motion blur (see Figure 11.1). But this is not time-lapse, in that it only creates one image. Time-lapse creates multiple images, so each one is crisp and clear. Playing a sequence of images creates a sense of motion, but without the blur.

Some cameras have a built-in time-lapse shutter ability where you can set how often a picture is

Figure 11.1
Motion blur example.

taken, how long the shutter stays open, and how many pictures you want to take. For those who don't have it, you can purchase an external "shutter controller" that will do this for you. It controls the shutter release on your camera. You should also incorporate a tripod to keep the camera still for the duration of your shoot.

Many digital video cameras also have a time-lapse ability through a feature called *interval recording*. In this case, in the camera's menu, you tell it how many frames you want to shoot each time and how many times you want to do the shoot. Sometimes, it'll just go until either the battery dies or you run out of storage space. Creating a video using a built-in time-lapse feature saves on storage space in your camera. You can still create a time-lapse video in VSX4 of a video captured at regular speed by just speeding up the clip in the Timeline. VSX4 will toss out unnecessary frames at that stage of the process instead. The downside to that is, if you want to shoot a time-lapse sequence and just shorten it afterward, you'll have to shoot for hours to get what you want. Not a very efficient use of storage space.

Creating a Time-Lapse Effect

YOU'RE GOING TO CONCENTRATE on creating a time-lapse video from a series of photographs from a digital still camera. Included with your lesson files is a folder called Time-lapse. Inside it is a sequence of over 800 digital photos spanning the length of a day overlooking the city of Taipei, Taiwan. Can you imagine having to import all these photos into one of your project libraries?

You probably remember that you can import media straight into the Timeline, bypassing libraries, via the File > Insert Media File to Timeline command > (Insert video, digital media, and so on). VSX4 has an additional choice now, called Insert Photo for Time-lapse/Strobe. The command in this process will also give you additional options, specifically geared toward time-lapse.

You might be thinking why you just can't import the photos to the Timeline using the normal File > Insert Media File to Timeline command > Insert Photo. You can, but the issue here is that a photo would be placed on the Timeline for a duration of 3 seconds (90 frames) each. Doing it this way would make your video 41 minutes long! Using the VSX4 Time-lapse feature makes each image last only one frame.

Now that you understand what time-lapse is and how it works, it's time to put this into practice. To create a Time-lapse effect in VSX4, follow these steps.

1. Open VSX4 as a new project. Save it as **MyTimeLapse**. Create a custom library called Chapter 11 and open it. You'll use this library to save all the movies you'll create in this chapter.

2. Select File > Insert Media File to Timeline > Insert Photo for Time-lapse/Strobe. Locate and open the Time-lapse folder. Just in case there are other files in there you won't need, select JPG from the Files of Type drop-down list.

3. Click anywhere in the images window, press Ctrl+A to select all the images, and then click Open. The Time-lapse/Strobe dialog box will appear. (See Figure 11.2.) You'll try this process with different settings so that you can see the differences in the video, but first let's learn about the options. I'll start at the bottom of the dialog and work up.

Figure 11.2
Time-lapse/Strobe dialog box.

▶ **Total Duration:** At the very bottom, above the OK button, is the total duration of your video, if all the images were used in the Timeline. There are 808 images in the timeline. 808 divided by 30fps (frames per second and normal video playback speed) equals a video of length 26 seconds and 28 frames long, or just short of 27 seconds. Watch this number change as the choices above it are altered.

▶ **Keep field:** Displays how many frames in a row you would like to keep.

▶ **Drop field:** Displays how many frames you want to discard in between the frames you want to keep.

▶ **Frame Duration:** This allows you to set how many frames each frame you keep will last on the Timeline.

▶ **Preview:** You can click the Play button to preview any setting before adding it to the timeline.

In conclusion, you can tell VSX4 which frames to keep, for how long, and which frames to delete. The limitation is that these settings apply to the entire sequence—you can't designate the display of non-sequential frames. You would have to do this manually in the Timeline, and it would play back weird anyway.

The top portion displays one example of what frames are saved when certain options are used.

4. Leave the options at Keep: 1 frame, Drop: 0 frames, and Frame Duration: 0:0:0:1 (1 frame). These are the most basic options and keep all the photos you took at one frame duration each. Click OK.

5. Fit the project in the Timeline window. (See Figure 11.3.) Your Timeline will show a series of many, many vertical lines. Remember there are 808 images in there. By clicking the plus (+) magnifying glass in the upper right of the Timeline, zoom in five times, and you'll finally start seeing individual frames. In the Preview panel, click the Enlarge icon to play back at full screen. Play the sequence to preview it. Hit the Escape key when done to return to the regular view.

Figure 11.3
Timeline view of 808 images.

Now let's try some different options when you import the sequence of images. Select Undo or Ctrl+Z to empty the Timeline.

1. Repeat steps 2 and 3 to grab the same 808 images again and return to the Time-lapse/Strobe dialog box.

2. This time, keep 1 frame and drop 4 frames. Notice the updated duration, and click OK.

3. Fit the project in the Timeline window and play it back. Notice that even at such a speedy playback, the motion is still pretty smooth. Try playing it back at full screen, too. Undo and repeat to return to the Time-lapse/Strobe dialog box again.

Creating a Strobe Effect from a Time-Lapse Sequence

BY HOLDING FRAMES (duplicating them) for longer than 1 frame, you can create the impression of a strobe effect. A strobe effect (think of the 1970s disco scene) will appear to freeze motion with each flash of light, or frame, go out for a time, then flash again with objects in new locations. This makes videos appear jumpy. The more you hold the frames (or actually duplicate them), and the more frames you drop in between, the jumpier the appearance.

The following steps will show you how to create a strobe video effect using the Time-lapse options.

1. Repeat the process of importing the 808 images into the Time-lapse/Strobe dialog box. Keep 1 frame, drop 2 frames, and increase the duration to 4 frames (see Figure 11.4). The video remains close to the original length, but will now seem to jump from one frame to the next and hold a bit longer. Click OK. Enlarge the view and click Play. Watch the clouds and the cars on the bridge to notice the effect.

Figure 11.4
Detail of the Time-lapse/Strobe dialog box selections.

2. Undo. Increase the previous effect by repeating step 1 and keeping 1 frame, dropping 4 frames, and holding each kept frame for 8 seconds. Now the effect should be very evident. Click OK and preview this setting as well.

3. You cannot, in the current video format, add effects to this sequence of images in the Timeline because each image is treated as a separate clip. You'd be adding effects separately.

 The best thing to do is save it as a video clip, then bring it back into your Timeline to replace what is currently there. Make sure your Chapter 11 library is open. Go to the Share step and click Create Video File. Save the sequence as a WMV > WMV HD 720 30p to your lessons folder. After it's done rendering, a link to it will be placed in your Chapter 11 library (assuming you had the library selected before you started the render), and it will start playing in the Preview panel.

4. Hit the Undo arrow in the Timeline's toolbar. If this doesn't empty the Timeline, click anywhere in the Timeline to activate it, press Ctrl+A and hit your Delete key. Bring your new MyTimeLapse.wmv clip from the library into the Timeline.

5. Go to Filter library. Drop the Bubble effect on to the Timeline clip. This effect actually reflects parts of your video into the bubbles. Double-click the Timeline clip to open the Options panel. In the Filter preset drop-down list, double-click the last choice on the second row (see Figure 11.5).

Figure 11.5
Choosing the Bubble effect preset.

6. Click Customize Filter. In the Basic tab on the lower left, adjust Density to 40 and Variation to 80. This will create more bubbles and increase the size variations from small to large. Click OK and preview your movie. It's even better in full-screen mode.

7. From the Filter library again, drop the Brightness & Contrast effect onto the video and choose the last preset in the second row. Preview your video. Save your video with both effects as **Mytime-lapse-effects** using the same WMV choice as last time.

Creating a Strobe Effect from an Existing Video

YOU CAN ALSO CREATE THE same strobe effect using an existing video clip. It will do the same thing as it did with a time-lapse sequence, by dropping some frames and increasing the duration of others.

This technique would not make sense for the city scene we worked on earlier. It's only logical for shorter scenes. You wouldn't want to take a single all-day-long video shot of Taipei, only to drop frames and make it a time-lapse, would you? You would just use the Time-lapse feature instead. The original video would be 18 hours long and take up, who knows how much amount of storage space.

1. Clear your Timeline.

2. Open your Chapter 11 library and import from your lessons folder the three videos from Kauai. Place all three videos in order (1,2,3) into your Timeline. Fit your project into the Timeline window. Deselect the three clips and reselect just the Kauai1.avi clip. Preview this clip before any adjustments are added.

3. Right-click on the Kauai1 clip in the Timeline and select Speed/Time-lapse. The Speed/Time-lapse dialog box will open (see Figure 11.6). You used this dialog earlier in Chapter 4, when you adjusted only the speed of a video clip.

Figure 11.6
Speed/Time-lapse dialog box.

4. Let's alter Kauai1, but try to keep it as close to its original length as possible. The Original Clip Duration value, in the center of the window, indicates this clip is 52 seconds, 29 frames long, for a total of 1589 frames. Notice there is not a Drop frames setting. In this case, the Speed setting will take care of this for you. Set the Frame Frequency to 4, and click the Preview button at the bottom. A preview will display in the Preview panel in the main window.

 Notice the strobe effect that's created. Remember that if you have a frame duration of 2 frames or more, this will happen because the video pauses, then moves, pauses, then moves, and so on, creating a staccato effect. The effect will only increase with higher frame frequencies.

 Also notice that the duration has remained exactly the same. This happens because you kept the speed at 100%. The Speed setting determined what frames were dropped to maintain the desired speed. Click OK.

5. Right-click on the Kauai2 clip in the Timeline and select Speed/Time-lapse again. Click Preview to see the original. This time, set Frame Frequency to 4 frames and the Speed to 200 (either type it in, use the arrows, or the slider) and preview. This really destroys the video and interferes with the audio, too. Not liking it? Return the Frame Frequency to 0 frame and preview it. Still not the best, but it's better. Now you know you'll need to consider any audio in a clip when doing any time-lapse effect. Click OK.

6. Right-click on the Kauai3 clip in the Timeline and select Speed/Time-lapse. Click Preview to see the original. This clip just begs for anything to speed it up. Increase the Speed all the way up to 600 and preview it. It might play a little choppy the first time. Preview it again, if necessary. Increase the Frame Frequency to 8 and preview it again. Click OK. All the clips should now reflect their new, mostly shorter, durations.

7. Drop the video filter Fish Eye on to the Kauai3 clip and preview it.

In conclusion, you have learned that time-lapse photography and time-lapse video is a combination of increased playback speed and dropped frames. Adding frame durations of longer than one frame, along with higher speed and dropped frames, will create a strobe effect.

Where creating a time-lapse video from a series of photographs can have artistic, but also technical, even scientific purposes, creating one out of an existing video is really just for fun and creativity.

Let's now tackle the other big new feature in VSX4—stop-motion animation.

What Is Stop-Motion Animation?

STOP MOTION, ALSO REFERRED to as *stop action*, is the process of making an object appear to animate, when it's normally unable to do so on its own—in other words animating an inanimate object. Examples can be a Transformer toy that transforms from a car to a robot. You know it doesn't do this on its own, but you could take photos of small, incremental position changes at each stage of its transformation. You would move it, take a picture, move it again, take another picture, and so on. If you string these photos together into a video, it would look as if the toy was transforming on its own, without any human intervention, assuming of course your hands don't appear in the video! Similar techniques can be applied to action hero figures as well as LEGOs and other objects.

Another example is the technique called Claymation. You might be familiar with the Wallace and Gromit cartoons and movies by the famous Claymation expert, Nick Park (www.wallaceandgromit.com). Claymation originates from the process of molding each character from clay.

Claymation is popular because of the ease with which you can create and pose unlimited characters and objects. Stop motion can be an extremely tedious process, especially for something so exacting as Claymation. You need to determine how many frames each position needs in order to make the animation look realistic, as well as how much to reshape an object so it doesn't look like it's moving too fast or too slow. The big plus side to this cool technique is its low cost; anyone can do it using even household objects. You can even practice stop motion animation by making a coin move across the table.

Stop Motion in VSX4

CREATING STOP MOTION IN VSX4 is a record/capture process; therefore, you'll be working in the VSX4 Capture step for this section, It will also be necessary for you to have a capture device, such as either a digital video camera or webcam. Obviously, a DV camera would be easier to maneuver and position for the best shots, but in a pinch, a webcam can still work for you.

> VSX4's Stop Motion animation feature works with any webcam supporting Microsoft's DirectShow media capture and playback architecture.

If you have a DV camera, connect it to your PC as described in Chapter 4 in the section, "Importing via the Capture Tab." You will not need a storage device (e.g., mini-disc or DV tape), as you'll be capturing directly to your PC. If you only have a webcam and it's either connected or built in, VSX4 will recognize it and turn it on automatically, using it by default for this feature. If you have both, you will be able to select which one you want to use via a drop-down list when you launch the stop-motion operation.

Remember that the idea of stop-motion animation is to create motion out of something where no motion is expected or naturally occurring. There are no demo clips included to work with here, you are on your own, but with my guidance, of course! You'll create two levels of stop motion. You will need your dining room table or a similar surface that has at least a 2×2-foot square area cleared so objects can move around without interference. Don't worry about background noise, as this process does not capture audio.

The first attempt will be an easy one using the Auto Capture technique and some coins moving around your table. For this, you'll need four quarters and a silver dollar, or five pennies and a nickel.

The second test will be using the manual capture feature, so you'll have more time to set up each scene. This allows you to use a more complex object to reposition, such as a Transformer toy (what I'll be using). You could also use a Rubik's Cube to show how to solve it (I won't be using one of those, I'm not that smart), or a jigsaw puzzle in the act of being completed (could take you awhile, so maybe a small puzzle).

Capturing Stop Motion Automatically

These steps for the automatic technique may seem intimidating at first, but you can repeat them until you're happy with the results. I want you to learn this method because it will make the manual process seem SO much easier. This method is perfect if you're comfortable with repositioning your objects quickly.

1. Clear your Timeline.

2. Go to the Capture step and select Stop Motion (see Figure 11.7). The Stop Motion window will open (see Figure 11.8).

Capture tab Stop Motion option

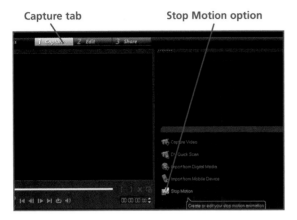

Figure 11.7
Launching the Stop Motion feature.

Figure 11.8
The Stop Motion window.

3. At the top, name your project **Coin Duel**.
 If you're using just your webcam, it will turn
 on automatically and you should see yourself.
 (Eeek!) If you have a digital video camera
 connected, turn it to the Record position
 (VSX4 will take a moment to discover it) and
 VSX4 will ask if you want to use this device.
 If you click Yes, give it a minute or two, and
 its view will show up in the Stop Motion
 preview window, replacing the webcam view.

You may also choose your desired device
from the drop-down list in the top-right
corner of the Stop Motion window.

4. In the drop-down list adjacent to Save to
 Library, select Chapter 11. If you forgot to
 create this library, click the plus sign (+) to the
 right of this list to add a new library folder and
 name it Chapter 11.

5. Next to Auto Capture, select Enable Auto
 Capture (the first button on the left). See
 Figure 11.9.

Figure 11.9
Enable Auto Capture button.

1. Click the Set Time button to the right, as
 shown in Figure 11.10. In the Capture Settings
 dialog box, set Capture Frequency to 0:0:5
 (5 seconds). Set the Total Capture Duration to
 0:1:15 (1 min, 15 seconds). These settings
 will provide you with 15 shots, each taken
 5 seconds apart.

 Leave the Onion Skin slider where it is.
 This feature allows you to set a transparency
 of the previous shot, and at the same time,
 compare the previous shot to the shot you're
 about to take. (See Figure 11.11.) Think of
 the term *onion skin* as akin to using tracing
 paper that allows you to draw while seeing
 the previous image underneath, which you
 can use as a reference.

Set Time button

Figure 11.10
Stop Motion feature Capture Settings dialog box.

Figure 11.11
Onion Skin feature.

I would suggest grabbing a pencil and blank piece of paper and storyboard your 15 shots (see Figure 11.12). It need not be elaborate at all; it's just enough planning so you can quickly refer to and create these moves in the set time. If you need more time, feel free to increase the capture frequency. You'll also need to increase the total capture

time to compensate. Take the frame duration and multiply it by how many frames you want to arrive at the total frame duration (e.g., 5 seconds frame duration × 15 shots = 75 seconds, or 1 minute, 15 seconds). It might be easier to attempt the settings listed here first, then try yours.

Figure 11.12
Simple storyboard.

7. Read through this step *completely* first before attempting.

After you hit the red Record button, the first frame will be captured immediately, so make sure it's positioned correctly. After that, you'll have 5 seconds to move the coins into their next positions before the next shot is captured. Each captured shot will be instantly deposited in the tray at the bottom of the Stop Motion window. This can be a tough process, as one mistake will throw off your whole sequence; but give it a try anyway. You won't hurt anything by trying, and you can always start over.

When your coins are in the starting position (refer back to Figure 11.8), and you're mentally and physically prepared to reposition the coins after each shot, hit the Record button. Keep repositioning after each shot, and be sure to get your hands out of the way. Watch for the new frame to appear in the tray and then reposition your coins again, until all 15 frames are captured into the tray.

The recording will stop automatically when the total set time has been reached. All the frames you captured will appear in the tray (see Figure 11.13).

Last frame Captured frames

Figure 11.13
Completed captured frames.

Did you do it? If not, don't be discouraged. (I SO did not do it right the first time, nor the second time either). If you're going to try again, select all the captured frames in the tray, right-click and choose Delete, then repeat this step again. You won't be doing anything wrong by trying again.

8. If you want to keep what you've captured, click the Save button on the bottom of the Stop Motion capture window. Then click Exit to leave the Stop Motion window and return to the Capture step window, and see your new capture movie in the Capture library with a file extension of .UISX (the Ulead Image Sequence capture file format).

9. Return to the Edit step. Your animation will be visible in the Chapter 11 library (assuming that library was open beforehand). Add the .UISX file to the Timeline, and then fit the project to the Timeline window. Right-click on the Timeline clip to access the context menu (see Figure 11.14). Items to note:

 A. You cannot adjust the Speed/Time-lapse of this clip in its current format.

 B. You can edit the clip by right-clicking on it in the Timeline and choosing Edit in Stop Motion from the context menu. You may want to do this to delete unwanted frames or add additional ones to the end.

 C. Because this is an image sequence in a video container, as opposed to an actual movie clip, you can still split the animation back into its separate images.

Figure 11.14
UISX Options menu.

10. I think this coin animation goes a little too fast. We can't adjust the speed in the Timeline, so do we need to start all over? Nope. Right-click on the clip and choose Edit in Stop Motion. Click OK in the warning box.

11. Adjust the Image Duration to 10 frames. At the bottom of the screen, click Save, then Exit. The Timeline clip will double in length and, when previewed, will play at half speed.

12. Try adding video effects for additional flair. Try FX Ripple or Kaleidoscope or Light or RotoSketch.

13. Go to the Share step. Create Video File > WMV > WMV HD 720 30p. Name it **MyStopMotion1**. As an option, when it's finished rendering, replace the clip currently in the Timeline with the new movie you just made and that is now in your library. Afterward, if you right-click on the clip in the Timeline, you'll see that the normal video options appear, as well as in the Options panel.

Capturing Stop Motion Manually

I'm about to make the previous section a whole lot easier for you by letting you snap Stop Motion frames when *you're* ready, not when the timer says so. You have to promise though that you'll find a much more complex item to maneuver. I would like you to find an object that will look cool animating forward as well as backward. I used a Transformer robot toy. What? You think I'm kidding?

1. Return to the Stop Motion window (via the Capture step). Choose either your webcam or digital video camera to use again.

2. Set up your object for the first frame. Name your animation **MyStopMotion2**. Set your image duration to 10 frames. Click the Disable Auto Capture button (see Figure 11.15). Now you will not need to hurry up and position your objects between frames; you can take your time.

Told you I had a Disable Auto
Transformer! Capture

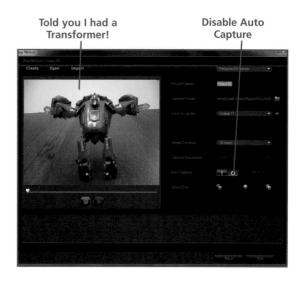

Figure 11.15
Disabling the Auto Capture option.

3. When you're ready for the first shot, click the red Record button. It will snap only one frame. Keep doing this through one sequence of building or breaking down your object. Either build it or break it down, but don't go both ways, you won't need to. You'll see what I mean shortly.

4. When you're finished, click Save, and then Exit. You can just click Exit, too, and it'll ask if you want to save the animation.

Tip

You'll notice that after the first frame is shot, the preview window dims somewhat. This occurs because the Onion Skin feature switches on. If you want to compare the previous frame without the Onion Skin feature, you can either move the slider all the way to the left, or just click the previous (or any) frame in the tray, and it will turn off temporarily. Click the Record button just once to return to capture mode and turn Onion Skin back on. Click Record again to take the next shot.

5. Return to the Edit step and make sure your new stop-motion animation is in your library. It should be titled MyStopMotion2.uisx. Clear your Timeline and place your new clip into it. Fit the project in the Timeline window. Drop the same clip again at the end of the first one. You should have two of the same MyStopMotion2.uisx clips in a row. Fit the project in the Timeline window again.

6. Select the second clip in the timeline. In the Options panel, select Reverse Video. Rewind and preview your project. Your object (and my Transformer) will now build up and break down in one sequence. Save it as a .WMV video as before, if you desire.

I put examples of my time-lapse and stop motion animations in the Lessons folder. It's nothing professional; I just used the same tools and instructions I've covered in this chapter. In case you were wondering, for this last sequence, I used the Transformer Cliffjumper.

Conclusion

S O, THERE YOU GO. Along with the Painting Creator, the Time-lapse and Stop Motion features are probably the coolest and most unique features you'll find in VSX4. Hopefully, this chapter has taken the fear out of attempting these features on your own. As with all software, you can't break anything by trying. You can either undo steps or delete entire processes and start over. If you feel you were overwhelmed by this chapter, go through it again. I guarantee that feeling will pass.

Can you distinguish the difference between time-lapse photography and stop-motion animation? Time-lapse captures real objects and places going through their processes. Normally lasting hours or days, this process shortens them to minutes or seconds, so you can see what occurs much more quickly, saving time and storage space.

Stop-motion animation creates motion from inanimate objects by manually adjusting them to create a sense of motion or activity. This can be for entertainment (Claymation), simulation (my Transformer animation), or for training purposes (product assembly).

The next chapter will cover other advanced features. Although ones that are simpler and perhaps less creative in nature, they are no less important; in fact, they're perhaps even more important for purposes of efficiency and group collaboration.

Quick Review

▶ Describe time-lapse photography (See "What Is Time-Lapse Photography?")

▶ In time-lapse, what is the result of increasing frame durations? (See "Creating a Strobe Effect from a Time-Lapse Sequence.")

▶ Describe Stop Motion animation (See "What Is Stop Motion Animation?")

▶ What is the Onion Skin feature used for? (See "Capturing Stop Motion Automatically.")

▶ What was the name of the Transformer toy I used for the Stop Motion example? (See "Capturing Stop Motion Manually.)

<div style="text-align: right;">

12

</div>

Advanced

Features

T HIS CHAPTER ON ADVANCED features brings you close to the end of learning all there is to know about capturing and editing your videos in VideoStudio Pro X4. VSX4 has many extra features that, if it weren't for this book, you might not even bother to explore. While they're not necessary for creating a quality video production for the beginner to intermediate videographer, they can make finishing and sharing your projects quicker and easier.

Here are some of the features I'll cover in this chapter: Creating custom mask frames and making your own screensaver will allow you to advance your creativity. Batch conversion allows you to concentrate more on the creative part of videography by taking out the monotony of file maintenance and reducing the time of processing multiple files individually. Creating a Smart Package will organize your project in a way that makes it easier to share with colleagues so that they can also work on it. Smart Proxy Manager makes working with large HD video files a breeze by avoiding the sluggish performance normally associated with editing and previewing such memory hogs. The Movie Template Manager will help you create reusable settings when sharing your movies. Chapters divide your DVDs into, well, chapters. Cue points are markers, or notes, you can add that will also assist you in working in a collaborative environment.

Although titled "Advanced Features," the features covered in this chapter are all very easy to use. Let's try some out.

Creating a Custom Mask Frame

BACK IN CHAPTER 7, in the section "Applying a Mask Effect," I made mention of the ability to import and apply your own custom masks created in image editing software. Here are the steps for creating a custom mask frame in Corel's Painter application. I used Painter because of the abstract painting effect I could easily create, You could also consider Corel's PaintShop Photo Pro or Adobe's Photoshop.

1. Open up Painter or any other image editing application. Open a new canvas/file/window and size it as follows: Width = 800, Height = 500, and 300 pixels per inch.

2. Use the paint bucket to fill the canvas with black.

3. Select a paintbrush. Use a Gouache or Felt Pen to make a solid mask. Use something like a Real Bristle or Impressionist brush to make a variable patterned fill. Select white as your brush color.

4. Paint your mask shape as shown in Figure 12.1. Remember that your video will show completely through anything that you paint white. It will not show at all anywhere that is black. It will also show through anywhere that's a shade of grey, but only to a certain degree. The closer the color is to white, the more of your video will show. The opposite is true where the color is closer to black. This is how masks work. The more white, the more you see.

Figure 12.1
Custom mask created in Corel Painter.

5. Save the file as **Mymask.BMP** to a convenient place that you'll remember. If you can't save as a BMP, a good backup format is PNG.

6. Open your VSX4 Chapter 10 project and save it as Chapter 12.

7. Toward the end of your project, directly under your second Painting Creator file, add the intro family.jpg image (from your Balloon Trip library) to Overlay Track 2. Make the length match that of the clips above it.

8. In the Preview panel, make the image smaller and tuck it down to the lower-left corner (see Figure 12.2).

Creating a Time-Lapse Effect

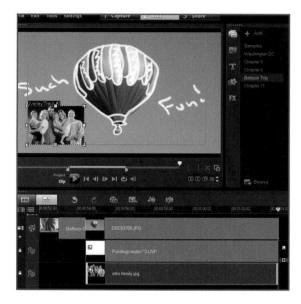

Figure 12.2
Change to Overlay Track 2.

9. Double-click the intro family.jpg image in the Timeline. In the Attribute panel, click Mask & Chroma Key.

10. Check Apply Overlay Options and then Mask Frame from the Type drop-down list.

11. To the right of the Mask library, click the plus sign (+).

12. Import your BMP mask image. Click OK in the Convert dialog box.

13. Your new mask frame is now in the Mask Frame list and is automatically applied to your overlay clip (see Figure 12.3). And that is how custom mask frames are done!

Applied here

Imported here

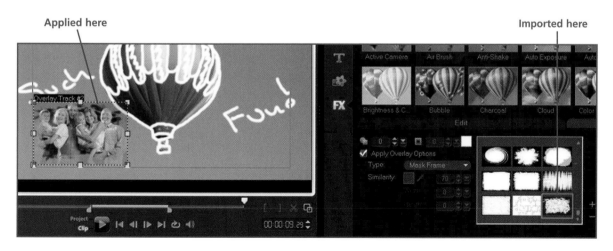

Figure 12.3
Adding a custom mask frame.

Saving Time with Batch Convert

BATCH CONVERSION IS A great time-saver and available in many applications that work with images, videos, or any other large collections of files. It accomplishes what the name implies: the Batch Convert feature allows you to quickly and easily convert a large number of video files to another video file format, instead of doing it one by one.

The Batch Convert feature also lets you convert VSX4 projects into finished video files. This is the same as going through the Share step, but it will do it to multiple projects and apply the same settings all at once. The options provided to you here are the same ones available when you export a movie through the Share step.

1. Go to the File menu and select Batch Convert (see Figure 12.4). This will take you directly to the Batch Convert dialog box.

2. Click the Add button in the upper-right corner. In the Open Video File dialog, click the Files of Type drop-down list to view all the file types that can be converted. Notice that they are all video or animation file formats. Keep the All Formats option selected. Locate and select the five videos in the Lake Tahoe folder of your Lessons video folder. Click Open.

Figure 12.4
Accessing the Batch Convert feature.

3. In the Batch Convert dialog box, click the Browse button to the right of the Save in Folder field (see Figure 12.5). Create a new folder called **Converted** within your Lessons folder. Click OK.

4. Choose MPEG-4 Files from the Save as Type drop-down list. Click the Options button to set the video save options. Since you won't actually be using the converted files, you don't need to add them to a VSX4 library. Keep the Save to Library box unchecked.

Browse button

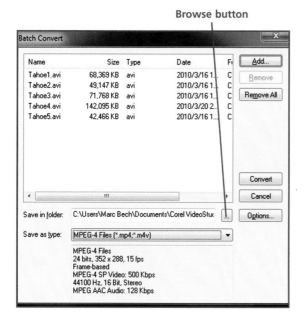

Figure 12.5
Saving your files.

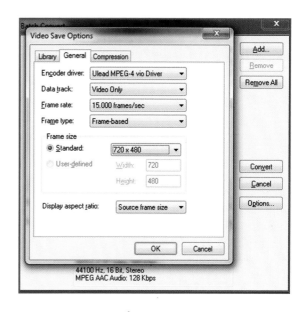

Figure 12.6
Video Save Options dialog box.

5. Next click the General tab, and choose Video Only from the Data Track drop-down list. Select Frame Size > Standard > 720×480. Review the other choices but leave them unchanged. For the correct settings, see Figure 12.6. Click OK to close only the Video Save Options dialog box.

6. Click Convert. After the rendering has completed, the Task Report dialog box should indicate that all the files were successfully converted (see Figure 12.7). Click OK to close the Task Report dialog. Compare the file sizes from the original .AVI ones to the new MPEG ones. Tahoe1 should have been reduced from 66.7 MB down to 2.38 MB. Feel free to play both movies and notice, not surprisingly, that there are trade-offs in quality.

Figure 12.7
Task Report dialog box.

Let's do a batch conversion with a couple of the chapter projects you've created. This technique is great if you have a bunch of projects that all need to be shared at the same settings, perhaps for a website, wedding videos, or a corporate marketing campaign.

1. Return to File > Batch Convert. In the Batch Convert dialog, add the following projects: Chapter 8, Chapter 10, Chapter 12. (You should have these saved in your Lesson Plans folder.) Click Open.

2. In the Batch Convert dialog box, this time choose QuickTime Movie Files from the Save as Type drop-down list.

3. Click the Options button, and in the General tab, choose a standard frame size of 720×480. Keep all other choices at their defaults. Click OK and click Convert. Your files should still be saved to the Converted folder you made earlier. When finished, play one of the files to preview it.

Creating a Smart Package

REMEMBER BACK WHEN I discussed the project file that VSX4 creates and how it only contains pointers to the media files it uses and instructions on how to use them? Also remember that if any of the media files are moved on your PC that the library files would then show up as broken links and you then have to re-establish the links manually?

This becomes a major issue when working in a collaborative environment, whether it a be a multi-media team at work, an outside advertising agency, or even just transferring your project to a different computer (e.g., from work to home). If you're missing just one file, then the project screeches to a halt until that file is found and returned to its proper location, creating time and cost delays. This is where the Smart Package feature can help.

Creating a Smart Package is a very simple feature, but it's a huge time and stress saver. Instead of saving just the project, Smart Package saves the project and all the associated files that go with it into a single folder. A Smart Package will ensure that there are no missing files or broken links. A nice bonus is that it doesn't move any of your original files, but instead makes copies of them so that the original ones stay where you put them.

You can even "zip" (or compress) the package if you like, making it even smaller. This new feature in VSX4 provides the ability to save either uncompressed files or compressed files to save space. Compressed files are saved in the ubiquitous WinZip format. Another benefit is that the compressed package is reduced to one file, instead of a folder of multiple files. You'll try both in this section in order to see the differences.

The following steps will guide you through this career-saving feature of using Smart Package to gather your files and save them in a convenient folder or single file.

1. Open your Chapter 10 project, then select File > Smart Package (see Figure 12.8). VSX4 might ask you to save your project again.

Figure 12.8
Opening the Smart Package feature.

2. In the Smart Package dialog box (see Figure 12.9), make sure the Folder radio button is chosen. Create a location for your folder. (I created a folder called MySmartPackages.) Insert the name **Chapter10Package** in both the Project Folder Name and the Project File Name fields.

3. In the lower portion, you'll see information displayed about your Smart Package, including the number of files it will gather and the resulting size of the folder. Click OK to create the Smart Package. You will receive a confirmation of its success.

Figure 12.9
The Smart Package dialog box.

In VSX4, create a new project. Under File > Open, locate and open the Chapter10Package.vsp file in the folder you just created. The project opens completely and without any broken links. You can now hand this entire folder off to someone else and be assured that all the files involved in your project will be included and will open correctly.

Now I'll show you how to use and compare the WinZip option.

1. Return to VSX4 and select File > Smart Package. In the Smart Package dialog box, select the Zip File radio button instead of Folder. Insert the name **Chapter10Zip** in both the Project Folder Name and the Project File Name fields.

2. In the Zip Project Package window that displays, click the Change Compression button. Legacy Compression will ensure that anyone with the WinZip application will be able to open the file, even very old versions. If you know that others involved in your project have a more recent version of WinZip, choose the Best Method option. That way, you'll be assured of maximum file size savings. If you're familiar with the individual compression choices, feel free to choose the last choice and then choose your desired compression method from the list. I chose the Best Method option for my project.

3. If you'll be transferring your files via e-mail or a small capacity thumb drive, you may opt to split the file sizes into smaller chunks by using the Split Zip File option. When you've chosen your desired options, Click OK to create your zipped Smart Package.

It's possible that you may not see any file size savings. Digital videos, JPGs, and MP3s are already compressed files.

The Smart Proxy Manager

HIGH-DEFINITION (HD) FILES can be four times larger (or more) than their standard-definition counterparts. Working with large HD files can bring your PC to a slow crawl when scrolling the Timeline and previewing HD clips, especially when filters and overlay layers are involved.

The main purpose of the Smart Proxy feature in VSX4 is to improve your editing experience when working with these large, high-resolution (or even large standard-resolution) files. When you edit and preview files above a certain size, Smart Proxy will kick in and use substitute files that are lower in resolution and file size.

This will make scrolling the Timeline faster and previewing clips smoother. This feature is especially useful when working with a less than optimal video editing computer and when using HDV, AVCHD, and Blu-ray video clips. When your project is shared, VideoStudio will resort back to and render your project using the original larger, higher quality files.

Follow along with these steps to learn how to take advantage of the Smart Proxy feature.

1. Open a new, blank project.

2. Go to Settings > Smart Proxy Manager > and check Enable Smart Proxy (see Figure 12.10). You can also do this in the next step; this is just a shortcut you should know about.

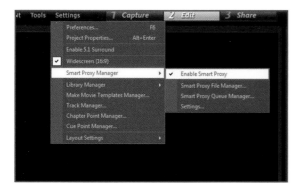

Figure 12.10
Enabling the Smart Proxy feature.

3. Go to Settings > Smart Proxy Manager > Settings. This is the same window you'll see if you go to Settings > Preferences > Performance. Because of step 2, Enable Smart Proxy will already be checked.

4. Since the largest files that are included in the lessons are 720 × 480, you need to lower the minimum file size limit that Smart Proxy will work on so Smart Proxy will kick in when it detects files smaller than that. In the Video Size drop-down list, select 352 × 240. This is the smallest size that Smart Proxy will work with. Uncheck Auto Generate Proxy Template. Click OK.

5. Open your Balloon Trip library, then select the six original HD video clips and only the video clips. Skip the Painting Creator movies and the ones you created from the project.

6. Follow this step quickly with step 7. Place all the selected video files (drag the first one and the rest will follow), in one step, into the main Video track of the Timeline.

7. Quickly open Settings > Smart Proxy Manager > Smart Proxy Queue Manager. This dialog box shows you the progress of VSX4 creating those smaller sized proxy files to work with in the Timeline (see Figure 12.11). Let it complete its job. When the Queue Manager is finished, the list should be empty, and your files are now listed in the Smart Proxy File Manager. Click OK to close the Queue Manager.

Tip

The Queue Manager does not have to remain open for this process to continue. I just want you to observe the process.

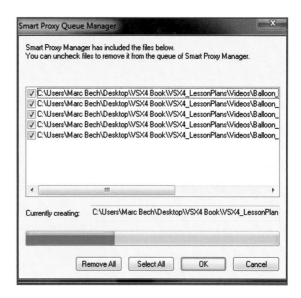

Figure 12.11
Smart Proxy Queue Manager.

8. In the main Video library, right-click on Balloon2.mpg and choose Properties. Note the file size. In this case, it's almost 23 MB. Click OK.

9. Go to Settings > Smart Proxy Manager > Smart Proxy File Manager (see Figure 12.12) . This dialog box shows the results of the Smart Proxy process. These are the file sizes of the clips currently in the Timeline. Which ones do you think will respond better during editing and previewing? Until you delete them from this list, the smart proxies will remain and will continue to be used when added to the Timeline. Click Exit.

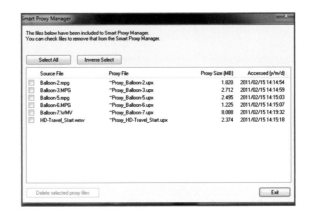

Figure 12.12
Smart Proxy Manager dialog box.

Using the Movie Template Manager

MOVIE TEMPLATES IN VSX4 are presets used to create multiple final movies for the same purpose, a template for creating a movie a certain way, size, format, and so on. Currently, the Share step > Create Video File list only contains choices for particular file formats, screen sizes, and destinations. What if you're always creating files for your website where you want to create a consistent look and feel from page to page?

Wouldn't it be nice to choose a template that would use all the appropriate option settings with just one click instead of going through and setting all your required options each and every time? That's what the Template Manager allows you to do. Let's have you create one.

1. Go to Settings > Make Movie Template Manager and click New.

2. Choose Flash Files from the File Format list. Name your template **For My Website**. Click OK.

3. In the Template Options window, notice that you can create files of a specific size. This is helpful for sites designed for users with limited bandwidth, companies that set file size limits, or those who may not have the capabilities of using a streaming server. Leave it unchecked.

4. In the General tab, choose a frame size of Standard > 320 × 240.

5. In the Compression tab, under Quality level, choose Lev2. Click OK. Close the Make Movie Template Manager window.

6. Open your Chapter 10 project without saving the current one. Go to the Share step. Click on Create Video File. At the bottom of the list is your newly created For My Website option (see Figure 12.13). Notice that Flash is already selected as the file type. Name your file **MyWebsiteMovie** and click Save. Locate the new file and notice the small file size of your new FLV (Flash Video) file.

Tip

If you don't have Adobe Flash to view your FLV file, you can download a free viewer at www.applian.com/flvplayer/.

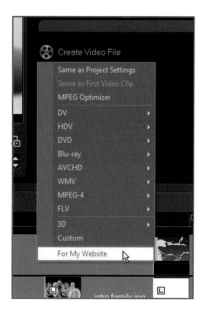

Figure 12.13
New video file template.

Creating a Movie Screen Saver

HOW ABOUT SAVING ONE of your movies as a screen saver? You know those animations that play when you've left your PC unattended for a certain amount of time? Cool idea? Screen savers are meant as both entertainment and as a way to avoid screen burn-in from having the same image displayed for too long on your monitor. You can do this for movies or slideshows. Creating a screen saver in VSX4 will automatically place it where your operating system will find it and set it as the default screen saver. (You can control the screen saver in your computer's Control Panel.)

1. Open your Chapter 10 project and open your Balloon Trip library.

2. Go to the Share step, and choose Create Video File > WMV > WMV HD 720 30p. Save it as **MyScreensaver**.

Tip

Only a single WMV file will work as a screen saver.

3. When your movie is created, a link to it will be placed in your Balloon Trip library. Clear your Timeline by going to File > New Project. Place the new Myscreensaver movie in the Timeline. This is necessary because the Screen Saver feature can only be created from one single video clip. Placing your new movie in the Timeline will allow this to happen.

4. Go to File > Export > Movie Screen Saver (see Figure 12.14). Your video will preview in the Screen Saver Settings dialog box. This is also the exact same window as the screen saver Control Panel on your PC. Click OK to keep it. Wasn't that easy?

Figure 12.14
Creating a movie screen saver.

5. On your PC, go to Control Panel > Appearance and Personalization (Windows 7) > Change Screen Saver. This window is the same as the one you just left.

If you want to rename or delete the screen saver you created, you'll need to find it on your PC and do it manually. To find it, go to this location: C:\programfiles(x86)\corel\Corel VideoStudio Pro X4\ppp.

In this folder, you'll see a file named uvScreenSaver. You can either delete or rename (right-click and choose Rename Only) this file to a more appropriate name. Be aware that if you create another screen saver without renaming the previous one, your new screensaver will replace the older one.

Adding and Managing Chapters

CHAPTERS ARE ADDED TO movies destined for DVD stardom. You can add chapters at scene breaks or other logical locations. They're then displayed on the DVD menu as the familiar Scenes or Chapters navigation buttons you're used to seeing in rented DVDs. Hitting the Next Chapter button on your remote will advance you to the next one. These can be added in a couple different locations in VSX4. You can add them in the Timeline from the Edit step or in the Share step in the Create Disc option. The following steps will show you the process of laying down chapter points.

1. Create a new project. From your WashingtonDC library, place the three fireworks clips into the Timeline in order, followed by DC2. Save your project as **ChapterPoints**.

2. A chapter point is always added at the start of a title and cannot be renamed, so if you want to add chapters at the start of each scene (clip), you need to add three more chapter points, each one at the start of all the clips except the first one.

3. Click the tiny (really tiny) down arrow to open the Chapter/Cue menu (see Figure 12.15).

4. Make sure Chapter Point is checked in the menu (see Figure 12.16).

5. Place the playback head at the beginning of the second clip. This is most easily done by just selecting the second clip in the Timeline.

Figure 12.15
Accessing the Chapter/Cue selections.

Figure 12.16
Selecting Chapter Point.

6. Click the Add/Remove Chapter Point icon (+/−), just to the left of that tiny down arrow. This will add a small green up arrow to your timeline (see Figure 12.17). That is your new chapter point.

7. Move the Timeline playback head to the start of the third clip. Click Project and note the timecode. (It should be 01:34:00.) Go to Settings > Chapter Point Manager. The first point you added will be listed here along with the timecode pinpointing its location. Click Add. Name it **Fireworks2**. Enter the timecode (01:34:00) and click OK. Rename the first clip **Fireworks1**. Click Close. Your new chapter point is now added to the Timeline.

8. Click the Add/Remove Chapter Point icon to remove the chapter point. Click it again to add it back.

Tip

The playback head does not need to be at any certain place to add a chapter (or a cue point). See where the chapter points are displayed in the Timeline? You can just click anywhere along the thin horizontal strip where these are located to add a chapter point, whether the playback head is there or not. You can also reposition them by moving them along that same path.

9. Using either method described above, add a chapter point at the start of DC2. Return to the Chapter Point Manager and name it **Washington Monument**. Make sure all of your chapter points are named as shown in Figure 12.18. These names will be used as chapter names when you create a DVD from this project. (Notice that in here, you can also convert chapter points to cue points.) Click Close when done.

Figure 12.17
Adding a chapter point.

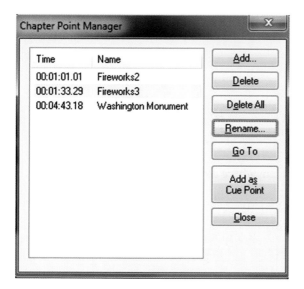

Figure 12.18
Naming chapter points.

Tip

Although, you can just double-click a point in the Timeline to rename it, using the Chapter Point Manager is the preferred method for naming and editing these markers. Double-clicking the actual chapter point is very difficult to do without either accidentally moving it or creating another one.

Deleting Chapter Points

There are several ways to delete chapter points. But if you do delete any, undo will not bring them back. You will have to re-add them.

You can put the playback head where a chapter point is located, then click on the Add/Remove Chapter Point icon, and the point will be deleted instead of added. The issue here is that it's difficult to navigate to exactly where a chapter point is located, so if you hit Add/Remove Chapter Point where there isn't one, you will add one. Then you'll have two to delete. The following options are the preferred ways to delete a chapter point:

▶ Using your mouse, grab a chapter point and simply drag it off the Timeline.

▶ Use the Chapter Point Manager to delete individual markers.

▶ Right-click in the Timeline strip where the points are and choose Remove All Chapter Points.

Although chapters can be automatically created by scene breaks when exporting to DVD, chapter points allow you to enter breaks in between scenes and will then be carried over when you create a DVD disc.

Adding and Managing Cue Points

UE POINTS ARE ADDED the same way as chapter points, but they are used for a different purpose. Use cue points as markers or notes in your video. These are not carried over to the DVD creation process. Cue points are especially helpful when sending notes from one videographer to another, such as where to place a title, where to add another clip into the Timeline, a special title, or the call to action at the end. They can also be useful during presentations to give the presenter some notes on what to say and when. These are akin to notes in a PowerPoint show, although in a much more limited fashion.

To add a cue point to your video, follow these steps.

1. In the Chapter/Cue menu, check Cue Point (see Figure 12.19). Now every time you add a point the way you added a chapter point, a cue point will be laid down instead.

Cue points look just like chapter points, except they're blue, not green. Your chapter points have also disappeared temporarily. They will reappear if you go back to showing your chapter points. The Add/Remove Chapter Point icon is also now renamed Add/Remove Cue Point.

2. Use the Add/Remove Cue Point icon to add a cue point to the start of the second clip (see Figure 12.20).

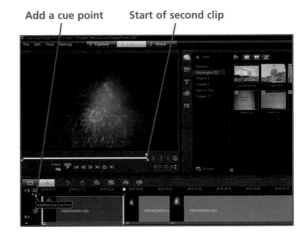

Figure 12.20
Adding a Cue Point.

Figure 12.19
Choosing the Cue Point option.

3. Using the Cue Point Manager, add the note **add transition here**. Click OK.

4. Add another cue point at the very end of the project. Name it **Add Museum clips here**. Click OK and Close.

Quick Review

5. Close VSX4 without saving this project.

▶ What colors are used to create a custom Mask Frame? (See "Creating a Custom Mask Frame.")

▶ What's the main benefit of using the Batch Convert feature? (See "Saving Time with Batch Convert.")

▶ What's the main benefit of saving your project as a Smart Package? (See "Creating a Smart Package.")

▶ When is using the Smart Proxy Manager helpful? (See "The Smart Proxy Manager.")

▶ How does the Movie Template Manager make outputting your movie easier? (See "Using the Movie Template Manager.")

Sharing Your
Videos

S O YOU'VE LEARNED JUST about all you can learn about creating awesome videos in VSX4, but that won't do you much good until you learn how to share them with the world. You know that there are three steps in VideoStudio: Capture, Edit, and Share. Its time to delve into the Share step. This step will give you opportunities to send your videos to all corners of the digital universe, including video files and audio files, regular movies and DVDs, standard definition and high definition, export to something as big as your TV or as small as your video iPod, and even make an e-mail attachment. You can create movies for YouTube, Vimeo, Flickr, Facebook, and even 3D movies!

The advantage of the way VSX4 organizes the Share step for video neophytes and intermediate hobbyists is that it lets you choose the destination or file type first, rather than a particular file format. You only need to know where you want your video to play or what kind of file you want, such as video or sound, regular file or a DVD, standard or HD, for Facebook or YouTube or your iPhone. From there, you select the appropriate options to set dimensions and frame speed, interlaced or progressive, and so on.

After these choices are made, VSX4 will select the details, such as video and audio compression. You can still choose your own details if you like through the options and custom settings, but you don't have to.

Finishing Your Movie

T HE FIRST THING YOU NEED to do is make some final adjustments to the Balloon Trip project to make it complete and ready for prime time. Many of the current scene changes are rather abrupt, so you'll need to create some smoother transitions, and perhaps some pauses, so the viewer can grasp a scene before it changes to the next one. This will also help you review some of the things you've learned so far.

1. Open the Chapter 10 project and save it as **Final_movie**.

2. Make sure that Ripple Editing is enabled on all your tracks. The little padlocks should all be locked.

3. Extend both the first black color chip in the background Video track and the first text clip in the Title track to 6 seconds.

4. Double-click the text clip you just extended to bring it up in the Preview panel (see Figure 13.1). The first block of text should be selected (Our Summer Balloon Trip). Go to the Attribute tab in the Options panel.

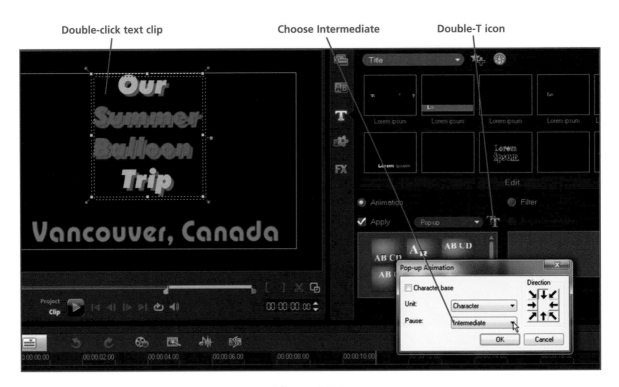

Figure 13.1
Creating a title pause duration.

Creating a Time-Lapse Effect

5. Select the Double-T icon adjacent to the animation drop-down list. In the Pop-Up Animation dialog box, choose Intermediate in the Pause list. Click OK.

6. Repeat step 5 with the lower block of text in the same clip. This will ensure that the entire text clip will animate on entry, and then pause for effect, before moving to the next scene.

7. Also add a pause duration to the text under the pickup truck video clip. These pauses will eliminate the abruptness from the end of the title animations to the next clips.

8. Add a black color chip to the main track right before the other black color chip above the ending credits. Set it to only a 1-second duration. Because Ripple Editing is set, this will also move the ending credits forward 1 second, creating a short pause before the credits roll.

Preview the part of the project just before the appearance of the pickup truck. See how it ends abruptly and jumps right to the truck clip? Let me show you how you can fix this.

1. Select the MAP image in the background Video track (not the Overlay track). In the Preview panel, click the End button to move the playback head to the end of the MAP clip. This also happens to be the same frame where the other three clips in the overlay tracks under it end, too.

2. Click Project to view all the clips at that particular time. Make sure your Balloon Trip library is open. Go to Edit > Take a Snapshot. (See Figure 13.2.) This will save a BMP of that frame and deposit it in your Balloon Trip library. (VSX4 saves it as some weird, unrelated name again. Don't bother changing it.)

Figure 13.2
Saving a single frame.

3. From the library, drag the BMP file into the main Video track right before the Balloon-2 video. Leave the clip at its default duration of 3 seconds. Drop a crossfade transition between the snapshot and Balloon-2 (see Figure 13.3). This will again move all other clips directly below forward, creating a 3-second pause between the map and the next video clips.

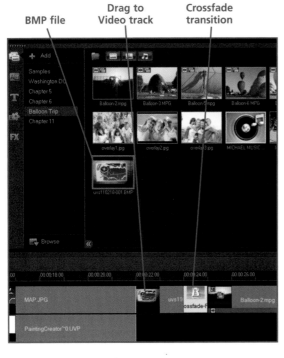

Figure 13.3
Using a snapshot to create a pause.

4. Save your project. You are now ready to create a video file.

Creating a Video File

THE FIRST EXPORT OPTION in the Share step, Create Video File, outputs single, all-in-one video files for multiple destinations in your choice of file formats. You first choose the file type, then such items as the dimensions and frame rate, video or slideshow, or mobile device type.

1. Go to the Share step and click Create Video File. As I go through the following list, feel free to expand each Create Video File selection by mousing over it and viewing the fly-out list to the right to see the more specific choices available. (See Figure 13.4.)

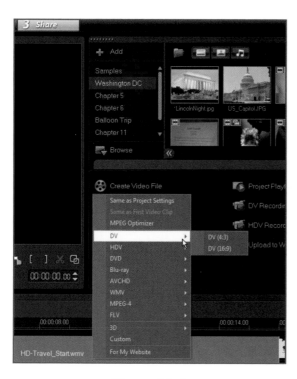

Figure 13.4
Viewing Create Video File options.

▶ **Same as Project Settings:** This is a great choice if you want to create a movie with the same dimensions as your project settings or the clips you've been using. This takes all the guesswork out of trying to determine these settings manually. Your project will be saved as either an MPEG or AVI file, depending on the choice you set in Settings > Project Properties.

▶ **Same as First Video Clip:** Ensures that all other clips in your Timeline conform to the first clip you used. This will only work though if you have a video clip as the first clip in your Timeline. It will not work for this project because it has a color chip as the first clip.

▶ **MPEG Optimizer:** This slick tool eliminates the need for multiple renderings of your MPEG-2 files that are going out to a DVD. It will render your movie once and save the info for future use. When rendering your movie again, it will look at the list already created, use as much of that info as possible, and only render what's been changed. You can also set a maximum file size. I'll expand on this in the section "Using the MPEG Optimizer" later in the chapter.

▶ **DV:** Creates standard definition AVI movies in either standard (4:3) or widescreen (16:9) views.

(4:3) for standard and (16:9) for widescreen refers to the aspect ratio of your movie screen. For example, in standard, for every 4 inches across, there is 3 inches of height. For widescreen, there is 16 inches of width for every 9 inches of height.

▶ **HDV:** Creates high-definition MPEG movies at different fields (720, 1080), interlaced (i) or progressive (p), and for TVs or PCs. Again, choose your options and VSX4 will do the rest.

▶ **DVD:** Creates single file movies in the DVD standard MPEG-2 format, but it won't send you through the disc editing and burning process. This allows you to create movies with DVD settings ahead of time. Combine them later with other MPEG-2 movies to create a longer DVD, and the project settings will already be done. You can then use the Create Disc option to add menus and chapters.

▶ **Blu-ray:** Creates movies in the MPEG Transport Stream (m2t) format and has choices for DVDs and a higher compressed setting for the web (H.264).

▶ **AVCHD:** This is the most popular output today for HD videos. They can be burned to a regular DVD disc or copied back to an AVCHD camcorder.

▶ **WMV:** This is the preferred file format for playback on your PCs, but it creates larger files due to less compression.

▶ **MPEG-4:** This is the best choice when you need the smallest file possible for things like iPods, iPhones, PSPs, and so on. There are even a couple choices that will keep the resolution at HD for you.

▶ **FLV:** This creates Flash videos that are extremely popular on the web. It requires the already ubiquitous Flash plug-in for playback. Flash also creates very small files. Flash video, though, is not scalable in size like their graphics counterparts. The resolution will decrease when you do so.

▶ **3D:** This is a new feature in VSX4 and a darn cool one at that. It will create two kinds of 3D content. The first can be viewed with those paper glasses of old (with one red lens and one cyan lens), which are the glasses most commonly used to view printed 3D images. The other type of 3D is the kind used in the new 3D HD TVs. The 3D feature here will save movies for DVDs (MPEG-2), Blu-ray, AVCHD, and WMV (see Figure 13.5). (See the section "Exporting to 3D" later in this chapter, where you'll get to make both file types.)

▶ **Custom:** Allows you to create video files not found in the main list (see Figure 13.6). These include AVI, 3GPP (for 3G phones), AutoDesk animation files, QuickTime, and others. After making a choice, use the Options button to narrow down your settings.

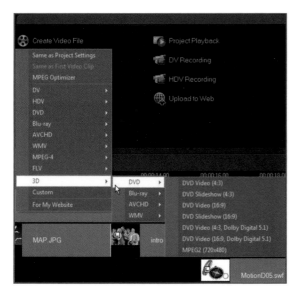

Figure 13.5
3D DVD choices.

Figure 13.6
Custom output choices.

Let's try out some of these options to practice the various ways of creating single video files for playback on various digital devices.

1. Under Create Video File, select Same as Project Settings and save your movie into a new folder called **Final_movies**. Name the file **Same_Settings_Movie**.

2. Save your movie again as WMV HD 720 30p. Name it **Wmv_Movie**.

3. Create another one using MPEG-HD. Name it **MPEG4-HD_Movie**.

4. Create another one using iPod MPEG-4. Name it **iPod_Movie**.

5. Preview all the movie types for quality differences and compare all the file sizes (see Figure 13.7). Although you might expect the HD one to be the biggest, it's actually the WMV that's the largest file. The iPod one is the smallest. MPEG4-HD is highly compressed. It's the HD file type that YouTube uses for its HD files. The WMV movie is larger than the Same_Settings movie because Same_Settings also used MPEG (Project Properties), which compresses better, but it also throws more data away than WMV.

Tip

It's impossible to cover all the recommendations here for each situation you might need to create a video file for. There are just too many possibilities. I recommend Googling a situation such as, "Videos for the web," to learn more.

Don't be afraid to ask your friends who may have video experience, too. Try the Corel VideoStudio User Forum (see Appendix B). That and your own experience will get you where you need to be. Take each accomplishment as a learning experience, and don't be afraid to experiment with different selections. After all, they're only a bunch of bits that you can delete if it doesn't work, and then you can try something different.

Figure 13.7
File size comparisons.

Creating a Video File of a Portion of the Project

IF YOU HAVE A LARGE PROJECT and want to share just a portion of it, you can. You may want to do this to have someone else examine just a portion of it for recommendations, to create a preview trailer, or to split the video into multiple parts to e-mail them more easily.

1. Move your Timeline to the end of HD-Travel_ Start. This is done most easily by selecting the clip in the Timeline and clicking the End button in the Preview panel. Select Project so that all tracks will be previewed and saved.

2. In the Preview panel, set a Mark-Out point. This sets a preview range (see Figure 13.8).

3. Go to Share > Create Video File, and choose any setting.

4. Click Options. Make sure that the Preview Range option is selected. Also make sure that Perform Smart Render is checked. This will take advantage of previously rendered clips by using them again, avoiding re-rendering and speeding up the process. Click OK.

5. Name the video portion **Preview_Movie** and click Save. Play your new movie to preview.

New project duration Set Mark-Out point Move playback head here

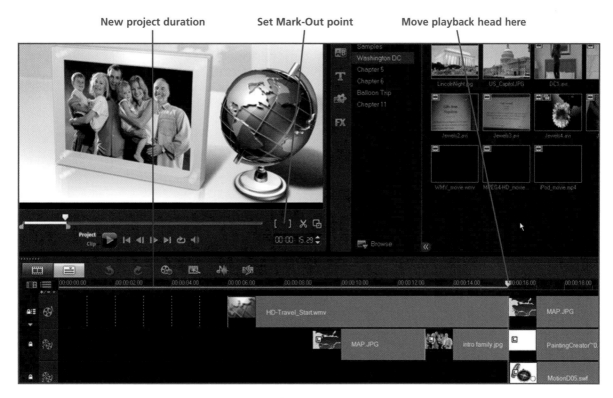

Figure 13.8
Setting a preview range.

Using the MPEG Optimizer

S INCE THIS PROJECT'S SETTINGS already
have your movie set in the MPEG format
(you'll make sure), you can now use the
MPEG Optimizer to speed up the rendering
process. The Optimizer uses Smart Render. Smart
Render only spends time rendering what has not
been rendered before. In large DVD projects, this
can save a huge amount of time, as DVDs are
rendered in the MPEG-2 format, the exact format
that the Optimizer uses.

When you use Create Video File, you also have the
option to use Smart Render, even when your project
template is set to AVI, not MPEG. So what is the
benefit of using the MPEG Optimizer if it also uses
Smart Render? The answer is, for when you create
DVDs. When you burn the DVD in the final step, it
will use the info, and thus, the time savings from
the Optimizer, since both work on MPEG-2 files.

A newer feature in the Optimizer is that you can set a maximum file size, and it will compress your project to that size. Just remember there will be a trade-off in quality.

1. Go to Settings menu > Project Properties. Referring to Figure 13.9, make sure that the MPEG Files option is selected in the Edit File Format list. Click OK. If you receive a warning message, click OK.

Figure 13.9
Setting the project template to MPEG.

2. In the Preview panel, grab the right orange handle and extend the white bar all the way across so that your entire project will be selected for output.

3. From the Share tab, select Create Video File, and choose MPEG Optimizer (shown in Figure 13.10).

Figure 13.10
MPEG Optimizer window.

4. Click the radio button Customized Converted Result File Size. This allows you to create a file size targeted to comply with any bandwidth or server size limitations you may have. You can then set a desired file size in the Size Under field, using the minimum and maximum numbers to the right as a guide.

5. Select the radio button Optimal Project Settings Profile. This will deselect the previous choice and let the Optimizer figure out the best settings instead. The green portion of the line represents parts of the project that are already MPEGs and will not need to be rendered at all.

6. Click Accept. Name the file **MPEG_Optimized** and click Save. The file will be rendered as it would when creating any other movie, and the size will be the same as creating an MPEG from scratch.

7. To test the Optimizer, go to Create Video File > HDV > HDV 10801 – 60i (for PC). Name it **MPEG-Optimized**. The file should take no time at all to create, right?

8. This time, shorten Balloon-3 in Overlay Track 2 just slightly so that it will have to be rendered again. Repeat step 6, overwriting the previous file. It will jump to about 1/3 of the way until it encounters the change, pause there to re-render that section, then it will proceed quickly to the end.

9. When the new file is finished, click Undo to return the shortened clip to its previous length, and save your project.

Creating a Sound File

I F YOU WANT TO SAVE JUST the audio from your project, you can. This is especially helpful if, after you split the audio off a video, you want to use the same sound with another movie. Or perhaps you want to convert the audio of a captured live performance and burn it to an audio CD. You can save the audio portion in the MP4, WAV, or WMA format.

The Create Sound File feature will save audio from both audio tracks as well as any audio you have in the video tracks. Keep this in mind when choosing what you want to save out. If you wish to not save the video's audio, right-click on it in the Timeline and choose Split Audio to place the audio in a separate audio track (provided you have one available). You can then delete it from the audio track.

1. Select Create Sound File in the Share step.

2. Name your file and choose which audio format you want. (Formats are explained near the end of Chapter 6 in the section called "Exporting Audio-Only Files.") Under Options, in the Files of Type drop-down list, click on the Compression tab to choose the compression you would like.

3. Click Save and preview your new audio file. Notice that it saved the music and the audio from one of the video clips near the end.

Creating a Disc

THE CREATE DISC OPTION (DVD) goes much farther than the single file created using the DVD option under Create Video File. Create Disc will launch VSX4's DVD authoring wizard, which will guide you through the steps of adding a menu to access different chapters (scenes) and a theme with an opening screen and a music track, all very similar to what you get when you rent a DVD title from the store or online. None of the additions you make here will add to your project's content. It keeps them separate.

Because of the full turnkey (all inclusive) process that this feature provides, I've devoted not one but two separate chapters on it: one chapter discusses creating a standard-definition DVD and the other discusses creating HD DVDs.

Exporting to a Mobile Device

MOBILE DEVICES COMPATIBLE with VSX4 include iPods, iPhones, PSPs, and Androids, as well as Windows-based mobile devices, smart phones, and Pocket PCs. It will also accept other devices that use the same file formats created by these choices. You'll first need to create the video file, then choose it from the video library.

1. Hook up your mobile device of choice to your computer, usually via a USB connection, like you would when you sync it.

2. In the Share step, choose Export to Mobile Device and select your device (or one similar to it) from the list. See Figure 13.11. Then choose the video file and size to create. Even if your device isn't in the list, all the files are MPEG-4 anyway, so that's the easy part. When choosing a dimension and frame rate, remember that the larger dimensions and higher frame rates will increase your file size.

 You may need to experiment with files for devices that aren't in the list, so once you figure it out, be sure to make a note of it.

Figure 13.11
Mounted external devices.

3. Name your file at the top. Select your device in the window and click OK.

Project Playback

PROJECT PLAYBACK CLEARS the screen and displays the whole project or a selected segment against a black background. You can use this feature to also output to a video tape if you have a VGA to TV converter, camcorder, or a video recorder connected to your computer. Project Playback will allow you to manually control the output device when recording, too. Although I don't expect you to have the necessary recording equipment, I can at least show you what this playback screen looks like.

1. Create a preview area on your Timeline by adjusting the Mark-In and Mark-Out points in the Preview panel. An orange line will then appear in your Timeline. (Refer back to Figure 13.8.)

2. In the Share step, select Project Playback.

3. In the window that pops up, and if you have a preview area set up in your Timeline, you'll have the option to view the short section or the entire project in full screen. Select Preview Range and click Finish. A portion of your movie will now play without any background distractions or playback controls.

 Either wait until it's done playing or hit Esc or the spacebar to stop playback and return to the main view.

4. If you desire, repeat step 3 viewing the Entire project.

DV and HDV Recordings

THESE CHOICES WILL CREATE movies and control your connected DVD camcorder to send your projects out to DV tape, HDD (hard disk drive), or mini-disk camcorders. Use the DV option for standard-resolution recordings and HDV for HD recordings. You must first create a video that your camera will accept. You will need an AVI video for the DV format and an MPEG for the HDV format. Luckily, we already have several of these. (You'll be able to follow along, depending on the equipment you have.)

1. Make sure your Balloon Trip library is open so the movies you create will be deposited there.

2. With your Final_Movie open, go to Share > Create Video File > DV > DV (16:9). This will save an AVI file. Name your movie **DV_export** and save to your Final_movies folder.

3. Connect your DV camcorder to your PC.

4. When your movie is done rendering, highlight the new DV_export clip in the library. Open the Share step and click DV Recording.

5. In the DV Recording – Preview Window (see Figure 13.12), click Play to preview the movie you just made. Click Next.

Figure 13.12
DV Recording – Preview Window.

6. Using the controls on your camcorder, move the tape to where you want to start recording on it, then click the Record button in the Record window. (See Figure 13.13.) When your recording is done, click the Stop button.

Stop Record

Figure 13.13
DV Recording – Record Window.

7. Click Finish when your recording is done. Your tape-based camcorder will now have this movie recorded to it.

8. Return to the Share step and select HDV Recording. Choose either of the two options. Notice that this file will be saved as an MPEG instead. If you have an HD camcorder, follow the same steps in this section to send an HDV movie out to your HD camcorder.

Uploading to the Web

UPLOADING VIDEOS TO SOCIAL sites on the Web has become almost as common today as making a phone call. Everyone with a smart phone is pointing at something and recording anything that moves. Uploading these short movies to sites like YouTube, Facebook, Vimeo, and Flickr is easy. (Almost too easy!) These sites have to make it easy so that anyone can do it.

In VSX4, you can first edit your movie (more folks really should be doing this) then upload it to either of these four sites without even leaving VideoStudio.

Corel has agreements with all of them that integrates the VideoStudio workflow into the social sites' upload features.

It's okay if you don't have accounts with these sites; you'll have the choice to create an account or just log in and proceed. Let's try one by uploading the Final_movie file to YouTube. (Don't worry, I'll tell you where the upload actually occurs so you can stop if you like.)

1. With your Final_movie still open, choose Share > Upload to Web > YouTube > MPEG-4 HD (16:9). See Figure 13.14.

Figure 13.14
Choosing the Upload to Web > YouTube option.

2. Name it **MyYouTube_movie** and click Save. After the movie is rendered the Step 1 – Log In to YouTube window will pop up. See Figure 13.15.

Figure 13.15
YouTube log-in window.

3. In the Log In to YouTube window, enter your YouTube account info at the top or, to create a new account, click the Join YouTube link at the bottom.

 Joining YouTube will launch your Internet browser and open YouTube's Create Account page. Follow the instructions there to upload your movie (you'll need to locate your movie on your hard drive rather than in VideoStudio. Otherwise, in the Step –1 window, enter your username and password and click Next.

4 Check to agree to the terms and click Next again.

5. In the next screen, name your video, add a description, and search tags (search criteria like family, Balloon, vacation, and so forth). Choose a category you want it to be listed in and a private or public choice. Private means your video will not be searchable and can only be accessed by those with the Internet address (URL). Click Next.

6. (This is the step where uploading begins and, of course, is completely optional.)- Confirm your choices and click the Upload Video button. Once your video is uploaded, the window will confirm its success. You can then click Finish.

7. All the other choices (Vimeo, Facebook, and Flickr) are similar to YouTube. The prompt windows will look different, but they will still guide you through the same process.

Exporting to 3D

PROBABLY THE COOLEST NEW feature in version X4 of VideoStudio is the ability to create 3D movies. There is even a feature to upload these movies straight to your YouTube account (Upload to Web > YouTube 3D). VSX4 provides two methods for making 3D content, one of which you can view easily with glasses you probably already have lying around. The other method can be sent to the new 3D HD TVs. Let me first explain these two 3D options; then you'll create both of them so that you can see the differences.

Anaglyph is the rather old-fashioned, but still popular, method that is viewed through the paper glasses with the one red lens and the one cyan-colored lens. You probably already have a couple (or 50) of these paper glasses lying around. Anaglyph 3D is actually making a resurgence, as is everything in 3D, with the increased popularity of sharing photos and videos on the Internet.

There is a rather large limitation in how VSX4 renders out a 3D anaglyph movie. It doesn't do the 3D uniformly, but only at the top of the movie, gradually decreasing to zero change at the bottom. You'll see what I mean a bit later in this section. I'm not sure if or when this will be resolved.

The second 3D option in VSX4 is the side-by-side method. This is being popularized in the new 3D HD TVs. First VSX4 splits your movie into two movies displayed side-by-side, where each side is displayed in alternate half frames. When this signal is sent to a 3D TV, the TV stretches both sides to

fill the screen, but it still displays them in half frames. Your special (and expensive) polarizing 3D glasses are then responsible for letting you see one half frame in one lens and the other half frame in the other at just the right times without causing you to go into a seizure. This will produce the 3D effect without offsetting the images, meaning you can still view the TV without the glasses and it will look normal.

3D movies in the theater use the RealD cinema technique. It uses a different polarizing method that allows for 3D viewing at any angle and without needing batteries in the glasses. You might see this technique moving to 3D TVs soon.

To create a 3D anaglyph movie, follow these steps.

1. With your Final_Movie still open, go to the Share step > Create Video File > 3D > AVCHD > AVCHD (1440×1080). Name it **MyAnaglyph_movie** and click Options.

2. Because of your 3D movie selection in step 1, the 3D Simulator box at the bottom should already be checked. Below that you'll see the two 3D methods previously discussed. Choose Anaglyph.

3. The Depth value sets the amount of 3D effect you want. Crank it to the highest number, 99. See Figure 13.16.

Figure 13.16
Anaglyph 3D options.

Figure 13.17
Side-by-side 3D results.

4. Click OK and save your anaglyph movie to your Final_movies folder. After it's done, don your fancy paper or plastic 3D glasses and have a look at it. Notice how the depth is graduated from the bottom to the top? It makes the video "lean" backward. Hopefully, Corel can improve on that soon because, otherwise, it's an awesome feature.

5. Redo the preceding steps, but this time, choose Side-by-Side in the options window. Your resulting movie should look like Figure 13.17.

Quick Review

▶ In the MPEG Optimizer, how is the time savings achieved? (See "Using the MPEG Optimizer.")

▶ When saving as a sound file, what audio is saved other than what's in the audio tracks? (See "Creating a Sound File.")

▶ When using Project Playback, how is your movie displayed on your computer? (See "Project Playback.")

▶ What four social sharing sites can you upload directly to in VSX4? (See "Uploading to the Web.")

▶ What are the two methods in VSX4 for creating 3D movies, and what are the differences in how the movies are made? (See "Exporting to 3D.")

Creating a

Standard DVD

I'T'S TIME TO GET YOUR pyromania on, because you'll be learning how to use VSX4 to burn DVDs. Okay, so this type of *burn* doesn't actually involve fire or even anything flammable; it's the common term that describes computers using a laser to engrave data onto a disc. DVDs hold so much data that they are the easiest way to save, store, and share longer movies. Just ask Netflix and Redbox!

Sure, streaming movies are becoming more popular; however, you not only need a thick data pipe (such as a cable modem, fast wireless connection, or a T1 line) to download movies in a timely fashion, but you need access to a service that stores them so they're available to download. Many folks have the former, but hardly anyone has the latter. So, in the meantime, DVDs are the way to go.

Creating Hollywood-style DVDs in VSX4 is probably easier than you think. DVD choices run the gamut, including standard definition DVDs, AVCHD (currently the most popular consumer HD recording format), Blu-ray, and BD-J (Blu-ray Disc Java). All HD formatted DVDs will be covered in the next chapter, including AVCHD and various Blu-ray DVD discs.

Selecting Create Disc in VSX4 initiates the DVD options window (more like a separate mini-application), where you'll be guided through the entire process of assembling your clips/movies and adding chapters, menu items, and a theme, and then burning your DVD. The DVD options are similar to VideoStudio's DV-to-DVD Wizard that I'll cover in the final chapter. With all that you'll learn in this chapter, Chapter 16 will feel like somewhat of a review for you.

For this chapter, you'll need a couple of blank DVDs (not CDs) and a DVD player on your PC that can also burn DVDs.

Tip

Not all PC DVD players have the capability to burn new DVDs. The easiest way to find out is to look at the DVD tray door on your PC for a phrase such as RW (read & write), Compact Disc-Re-Writable, or DVD Multi-recorder. If any of these phrases, or something similar, is inscribed on the tray door, you'll be able to burn DVDs in addition to playing them.

 Multi-recorder will ensure that you can create both standard and at least AVCHD discs, but not necessarily Blu-ray; check your manual. Many PCs will also burn AVCHD without the multi-purpose statement. Again, check your PC documentation to make sure.

What Are Your DVD Options?

WHAT KIND OF DVDs can you make, and what kind of blank DVDs can you use to make discs? You'll learn a little bit about DVDs first.

The average DVD SL (single-layer) storage capacity is 4.70 GB (gigabytes). These are the most typical in an electronics store. You can also purchase dual-layer (DL) DVDs. These can record two layers on the same side (at different depths), upping the capacity to 9.40 GB. A dual-layer HD DVD (used to record Blu-ray) can store up to 50 GB. HD DVDs can record both standard and HD (including Blu-ray) content.

Blank DL and Blu-ray DVDs require your computer to have the special ability to record in these formats. Although Blu-ray recorders are showing up in PC desktops and laptops, dual-layer recording has not surfaced so far. DVD movies are created in the VOB (Video OBject) format to encompass extras such as audio, menus, and chapters.

Any of the blank DVDs you can get at locations like Best Buy and Office Depot are ones you can use to burn movies in VSX4, as long as they are single-layer. These include DVD+R/–R (write once, read many) and DVD+RW/–RW (write many, read

many) and Blu-ray. Don't worry about the differences between + and –. The + format is a newer and competing format to the – format. Although there are technical differences, you likely won't notice them. You can still purchase both formats in stores. DVD recorders and players will work with both. Blank DVDs are inexpensive these days; you can purchase packs of 100 for $15–30 depending on brand. (That's 15–30 cents each!)

Now you'll create a DVD movie and burn it to disc using the Balloon Trip and the Tahoe movies. There are three main parts to making your DVD: Add Media, Menu & Preview, and Output. The VSX4 DVD options window will guide you every step of the way.

Adding DVD Media

THE FIRST THING YOU NEED to do for your DVD is gather the movies you want to include. You're not limited to just the Balloon movie currently in the Timeline; you can import multiple previously rendered movies, video clips, and VSX4 project files. Your content doesn't even need to be the same format or dimensions, although differing dimensions will produce letterboxing frames around them, which is what you're about to do. Other content can come from mobile devices and compatible CD/DVD content.

The next chapter on AVCHD and Blu-ray movies will contain content that is widescreen. (All HD content is created in widescreen, but not all widescreen content is HD.) This chapter, though, will incorporate both standard dimension and widescreen content. I want you to see the effects on each kind of dimension when rendered together so you can plan appropriately later. The next chapter will use all widescreen movies.

This section will guide you through the first step in the DVD-making process, as outlined in VSX4.

1. Open your Final_Movie project. Go to Settings > Project Properties. Click Edit, and then go to the General tab. Make sure Display Aspect Ratio at the bottom is set to 16:9. Since the movie this time includes both standard and widescreen movies, you want to go with the largest common denominator. Click OK twice to lock in the project properties.

2. Click on Share and select Create Disc > DVD. This choice allows you to create a disc adding both standard and HD content. Since you have chosen DVD, instead of any of the HD choices lower in the list, the content (standard and HD) will all be converted to a standard definition in the end. This, combined with the previous setting, will create a standard definition DVD that has a 16:9 aspect ratio.

3. In the Add Media window, notice that the movie is located in a thumbnail version of a Timeline, similar to the Storyboard view in the main screen (see Figure 14.1). While in the process of creating a DVD, you can no longer edit the actual movies; you can only edit their order. That's why this thumbnail view is much more appropriate. Click on the thumbnail's title in the Timeline and rename your untitled movie to **Balloon Trip**.

Figure 14.1
The Add Media window.

Also make sure the Create Menu option is checked. (It should be by default.) You will then be prompted in the Menu & Preview section for your menu options.

4. Mouse over the four Add Media choices at the top left. The first option allows you to add all the video choices that VSX4 is able to convert into MPEG-2 DVD files. Click on it to view the Open Video File dialog box (see Figure 14.2). Your only choices will be compatible video files.

Figure 14.2
Compatible media files.

5. Navigate to LessonPlans > Videos > Lake_Tahoe and add all five Tahoe videos by selecting them and clicking Open. All the Tahoe videos should be added to the Timeline in order. If they're not in order, you can easily rearrange them manually.

The Balloon Trip movie is a widescreen clip, and the Tahoe movies are standard screen size.

The small filmstrip icon in the lower-left corner of each of the video thumbnails indicates the files are movies, as opposed to still graphics. See Figure 14.3.

The other three choices under Add Media include existing VideoStudio projects (VSP files), digital media from DVDs (DVD/DVD-VR, AVCHD), and BDMV (Blu-ray movies). Files will be copied from these discs into the Timeline.

Additional movies added

Figure 14.3
Adding additional media.

The last choice, Import from Mobile Device, opens a window similar to exporting to an external device. Instead, however, it displays compatible content on these devices where you can select files you want to use. (Go ahead and click Import from Mobile Device to see what happens.) Click cancel when finished.

The DVD-VR (Video Recording) may be a new term to you. It's yet another format for DVDs that encompasses all DVDs you can import content from. It encompasses DVD-R, DVD-RW, and DVD-RAM formats. DVD-RAM is (you guessed it) another DVD format that is supposed to provide better data integrity, data retention, and damage protection.

6. Below the Add Media icons, click Add/Edit Chapter. This option allows you to add scene breaks just like what you see in Hollywood DVDs. You can add chapters in two ways: either automatically through the naturally occurring scene breaks in your movies, or manually anywhere along the Timeline you choose. Try it manually first.

 A couple of the Lake Tahoe clips are not separated correctly by their scene breaks. Under the Currently Selected Clip list, choose Tahoe4. Move the playback head to the time-code 04:15 (see Figure 14.4). Click OK, and a new clip will be added to the Timeline.

Choose Tahoe4 clip Adjust timecode

Figure 14.4
Adding chapters manually.

7. Back under the Currently selected clip list, choose Balloon Trip. Then click Auto Add Chapters. The Auto Add Chapters dialog box will appear.

8. In the Auto Add Chapters dialog, make sure the default setting is Insert Scenes as Chapters. (If it isn't, select it.) Click OK. As a result, a whole slew of vertical red dashes will be added along the Preview panel's Timeline, and another slew of new clips will appear in the Timeline below it. (See Figure 14.5.) Each Timeline clip represents where scenes change in the movie.

Click Auto Add Chapters

Figure 14.5
Chapters automatically added to the Timeline.

Although this can be a useful feature, this has added a lot of chapters that are too short to be practical. Click Remove All Chapters to remove all the chapters from the Balloon trip movie. Then click OK to close the Add/Edit Chapter window.

9. If your blank DVD's capacity differs from the horizontal bar at the bottom of this window indicating the capacity of a normal single-sided blank DVD (DVD 4.7G), you can choose a different capacity from the drop-down on this bar. The bar next to that shows the current length of your movie (green) compared to the total capacity of the DVD. This will adjust depending on the DVD capacity.

Click Next to move to the second step in the DVD process: Menu & Preview.

DVD Menu & Preview

STEP 2 IN THE DVD process is where you'll select a theme that you can fully customize. This adds a sense of uniqueness to your DVD that no one else will have and that will make you the envy of friends, family members, and colleagues. Items you can consider adding include a decorative, themed introductory screen where your chapters will be listed.

You can add themes for school, vacations, or something nondescript for business use. These themes can be edited with your own background image, video, and background music. Other features include adding intro pages for notes or a story line introduction, perhaps introducing the cast of characters in your video. You can add decorations from a collection of clip art included with VSX4.

Tip

You can go back and forth through all three steps in the DVD options window without losing any of your changes, including titles and decorations. You can even close the DVD options window. It will save the work of your current project automatically and will open the same project when you again choose Create Disc. If you choose Create > Disc with a different project, the previous one is overwritten.

Use the following steps to add entertaining DVD themes and learn about the choices you have in customizing them.

1. From the previous section, you should now be in step 2, Menu & Preview. On the left is the graphical list of possible themes for your DVD. Choose All from the list at the top. Next, choose the theme displayed in Figure 14.6 just so you can follow along with these steps.

Figure 14.6
Choosing a DVD theme.

What about SmartScene gallery items? SmartScene menus don't look any different in functionality. Features in the Edit tab are even identical. So why the "SmartScene" moniker? In all the other gallery menus, if the screen contains three text buttons, after creating the disc, it will *only* generate one menu page. When the user clicks on the text button, the button jumps to that scene. No surprise, right?

In a SmartScene, if the screen contains three text buttons, after creating the disc, it will *also* generate three separate menu pages. When a user hovers over the text button, the scene will automatically jump to the corresponding menu page for preview (*auto-activation*). It won't just play a few seconds of video in the thumbnail window. In other words, it will jump to the corresponding menu page and begin playback of that scene, including audio, from the beginning.

Beware, though, that SmartScene will consume significantly more memory compared to regular text menus.

2. In the Preview screen, you'll see the familiar yellow frame of the title-safe zone. Double-click the text that starts with PRJ_ just above the Balloon Trip clip, and name it something corny like **My Summer Vacation**. That will encompass both the Balloon and Tahoe trips. Click away from it, but don't resize or reposition it. If you accidentally resize an object, right-click on it and choose Reset Selected Objects.

3. You should have three titles under the main My Summer Vacation title (Balloon Trip, Tahoe1, and Tahoe2). You can change these names as you did with the main title, or you can keep them as is. The arrows on the bottom of the Main Menu will advance you through the rest of the menus, but they won't work until you preview the movie, which you'll do soon.

The billboard screen in the main menu is black because the Balloon Trip movie starts off with a black color chip. It will appear shortly after the clips start playing in the menu.

4. The theme you selected added another menu page to incorporate the additional chapters you added in the Add Media step, specifically in the Tahoe4 clip.

Just above the Playback controls, open the list adjacent to Currently Displayed Menu and choose Tahoe4. This is the second page of chapter links.

Notice that the theme doesn't match the first page. There is a difference between the Main Menu and all the submenus after it. You can have a separate theme for the Main Menu and one for the rest of the submenus. (I'm not sure why you would want to, but that's just me.) Select the same theme as the Main Menu from the Gallery tab.

5. Still in the Tahoe4 menu, change the Tahoe4 title to **Lake Tahoe (cont.)**. Then change the subtitles to **Tahoe3** and **Tahoe4**. The little icon of the house in the lower left will take the viewer back to the Main Menu screen. You can try it when previewing your movie.

6. Click the Edit tab next to the Gallery tab. This is where you can swap out the background music, graphics, the video for this menu screen, or all the menu screens in the introduction.

 Click the small screen icon on the left, just below where it says Background Image/Video, to open the list of background customization options. See Figure 14.7. Notice the three options for each choice. You can change the background for this menu only. All Main Menus means all the intro menus that don't include additional ones you may have added, such as note menus. All Menus includes the first two choices. The last part of the list lets you reset the background to the original theme. Although this is a nice option, you don't need it for this project. Don't make changes at this time.

 This Background Image/Video list is more helpful if you have multiple menus and submenus, which you don't in this case. Most of your DVDs probably won't either, but the options are available if you need them.

7. Click the Customize icon on the left, a little past halfway down. This allows for several unique choices. Click Motion Filter, and select the one near the end that has stars on it. If you pause your mouse over it, it will identify itself with the label Star. Feel free to choose a different Menu In and Menu Out option.

8. At the bottom of the window is a series of different frame options for the clips in the menus. Scroll to near the end, and choose the filmstrip frame. Click the Motion Filter drop-down list, and select the option pointed out in Figure 14.8. When you're done, click OK.

Choose a Motion Filter option

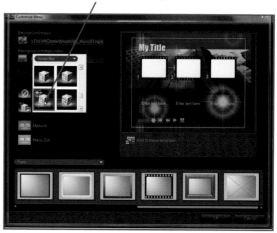

Figure 14.8
Choosing options in the Customize Menu window.

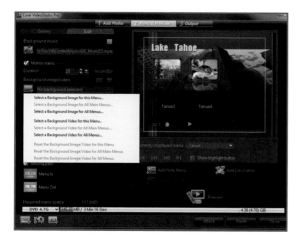

Figure 14.7
Options for setting a custom background.

SmartScene Menu gallery items are limited to customizations of the button styles. You cannot customize the video thumbnail frames or the layout.

9. Under the Currently Displayed Menu list, select Main Menu. Back in the Edit tab of the Menu & Preview window, return to Main Menu under the Currently Displayed Menu list. Click the Add Decoration icon in the lower right. This opens a collection included with VSX4 of fun embellishments you can place anywhere on screen and resize. Scroll down and open D32. Position it in the upper-left corner and enlarge it a little by grabbing the lower-right corner. (The cursor will display as a double-ended arrow.) This embellishment will help decorate the balloon movie thumbnail.

10. Reposition the My Summer Vacation title to the right so that it's in full view out of the way of the balloon decoration. See Figure 14.9.

Figure 14.9
Adding a decoration.

Tip

Again, if you accidentally resize/reshape an object (that is, a title or button) and want to reset it, right-click on the item in the Preview panel and choose Reset Selected Objects.

Decorations are in the PNG (Portable Network Graphic) format, which is a common format for Internet and print graphics. It allows for millions of colors (as opposed to a GIF, which is limited to 256 colors) and background transparency. PNG is also an open format, not requiring a license or royalties.

11. Return to the Tahoe4 menu and apply the same customizations that you did to the main menu in steps 7 and 8.

12. Click the Add Note Menu icon at the bottom. This adds another menu with the same theme after Tahoe4, where you can now add text in the billboard screen. Double-click on Enter Text Here and type the following text: **I hope you enjoy** (press Enter key) **the home video of** (press Enter) **our Summer and** (press Enter) **Winter vacations!**

 Click outside the text to set the entry. Click Font Settings on the far left to choose a nice, decorative font. (Remember, don't use a font with really thin lines.) Reposition and resize the text block to the center of the screen. This will also increase the font size.

Change the title to **Summer Vacation**. Your Preview panel should look similar to Figure 14.10.

Figure 14.10
Creating a note page.

13. Click Preview at the bottom of the window. This window allows you to use familiar remote control controls to test the running and interactivity of your movie before burning to disc. It starts playing automatically, so click the titles or the thumbnail clips to play each scene. Because of the widescreen dimension of the Balloon movie, there is some letterboxing (black bordering) going on at the top and bottom, but the other standard dimension clips fill the full screen perfectly.

14. Click Back (not Close) to leave the Preview panel. Click Next to go to Step 3, Output.

DVD Output

YOU'RE ALMOST THERE. In the Output step, you will set the final burn options, and the process begins. It's also the step where, if you screw up, you waste a bunch of blank DVDs, but such is the life of a videographer. Chalk it up to experience. I'll do my best to minimize any mistakes for you.

Be sure to grab at least two blank DVDs.

The Output step lets you set a bunch of options, but the most important one is the number of DVD copies. The Normalize Audio option is pretty important, too, because it evens out the audio variations between movie clips. The options are explained here:

▶ **Label**: Enables you to enter the name of the DVD you'll see on your C drive.

▶ **Drive**: Select the disc burner to use to create your disc, just in case you have more than one.

- **Copies**: Umm, duh.

- **Disc Type**: Displays the output disc format in your disc drive.

- **Create to Disc**: Allows you to directly burn your project onto a disc. This sounds like a "duh" choice, but it's optional in case you just want to do one or both of the next two options.

- **Create DVD Folders**: This is only enabled when the video file to be created is a DVD-Video. The files created are in preparation for burning the video file to a DVD. This also allows the user to view the finished DVD file on the computer using DVD-Video player software.

- **Create Disc Image**: Select this option if you plan to burn the video file several times. By selecting this option, you won't have to generate the file the next time you want to burn it.

- **Normalize Audio**: Different video clips may have different audio recording levels. To eliminate the varying levels when combined with other video clips, use Normalize to evaluate and adjust the audio to ensure a balanced level throughout.

The following steps will walk you through the DVD burning process.

1. Insert your blank DVD into your computer's DVD drive.

2. You might need to expand the DVD Output Options panel. See Figure 14.11.

3. Enter a Label name of **Summer Vacation**.

Expand output options icon

Figure 14.11
Click to expand DVD output options.

4. Set Copies to 2.

5. Create to Disc should already be selected. Keep the Recording format in the list to the right at DVD-Video.

6. Check Create DVD Folders. Navigate to and select your folder Final_movies.

7. Check Create Disc Image. Again, navigate to and select your folder Final_movies. Normalize Audio is not necessary since the only audio is in the Balloon Trip movie.

8. Click the Delete Temporary Files icon on the right (see Figure 14.12). Click Yes to the Continue warning box. Check your settings to match with those shown in Figure 14.12

Delete temporary files

Figure 14.12
Your DVD burn options.

9. Click the Burn icon in the lower right to start the DVD burning process. Click OK to the warning box.

The DVD rendering process can take from minutes to hours depending on the length.

Quick Review

▶ What is the capacity of most single-layer DVDs? (See "What Are Your DVD Options?")

▶ What's the difference between a DVD +/−R and a DVD +/− RW? (See "What Are Your DVD Options?")

▶ Name five things you can edit/customize on a DVD menu? (See "DVD Menu & Preview.")

▶ What is Normalize Audio used for? (See "DVD Output.")

Creating an

HD DVD

THESE DAYS, IF YOU DON'T have a high-definition (HD) video camcorder, you're close to being in the minority. Even digital still cameras are beginning to take HD video. Luckily for you, prices are lower than they've ever been. You can actually purchase pocket-sized HD camcorders for less than $150, which is amazing! Sure, they may not contain *all* the bells and whistles (okay, *any*) of the more expensive ones, but for ease of use and convenience, you can't beat them. They're also perfect starter camcorders for any video enthusiast and include easy upload capabilities.

Still in the budget arena, slightly larger hand-held camcorders can be found in the $250–$500 range. Extra features will include much larger zoom capabilities (pocket sizes may have up to 2X zoom), presets for different conditions (lighting, speed, and so on), still camera functions, and varying recording speeds and qualities. More expensive camcorders will bring you additional features such as a built-in light, image stabilization, and better shooting in low-light conditions. (See Appendix B for a camcorder buying guide from CNET.)

The HD format consists of Blu-ray (Blu-ray Disc, or BD) and AVCHD (Advanced Video Coding High Definition). BD camcorders, of which there are few at this point, start at about $600. Their discs are pricey, too; blank BD discs currently run about $1–1.50 each, which is about 3 to 5 times more than SD discs. To the average videographer, the quality differences between Blu-ray and AVCHD may not warrant the jump forward. AVCHD provides a huge leap compared to the quality of SD, but the leap from AVCHD to Blu-ray is not so drastic. It makes much more sense for Hollywood to use BD over regular HD-DVD because it enhances their already higher quality video. So when you go to buy your next camcorder, choose HD over SD—the better quality is worth the slightly higher price.

HD content takes up more storage and disc space than SD because of its higher bitrates. The higher the quality setting, the higher the bitrate and the better the captured data. AVCHD captures at a higher bitrate than SD, and BD captures at a higher bitrate than both SD and AVCHD. Many camcorders enable tweaking of bitrates. For example, your camcorder may have different quality settings for HD that allow for more recording in the same storage space. This is accomplished by changing the bitrate of your camcorder. The higher the quality setting, the higher the bitrate.

Now that you've read Chapter 14 and know how to create an SD DVD, it's a good time to learn the differences in creating AVCHD, Blu-ray, and Blu-ray-J discs.

Video data rate, generically known as *bitrate*, is the number of bits processed per unit of time. In digital multimedia, bit rate often refers to the number of bits used per unit of playback time in audio or video after data compression. The higher the bitrate, the larger the final output, but also the better the quality.

AVCHD Explained

MOST HD CONSUMER camcorders shoot in the much higher quality AVCHD format. Look for the AVCHD logo on your HD camcorder. This format can swallow up to 15 MB of storage per second of shooting, depending on the quality setting. The highest setting can fill a 30 GB camcorder drive in a little more than 30 minutes, but lower-quality settings can make it last up to an hour or more.

AVCHD uses a form of the video compression standard H.264, also known as a *codec* (compression/decompression). One of the great features of AVCHD in the HD realm is that AVCHD videos can be burned to regular blank DVDs and played back on regular DVD players. You will, of course, need an HDTV or PC with HD viewing to notice the increased playback quality. The differences between SD and AVCHD are quality and storage requirements. Blu-ray, though, is quite a bit different from both SD and AVCHD.

AVCHD may take up extra storage space over SD, but the vastly improved quality is worth it, especially since HD camcorders come with such large internal drives and available detachable memory sticks to handle the larger files.

Blu-ray Explained

AS OF 2008, ALL HOLLYWOOD HD videos are shot in the Blu-ray format. They then either produce Blu-ray DVDs and/or down-sample them for SD DVDs for those with only standard DVD players. Personal Blu-ray use has increased as well. Many of you probably own or have access to BD DVD playback capabilities with BD DVD players or Sony PlayStation systems, but my guess is that few of you have the capability to create your own BD discs or have a BD camcorder at this point. Next year, who knows?

The nice thing about Blu-ray players is that they will play all DVD formats, standard and HD.

Creating BD discs requires a special BD burner; a regular DVD disc burner will not do. You will also need a special digital video recorder that records in the BD format, so you'll have BD content to assemble and output. Although a BD burner can take any file and record it to a BD disc, unless it was recorded in the Blu-ray format, it will not be of Blu-ray quality.

BD doesn't just have a higher disc capacity; it also has a much higher data rate, which results in much higher video and audio quality. It still takes twice the storage space of SD movies, though. Blu-ray supports Dolby Digital, DTS, and LPCM audio formats. Just like DVDs and CDs, Blu-ray discs have read-only and read/write discs.

> Both LPCM (linear pulse-code modulation) and Dolby Digital are methods for encoding audio information digitally. LPCM is an uncompressed audio format designed for Blu-ray (and HD DVD) players that can supply up to 8 channel, 24 bit, 96 KHz audio. Dolby Digital also includes many sound formats, with the highest quality being compressed to 5.1 channel, 16 bit, 48 KHz audio. I've heard it described this way: Dolby Digital allows you to hear rainfall all around you. LPCM allows you to hear every single raindrop hit the ground.

The disc burning and reading mechanism in a BD recorder/player uses a blue (closer to violet actually) laser that's in a narrower wavelength, allowing it to burn and read more data in a tighter space (up to 10 times more and up to 50 GB on dual-layer discs). SD discs rely on a red laser. Standard recorders, burners, and players are not compatible with BD content; they can't read it. The upside, though, is that most BD devices are compatible with both AVCHD and SD video.

BD files are actually smaller than AVCHD files due to better encoding and the laser burning process that's involved. BD uses the M2TS codec as opposed to AVCHD's H.264 codec. The BD format is also known as *BDAV* and *BDMV*. BDAV is simply a BD movie on disc, whereas BDMV is a BD movie with the familiar Hollywood-style menus and scene breaks.

This chapter concentrates on creating these HD videos, both in AVCHD and BD. It also covers features that distinguish HD from SD. If you're unfamiliar with creating an SD disc in VSX4, be sure to read Chapter 14 first. Grab a couple more blank standard DVDs. If you have a BD burner and BD player, get yourself a couple of blank BD discs, too. You'll only be using the Balloon Trip movie in these next sections.

If you have your own AVCHD or Blu-ray content, you are welcome to use it here. Just be sure to capture/import into a VSX4 library first.

Creating an AVCHD Disc

CREATING AN HD DISC using AVCHD in VSX4 is identical to creating a disc in SD, so you won't have trouble catching on. The features of AVCHD, however, are different from SD in terms of the content, the theme templates available, the editing capabilities, and, of course, the higher-quality results. Let me show you what these differences are and where they reside.

1. Open your Final_Movie project.

2. Go to Share > Create Disc > AVCHD to launch the DVD Options window.

3. Click Next to go to the Menu & Preview step. This is where most of the VSX4 differences are when it comes to AVCHD content. The Gallery tab has fewer theme choices. Click the first theme choice in the second row.

4. Change the title and subtitle to **My Summer Vacation** and **Balloon Trip**, respectively (see Figure 15.1).

5. Click the Edit tab. Here you will notice the limited editing choices. Although you can add a video as a background (i.e., behind the marquee), AVCHD menu choices in VSX4 are basically limited to still images only because of the narrow capabilities of the themes. There are no multiple video windows displaying chapter clips. That's just the way it is. All other options are the same as for an SD DVD.

Choose this template Change to these titles

Figure 15.1
Choosing an AVCHD theme template from the Gallery tab.

6. Click the Preview icon at the bottom. Notice that there is no longer letterboxing of the video. The Balloon Trip video is widescreen, and so is AVCHD, so it fills the entire screen. Click Back.

7. Click Next to go to the Output step. As you'll see, Create to Disc is checked by default again, but there are no recording format choices. Also, there is no choice to create a disc image. Other than that, options are the same as with a standard DVD.

8. Click the Burn icon in the lower left to burn your AVCHD DVD. When it's done, your DVD tray will spit out your finished product. Pop it back in to view the movie, or go play it on your TV.

Choosing a Blu-ray File Type

YOU'RE PROBABLY SAYING to yourself, "Uh, what? There are different Blu-ray file types? Is there never one standard for anything?" I know, I feel your pain. Yes, there are several Blu-ray file types. This list covers the ones that are used in VSX4.

▶ **BDMV (Blu-ray Disc Movie):** This has three separate "profiles." I know. . .pain. These profiles support different features and require different hardware. The reason for multiple profiles was the lack of a finished specification at the time the first players were designed. VSX4 supports the most common 1.0 Profile, as do most BD players.

Tip

I ran into a BD disc incompatibility on my own BD player. I started running into errors in which the disc would just freeze after the previews and wouldn't play the actual movie.

After going to the support site of my BD player brand, I downloaded a Firmware update onto my computer. I then transferred the file to a thumb drive. Next, I inserted the thumb drive into the USB slot on my BD player and followed the online instructions to update the player's software. Problem solved.

1. **Profile 1.0**: The original profile supported on Blu-ray players prior to November 1, 2007. No secondary video decoder is included for Picture in Picture (PiP) support, and there is no Internet connectivity.

2. **Profile 1.1**: This adds PiP support via secondary video and audio decoders. It requires that a second program be present in the BDAV video stream. Also mandated is 256 MB of internal (persistent) storage.

3. **Profile 2.0**: The highest profile in the Blu-ray specifications increases internal storage to no less than 1 GB and adds an Internet connection for downloading content in conjunction with BDMV programming.

▶ **BD-J (Blu-ray's Java implementation):** These discs include interactive menus. BD-J is the name given to the Java-based software that will be included on BD-ROM discs and all BD players. BD-ROM stands for Blu-ray read-only memory, which are all playback-only BD discs. BD-J allows for BD menus and many other features.

▶ **BD-J Calendar:** A capability in BD-J discs, Calendar View automatically sorts still and video content by recorded date. This feature is not available in VSX4.

Creating a Blu-ray Disc

THERE ARE NOT A LOT OF differences in creating Blu-ray discs over SD or AVCHD discs in VSX4. In fact, the differences are so few that I'll just describe them to you. You should first complete the Share step with your Final_Movie file so you can follow along.

▶ In Menu & Preview (step 2), the Gallery theme choices are the same as for an AVCHD movie.

▶ In the Edit tab (see Figure 15.2), the custom choices are exactly like those for a standard DVD, except, under Moving Path in the lower left, there are Menu effects, but no Motion effects.

▶ Under Customize, the only custom layout choices are those for the navigation buttons. There are none for frames or overall layout placement.

▶ In Output (step 3), there is no Save as a Disc image option.

Available Menu effects

Figure 15.2
Menu effects, but no Motion effects, in the Edit tab.

Creating a Blu-ray-J Disc

BLU-RAY-J (BD-J) DISCS have increased interactivity over other DVD implementations. In Hollywood DVDs, this allows them to be far more sophisticated than bonus content provided by standard DVDs, including network access, PiP, and access to expanded local storage. Collectively, these features (other than Internet access) are referred to as Bonus View, and the addition of Internet access is called BD Live.

The part of the feature that's available in VSX4's BD-J implementation is that all menus are branched out but remain within the main menu. I'll show you what I mean. You can join in on this section.

1. With your Final_Movie, go to Share > Create Disc > BD-J.

2. Click Add/Edit Chapters.

3. Click Auto Add Chapters. The Insert Scenes as Chapters option should already be selected. If not, select it and click OK. Then click OK again.

4. Click Next. There are only three theme choices. Choose the top-right one.

5. Under the Preview window, you have three icons, all representing different stages in menu display. Click each one, from left to right, to see how the menus will be shown to the viewer. (See Figure 15.3.) These views are triggered by the left/right arrow keys on a remote control. Menus that are vertical will be controlled by the remote's up and down arrows.

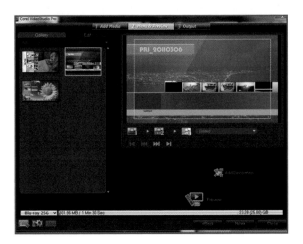

Figure 15.3
BD-J menus and submenus.

6. Missing from this screen is the ability to add a Note screen. That's because all menu features are displayed in one screen, with no room for notes. Click the Edit tab. Here, you'll notice other missing items but an addition of button sounds. Click the icon under the word *Button*. You have two button sound choices in VSX4, but you can access more from this window. Choose Select a Button Sound for All Menus (see Figure 15.4).

Notice the file type choices in the Files of Type drop-down. Click to highlight each one, and click the Play button at the bottom to preview them. See Figure 15.5. Choose either one and click Open.

7. Click Next. If you have a blank BD disc, go ahead and burn a disc to see the results.

Choose a sound file Play to preview

Figure 15.4
Choosing a different menu button sound.

Figure 15.5
Button Sound choices.

Quick Review

▶ What is the most common format for the recording and playback of consumer-level HD content? (See "AVCHD Explained.")

▶ What is the difference between BDAV and BDMV? (See "Blu-ray Explained.")

▶ What is the difference between the menu options in a BD movie as opposed to a BD-J movie? (See "Creating a Blu-ray-J Disc.")

▶ What is the only DVD format in VSX4 that doesn't allow you to add a Note page to a menu? (See "Creating a Blu-ray-J Disc.")

The DV-to-DVD

Wizard

NOW THAT YOU'VE REACHED the final chapter, I want to show you an application inside VSX4 that's a great shortcut for creating DVDs. It's called the DV-to-DVD Wizard. The Wizard, accessible under the Tools menu, is a separate mini-application for working only with content from a tape-based DV camcorder, VCR, or TV. It is not designed for importing from existing files. It is also only for creating DVDs, not slideshows, audio CDs, or uploads to a social site.

If you would like to create items other than DVDs with your tape-based camcorder content, you can still use the Capture Video and DV Quick Scan features under the Capture tab in the main work area. You will achieve the same results with the Capture tab, but the Wizard produces the results more quickly and easily than using VSX4 if you desire to go straight from tape/VCR/TV to DVD.

Deciding When to Use the DV-to-DVD Wizard

Your use of the DV-to-DVD Wizard (aka the Wizard) should be based on the considerations of your time, your level of experience, and the DVD's level of required editing. Also consider whether the project warrants burning straight to a DVD from the particular sources mentioned earlier, without the requirements of editing individual clips, adding special effects, and adding further audio. Although the Wizard does not contain these editing tools, it does have an extensive list of DVD menu features.

Because this chapter involves capturing from a source I couldn't include in the lesson plans (a digital tape camcorder), if you have your own similar setup and content, please use it to follow along, or just read along for the sheer pleasure of it.

Gather your DV-tape camcorder loaded with a tape you want to convert to a DVD, your FireWire cable, and at least one blank DVD.

A DV camcorder is considered any source that requires a FireWire (IEEE 1394) connection to your computer that allows real-time capture (or faster) from your source. It usually is best suited for mini-DV tapes where VSX4 will actually control the device. You'll read more about this as the chapter progresses.

Connecting Your Video Source

CAPTURING STRAIGHT FROM a DV camcorder is quite easy. You will need an IEEE 1394, commonly called FireWire, cable to go from the camcorder directly to your computer. (USB, USB 2.0, and eSATA will not work.) I should stress this again because it bears repeating: if either your digital tape camcorder or PC does not have a FireWire connection, you will not be able to use the DV-to-DVD Wizard.

DV camcorders usually require a mini-FireWire 4-pin connection. A desktop PC will most likely be equipped with the larger 6-pin IEEE connection. A laptop will have either the regular 6-pin or the mini-FireWire connection. No other hardware is necessary. Connect the 4-pin end of the FireWire cable to the appropriate port on your DV camcorder, called either the DV out or i.Link port. Connect the 6-pin end to the FireWire port on your PC.

Capturing from a VCR or TV is a different story. VCRs and TVs produce analog signals that need to be converted to digital ones. They require different cables and an analog-to-digital converter. Converters tend to be expensive, costing up to several hundred dollars. Output sources include RCA or S-video. The converter can be a card installed in your desktop computer or a separate stand-alone device that sits in the middle of the path between the camcorder and your computer.

You can purchase several types of FireWire cables, as shown in Figure 16.1: ones with the larger 6-pin on either end (second from the left), ones with the smaller 4-pin on either end (second from the right), or ones with a 6-pin on one end and a 4-pin on the other. There is also a 9-pin FireWire connection (far right), but you shouldn't need that in these projects. So that you can differentiate, a more common USB cable is on the far left.

Figure 16.1
Types of FireWire cables, also known as IEEE 1394 cables.

Alternatively, some folks use a DV camcorder rated to have pass-through capabilities; that is, the camcorder is the "in-between" that connects to the analog device via RCA or S-Video connectors (see Figures 16.2 and 16.3) at one end, then into the camcorder's AV-In jack. The camcorder is then connected, in Play mode, via its mini-FireWire port to your computer. The analog source plays,

its signal passes through the camcorder where the analog signal is converted to digital, and then that signal is captured on your computer into an application like the DV-to-DVD Wizard. Again, your camcorder must have this pass-through feature.

Figure 16.2
RCA cable.

Figure 16.3
S-Video cable.

Something you should know is that VSX4 cannot control the playback of a TV or VCR. You'll need to control these from the devices themselves and click Capture at the right time, or you'll need to trim off the parts you won't want later. VSX4's capturing tools and the Wizard, on the other hand, *will* allow you to control the operation of your tape-based DV camcorder.

For the sake of simplicity and commonality, this chapter only discusses capturing from a tape DV camcorder.

Load the tape that you want to capture content from into your camcorder. Connect it via the FireWire cable to your PC, and turn your camcorder on and switch it to the Play mode.

Scanning Your Content

NOW THAT YOU HAVE YOUR hardware connected and you're ready to scan/capture, it's time to prepare the software and begin the process of getting your content into the Wizard for your DVD.

Figure 16.4
Launching the DV-to-DVD Wizard.

I've discussed this previously, but it bears repeating. Scanning your content in the DV-to-DVD Wizard is different from actually capturing it. Scanning just notes information about scenes so you can decide if you want to capture individual scenes, and it displays that information for you. After you decide which scenes you want, Capture records the full scenes into memory to output to your DVD. Therefore, capturing in the Wizard is actually a two-step process.

1. In VSX4, click on the Tools menu and select DV-to-DVD Wizard from the drop-down list. See Figure 16.4.

2. In the Wizard's first screen, if your camcorder is connected properly, powered on, and in Play mode, the Start Scan icon at the bottom left will be blinking; you might already see a frame from your camcorder's tape in the Wizard Preview panel. (See Figure 16.5.)

Tip

If the Start Scan icon is not blinking, make sure the cable is firmly connected, your camera is on and in Play mode, and that you're using a FireWire connection (not USB). Try switching off and restarting your DV camcorder. Then make sure your camcorder was manufactured in this century.

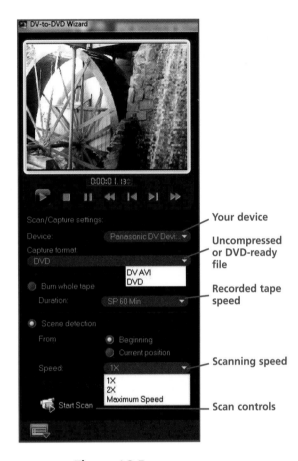

Your device

Uncompressed or DVD-ready file

Recorded tape speed

Scanning speed

Scan controls

Figure 16.5
DV-to-DVD Wizard Capture screen.

3. Your device name should be displayed below the Preview panel (again, see Figure 16.5). Under Capture format, choose either DV AVI to save uncompressed files, or choose DVD to convert to MPEG-2, thereby converting to DVD-ready files now, instead of later. I chose DV AVI. The process will work either way.

4. Choose either of the following options:

 ▶ Burn Whole Tape (ignore the settings under the Duration drop-down because VideoStudio will determine this setting based on the information on your DV tape).

 ▶ Scene Detection and From Beginning, or Current Position radio button. If Current Position is selected, use the controls under the Preview panel to move your tape's position to where you want to start capturing. If you set it to From Beginning, VS will move the playback to the start of your tape for you when you begin the scan process.

5. In the Speed drop-down list, if you want to watch the scanning process, choose 1X. If not, choose Maximum Speed. Refer to Figure 16.5.

6. Click Start Scan. Continue until you've scanned all the scenes you might want to put onto your DVD. It's often preferable to just scan straight through, because you can delete unwanted scenes easily afterward, as you'll see in the next section.

7. After you've scanned your desired content, click Stop Scan (formerly Start Scan). You should see something similar to Figure 16.6. There will be a thumbnail picture for each scene scanned. Thumbnails will be separated by when you started and stopped/paused recording your original footage. You're now ready to separate unwanted scenes.

Figure 16.6
After scanning.

Occasional first frames might be pixilated or blurry as you or your camera get situated when starting to record.

Choosing Which Content to Use

REMAINING IN THIS SAME screen (one of only two screens in the Wizard really), you'll now select which scenes you just scanned that you want to actually capture and save to use for your DVD.

1. From the thumbnail collection that the scan process just created (on the right side; refer back to Figure 16.6), select any scene you want to preview and click the Play Selected Scene icon (see Figure 16.7). Your camera will then rewind to the start of that scene and play it again. See the following Tip.

Tip

Do not use the Playback controls under the Preview panel when previewing scanned scenes. These control the tape in your camcorder from where it last stopped and have nothing to do with playing the content you've already scanned.

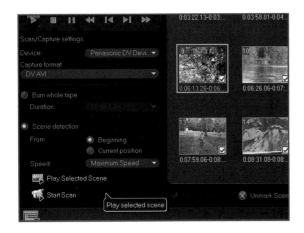

Figure 16.7
Preview a scene.

Although you can Shift-select a series of scenes and Ctrl-select a discontinuous set of scenes for other purposes, when previewing, you can preview/select one scene at a time.

2. All scanned scenes are selected for your DVD by default and are represented by checkmarks in the lower-right corner of each thumbnail. Shift- or Ctrl-select all scenes you do not want to include in your DVD. Then click Unmark Scene in the lower center of the window, as in Figure 16.8. You can also re-mark unmarked scenes by clicking Mark Scene.

Options Marked scenes Unmarked scenes

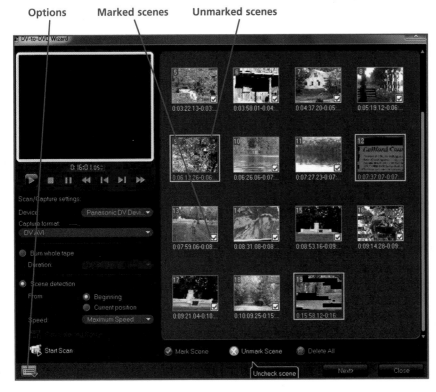

Figure 16.8
Marked and unmarked scenes.

3. Once you've selected all the scenes you want to save, click the Options icon in the lower-left corner of the Wizard window (see Figure 16.8 again) and select Save DV Quick Scan Digest. Save your file to your Chapter 16 lesson folder. This will create the Edit Decision List (EDL) discussed in earlier chapters. Using this Digest, the Wizard will know where to locate, on your tape, the scenes you want to capture. Again, the Wizard has yet to actually record the scenes; it has only scanned them for information.

4. To test step 3, close the Wizard, via the Close button in the far lower-right corner. Turn off your camera.

5. Quit and re-launch VSX4. Launch the Wizard. Using the same Options menu in the lower left, use the Open DV Quick Scan digest option to reopen the file you just saved. All your scenes will display. Click the Next button adjacent to the Close button. If you get an error message, click OK. This happened because your camera needs to be on so the digest can access the clips when it's ready to capture and burn them to a DVD. Turn your camera back on. Click No to the dialog box that shows up next, asking to delete the current scenes.

6. When the camera is ready, click Next again. You will be taken to the next window to add/edit a menu to your production and begin the burning process. Keep your camera connected and in the on/play position.

Formatting Your DVD

WELCOME TO THE SECOND of only two main screens in the DV-to-DVD Wizard. This work area will let you format the content you've just captured for final DVD output. Formatting will include adjusting such items as video settings and adding a theme with a menu so you can navigate the DVD when it plays on your TV or computer (see Figure 16.9).

1. Choose your theme from the Theme Template tray near the top. Choose your video quality from High, Standard, or Compact from the Video Quality section (see Figure 16.10).

Name your movie

Choose theme

Put DVD in drive

Edit titles

Add dates to scenes

Figure 16.9
Video formatting window in the DV-to-DVD Wizard.

Figure 16.10
Selecting the DVD video quality.

2. If desired, choose your video date information (see Figure 16.11). This is asking if you would like the date each clip was taken displayed as a caption on each scene, and for how long. Deselect Add as Title, if you do not want to display date/time info on your video clips. I usually find it intrusive and annoying, but for certain situations it could be useful.

Figure 16.11
Adding a date caption.

Figure 16.13
Menu formatting in the Edit Template Title
options for your DVD.

> **CAUTION**
>
> There is an issue with adding the date
> information as described in step 2. The
> date information is currently not an option.
> Checking it or not will still create a DVD
> with the video date as your title. Entering
> a volume name will not make a difference
> either. Corel has mentioned a fix for this in
> a future release. Please keep that in mind.

3. Click Edit Title just above the theme tem-
 plates selections to open the Edit Template
 Title dialog box for editing your DVD
 titles/menu (see Figure 16.12).

Figure 16.12
Click to access the edit DVD title area.

4. As shown in Figure 16.13, note the Begin and
 End tabs at the top of this screen. In the Edit
 Template Title dialog, you can only edit a text
 title at both the beginning and the end of
 your movie. Format the Begin and End text
 titles any way you wish. Click OK when
 you're done.

5. You can also add chapters by scene breaks,
 recording date, or specific time segments.
 Remember that adding chapters will also
 create individual scenes on the DVD that can
 be accessed by the DVD menus. To the right
 of the Recording Format drop-down list, click
 the Advanced button. The Advanced Settings
 dialog box will open.

6. In the Advanced Settings dialog, and using
 Figure 16.14 as a guide, make sure that Auto
 Add Chapter is checked, and in this instance,
 select the By Scene radio button. Keep every-
 thing else the same, including the Perform
 Non-Square Pixel Rendering option checked,
 and then click OK.

Figure 16.14
Advanced formatting options in
the DV-to-DVD Wizard.

Here is some information regarding the Perform Non-Square Pixel Rendering option in the Advanced Settings dialog box and which you'll probably encounter elsewhere in VSX4. Pixels in the graphics world are square. A 100-pixel vertical line is the same length as a 100-pixel horizontal line on a graphics monitor. Pixels in the video world are not square, but rectangular. (Go figure.) If you render rectangular video pixels as square, your video will be squished from the sides and look unnatural. Perform Non-Square Pixel Rendering is checked by default and should be kept that way.

Burning Your DVD

THE FINAL STEP IN THE DV-to-DVD Wizard is to burn the actual DVD. This process is identical to the previous tasks you've learned on creating DVDs, but the feature here is included in the same window where you just formatted your DVD. These steps are included below.

1. If you haven't already, insert a blank DVD. Back in the main screen, click the Burn icon in the lower right, as shown in Figure 16.15. There will be two blue progress bars to watch. The first one will show the total

disc burning process. The second blue bar shows the progress of capturing each clip (see Figure 16.16). Once your DVD is finished, the tray will pop out and the dialog box shown in Figure 16.17 will appear.

Figure 16.15
Click to burn your DVD.

Figure 16.16
DVD burning progress bars.

Figure 16.17
Your DVD is done!

CAUTION

You can only create one DVD at a time in the Wizard. Each additional copy will need to go through the rendering process again, instead of just the disc burning process.

So, there you have it: VideoStudio X4's absolute quickest way to capture from a DV camcorder and burn to a DVD. It uses only two main screens and a couple minor ones. The most complicated part is getting your hardware set up.

Quick Review

▶ What is the most common cable necessary to connect a digital video device to your computer? (See "Connecting Your Video Source.")

▶ What setting do you need to have your DV camcorder set to for the Wizard to capture your movies? (See "Connecting Your Video Source.")

▶ Why do you want to keep your video source constantly connected throughout the DV-to-DVD Wizard process? (See "Choosing Which Content to Use.")

▶ Besides individual movie clips, what's an alternative to creating individual scenes on a DVD? (See "Formatting Your DVD.")

▶ Why should you leave the Perform Non-Square Pixel Rendering option selected? (See "Formatting Your DVD.")

Appendix A: VSX4 Keyboard Shortcuts

THIS APPENDIX MIGHT BE useful for you to print out and keep handy. It covers all the shortcuts in VSX4 for tools and features that you can access using the keyboard instead of navigating to them with the mouse.

Menu Command Shortcuts

Keyboard Shortcut	Result
Ctrl+N	Create a new project.
Ctrl+O	Open a project.
Ctrl+S	Save a project.
Alt+Enter	Go to Project Properties.
F6	Go to Preferences.
Ctrl+Z	Undo.
Ctrl+Y	Redo.
Ctrl+C	Copy.
Ctrl+V	Paste.
Del	Delete.
F1	Go to Help.

Step Panel Shortcuts

Keyboard Shortcut	Result
Alt+C	Go to Capture step.
Alt+E	Go to Edit step.
Alt+F	Go to Effects library.
Alt+O	Go to Media library.
Alt+T	Go to Title library.
Alt+S	Go to Share step.
Up ↑	Go to the previous step.
Down ↓	Go to the next step.

Navigation Panel Shortcuts

Keyboard Shortcut	Result
F3	Set Mark-In.
F4	Set Mark-Out.
Ctrl+P	Play/Pause.
Space	Play/Pause.
Shift+Play button	Play the currently selected clip.
Home	Return to the starting segment or cue.
Ctrl+H	Go Home.
End	Move to the end segment or cue.
Ctrl+E	Go to End.
B	Return to Previous frame.
F	Proceed to Next frame.
Ctrl+R	Repeat.
Ctrl+L	Adjust system volume.
Ctrl+I	Split video.
Tab	Toggle between Trim Handles and Scrubber.
Enter	Press Tab or Enter to switch to the right trim handle if the left trim handle is active.
Left arrow	Use the left arrow key to move to the previous frame if you pressed Tab or Enter to make the trim handles or Scrubber tool active.
Right arrow	Use the right arrow key to move to the next frame if you pressed Tab or Enter to make the trim handles or Scrubber tool active.

Keyboard Shortcut	Result
Esc	Press Esc to deactivate the trim handles or Scrubber tool if you pressed Tab or Enter to activate and toggle between them.

Timeline Shortcuts

Keyboard Shortcut	Result
Ctrl+A	Selects all clips on the Timeline. Selects all characters in the onscreen Edit mode (single title).
Ctrl+X	Cuts selected characters in the onscreen Edit mode (single title).
Shift-click	Selects multiple clips in the same track. (To select multiple clips in the Library, Shift-click or Ctrl-click the clips.)
Left arrow	Select the previous clip on the Timeline.
Right arrow	Select the next clip on the Timeline.
+ / −	Zoom in/out.
Ctrl+Right arrow	Scroll forward.
Ctrl+Left arrow	Scroll backward.
Ctrl+Up/Page Up	Scroll up.
Ctrl+Down/Page Down	Scroll down.
Home	Move to the start of the Timeline.
End	Move to the end of the Timeline.
Ctrl+H	Return to the previous segment.
Ctrl+E	Go to the next segment.

Multi-Trim Video Shortcuts

Keyboard Shortcut	Result
Del	Delete.
F3	Set Mark-In.
F4	Set Mark-Out.
F5	Go backward in the clip.
F6	Go forward in the clip.
Esc	Cancel.

Layout Settings Shortcuts

Keyboard Shortcut	Result
F7	Switch to default.
Ctrl+1	Switch to Custom #1.
Ctrl+2	Switch to Custom #2.
Ctrl+3	Switch to Custom #3.
Alt+1	Save to Custom #1.
Alt+2	Save to Custom #2.
Alt+3	Save to Custom #3.

Other Shortcuts

Action	Result
Esc	Stops the capturing, recording, and rendering processes, or closes a dialog box without making changes. If you switched to a full-screen preview, press Esc to return to the Corel VideoStudio Pro workspace.
Double-click a transition in the Transition library	Automatically inserts a transition into the first empty transition slot between two clips. Repeating this process inserts a transition into the next empty transition slot.

Appendix B: Exploring Useful Websites

I'VE COME ACROSS SOME very useful websites in my videography research while writing this book. I hope you can take advantage of the knowledge these contain, just as I have. Some sites will contain content more current than others.

VideoStudio

Corel's VideoStudio website:
www.corel.com/servlet/Satellite/us/en/Product/
1175714228541

**Corel User-to-User Web Board
(http://forum.corel.com/EN/):**
A forum to ask questions and get answers. You must create a free account to ask questions, but the response time is usually very quick.

Corel User-to-User Web Board on Corel VideoStudio:
http://forum.corel.com/EN/viewforum.php?f=
1&sid=b2eb71cd9a3df0e5a7fdb26c5d3e28d8

Corel's VideoStudio Pro Tutorials on YouTube:
www.youtube.com/VideoStudioPro#p/c/
316C86D4F37ACD1D

www.youtube.com/user/VideoStudioPro#p/u/
1E7A011870433002/7/8UsTR5W-OY0

Creating a custom mask frame:
www.youtube.com/watch?v=MqTtHeZhLN8

Corel video on Vimeo:
http://vimeo.com/corelvideo

VideoStudio video tutorials you can purchase:
http://videostudiotutorials.com/

Custom VSX4-compatible music:
www.smartsound.com/

NewBlue FX: www.newbluefx.com/

**Videomaker magazine with buying guides
and videography tips:** www.videomaker.com

Corel's PaintShop Photo Pro

Corel's website on PaintShop Photo Pro:
www.corel.com/servlet/Satellite/us/en/Product/
1184951547051#tabview=tab0

**Corel's PaintShop Photo Pro YouTube
Tutorial Channel:**
www.youtube.com/PaintShopPhotoPro#p/c/
66BE117109B1AEA2

General Videography Knowledge and Tools

CNET is an excellent source for technical knowledge, product reviews, and comparison shopping:
www.cnet.com/

CNET camcorder buying guide:
http://reviews.cnet.com/camcorder-buying-guide/

Free Flash viewer: www.applian.com/flvplayer/

Reference website for MPEG: www.mpeg.org/

Dolby Laboratories: www.dolby.com/

JPEG Committee: www.jpeg.org/

How to convert MPEG files to other video files:
www.rersoft.com/mpg-video-file/

How to convert iPod audio files into other file formats:
http://docs.info.apple.com/article.html?artnum=93123

Wallace and Gromit Claymation:
www.wallaceandgromit.com/

Article on Side-by-Side 3D:
www.best-3dtvs.com/what-is-side-by-side-3d/

Online encyclopedia: www.wikipedia.org/

Index